CARRIE MAE WEEMS

OCTOBER Files

Richard Serra, edited by Hal Foster with Gordon Hughes
Andy Warhol, edited by Annette Michelson
Eva Hesse, edited by Mignon Nixon
Robert Rauschenberg, edited by Branden W. Joseph
James Coleman, edited by George Baker
Cindy Sherman, edited by Johanna Burton
Roy Lichtenstein, edited by Graham Bader
Gabriel Orozco, edited by Yve-Alain Bois
Gerhard Richter, edited by Benjamin H. D. Buchloh
Richard Hamilton, edited by Hal Foster with Alex Bacon
Dan Graham, edited by Alex Kitnick
John Cage, edited by Julia Robinson
Claes Oldenburg, edited by Nadja Rottner
Louise Lawler, edited by Helen Molesworth with Taylor Walsh
Robert Morris, edited by Julia Bryan-Wilson
John Knight, edited by André Rottmann
Isa Genzken, edited by Lisa Lee
Hans Haacke, edited by Rachel Churner
Michael Asher, edited by Jennifer King
Mary Kelly, edited by Mignon Nixon
William Kentridge, edited by Rosalind Krauss
Bruce Nauman, edited by Taylor Walsh
Sherrie Levine, edited by Howard Singerman
Michael Snow, edited by Annette Michelson and Kenneth White
Carrie Mae Weems, edited by Sarah Elizabeth Lewis with Christine Garnier

CARRIE MAE WEEMS

edited by Sarah Elizabeth Lewis with Christine Garnier

essays and interviews by Sarah Elizabeth Lewis, Huey Copeland, bell hooks, Coco Fusco, Carrie Mae Weems, Thelma Golden, Deborah Willis, Robin Kelsey, Katori Hall, Salamishah Tillet, Dawoud Bey, Jennifer Blessing, Thomas J. Lax, Kimberly Drew, Erina Duganne, Yxta Maya Murray, Kimberly Juanita Brown, Gwendolyn DuBois Shaw, José Rivera, and Jeremy McCarter

OCTOBER FILES 25

The MIT Press
Cambridge, Massachusetts
London, England

Published with generous support from the Hutchins Center for African & African American Research and the Harvard Art Museums at Harvard University.

This book was set in Bembo Std by New Best-set Typesetters Ltd. Printed and bound in the United States of America.

Library of Congress Cataloging-in-Publication Data

Names: Lewis, Sarah Elizabeth, 1979- editor.
Title: Carrie Mae Weems / edited by Sarah Elizabeth Lewis.
Other titles: Carrie Mae Weems (M.I.T. Press)
Description: Cambridge, Massachusetts : The MIT Press, [2021] | Series: October files | Includes bibliographical references and index.
Identifiers: LCCN 2019025837 | ISBN 9780262043762 (hardcover) | ISBN 9780262538596 (paperback)
Subjects: LCSH: Photographic criticism. | Weems, Carrie Mae, 1953—Criticism and interpretation.
Classification: LCC TR187 .C375 2021 | DDC 770—dc23
LC record available at https://lccn.loc.gov/2019025837

10 9 8 7 6 5 4 3 2

Contents

OCTOBER Files addresses individual bodies of work of the postwar period that meet two criteria: they have altered our understanding of art in significant ways, and they have prompted a critical literature that is serious, sophisticated, and sustained. Each book thus traces not only the development of an important oeuvre but also the construction of the critical discourse inspired by it. This discourse is theoretical by its very nature, which is not to say that it imposes theory abstractly or arbitrarily. Rather, it draws specific ways in which significant art is theoretical in its own right, on its own terms and with its own implications. To this end we feature essays, many first published in *OCTOBER* magazine, that elaborate different methods of criticism in order to elucidate different aspects of the art in question. The essays are often in dialogue with one another as they do so, but they are also as sensitive as the art to political context and historical change. These "files," then, are intended as primers in signal practices of art and criticism alike, and they are offered in resistance to the amnesiac and antitheoretical tendencies of our time.

The Editors of *OCTOBER*

This volume would not be possible without the support of Carrie Mae Weems's studio, particularly the research assistance and facilitation work by Amy Pennington-Lee, the extraordinary team at the Jack Shainman Gallery for their assiduous care for every aspect of this undertaking, and Rebecca Mecklenborg, in particular, for her assistance in collecting images from across Weems's oeuvre.

I do not know what I did to be fortunate enough to have Carrie Lambert-Beatty ask me to edit this volume on behalf of the *OCTOBER* editors one day in her office, but I do know that I will always be grateful. It is such a privilege to have her and Benjamin H. D. Buchloh, also an editor for OCTOBER Files, as colleagues. My work is immeasurably enriched by our conversations and inspired by their example.

To each of the contributors to this volume, thank you, not only for your scholarship, but also for your generosity and collaborative spirit as we produced this volume. One of the most rewarding parts of this process was receiving responses to the permissions letters we would send. "You had me at 'Carrie Mae Weems,'" one colleague responded, as if speaking for us all.

At every stage, my process of editing this volume was aided by the care and professionalism of Christine Garnier, currently a graduate student in the History of Art and Architecture Department at Harvard University. Compiling this with her assistance was, for me, quite important and a symbolic act. This book is, after all, about the future of the field. So it was a particular joy to see her model the kind of rigor, focus,

and dedication one hopes to see in such an insightful emerging scholar. I thank her for her sustained commitment to attending to all aspects of this volume for the past few years.

Of course, all of our thanks go to Carrie Mae Weems herself. What a gift it is to be in the field at this time, transformed by her inimitable and indispensable practice. I have had many occasions on which to thank Carrie, but no words seem sufficient. Perhaps this volume will not only serve the field, but also create a chorus of voices that show just how much she means to us all.

I also thank presses with published essays, short texts, and interviews included in this volume. We would like to note that this anthology retains the capitalization of the noun "black" as it appeared in the original publications. Huey Copeland's essay, titled "Specters of History," was originally published in *Artforum* (September 2014): 342–345, and appears here courtesy of the author. The foundational "Diasporic Landscapes of Longing" by bell hooks was first published in the exhibition catalog *Carrie Mae Weems* (Philadelphia: The Fabric Workshop, 1994), 29–39; and we have included that original version here courtesy of the author. Coco Fusco's review of Weems's work was originally published in *Nka: Journal of Contemporary African Art* 4 (Spring 1996): 64–65, and is republished with permission of the magazine's editors. The text "Compassion" by Carrie Mae Weems was originally published as part of *Art21: Art in the Twenty-First Century 5* (New York: Art21, Inc., 2009). We have excerpted this version to include content from pages 44–49 and 55–57 with the permission of *Art 21*, art21.org. Sarah Elizabeth Lewis and Thelma Golden's interview of Carrie Mae Weems was conducted on October 6, 2018, for inclusion in this volume, to reflect on the past and current trajectory of Weems's work and career. "Photographing between the Lines: Beauty, Politics, and the Poetic Vision of Carrie Mae Weems" by Deborah Willis was published in the exhibition catalog *Carrie Mae Weems: Three Decades of Photography and Video* (New Haven, CT: Yale University Press and the Frist Art Museum, 2012), 33–42. Sarah Elizabeth Lewis's foreword to *Carrie Mae Weems: Kitchen Table Series* (New York: Damiani/Matsumoto, 2016), 5–7, is included here with the permission of Matsumoto Editions. Reprinted with the permission of *Aperture* magazine, Robin Kelsey, Katori Hall, Salamishah Tillet, Dawoud Bey, and Jennifer Blessing's combined essay, "Around the Kitchen Table," was originally published in the special issue, "Vision and Justice," edited by Sarah Elizabeth Lewis, *Aperture* 223 (Summer

2016): 52–56. Thomas J. Lax provided "Carrie Mae Weems's Convenings" for this edited volume with the support of the Social Studies 101 foundation and courtesy of the author. "Carrie Mae Weems: The Legendary Photographer on Becoming and Exploring Personhood through Art" by Kimberly Drew was part of the interview series run by *Lenny Letter* published online on August 26, 2016; it is printed here with permission of the magazine's editors. Erina Duganne's "Family Folktales: Carrie Mae Weems, Allan Sekula, and the Critique of Documentary Photography" was originally published in *English Language Notes* 49, no. 2 (Fall/Winter 2011): 41–52. The essay by Yxta Maya Murray, "*From Here I Saw What Happened and I Cried*: Carrie Mae Weems's Challenge to the Harvard Archive," is published here as an abridged version with permission of the author. Murray originally published the piece in the legal journal *Unbound: Harvard Journal of the Legal Left* 8, no. 1 (2012–2013): 1–78. (The copyright of *Unbound* is held by the President and Fellows of Harvard College.) Dawould Bey's interview, "Carrie Mae Weems," was commissioned by and first published in *BOMB*, no. 108 (Summer 2009). (Copyright of *BOMB* Magazine, New Art Publications, and its contributors; all rights reserved. The *BOMB* digital archive can be viewed at www.bombmagazine.org.) Kimberly Juanita Brown's essay, "Photographic Incantations of the Visual," was originally published as the conclusion to *The Repeating Body: Slavery's Visual Resonance in the Contemporary* (Durham, NC: Duke University Press, 2015), 177–191. This work is republished here by permission of the copyright holder, all rights reserved (www.dukeupress.edu). Gwendolyn DuBois Shaw's article, "The Wandering Gaze of Carrie Mae Weems's *The Louisiana Project*," was first published in the journal of the Association of Historians of American Art, *Panorama* 4, no. 1 (Spring 2018). It appeared in a special section entitled "Riff: African American Artists and the European Canon," guest-edited by Adrienne L. Childs and Jacqueline Francis, which was an outgrowth of an Association for Critical Race Art History panel of the same name that took place at the annual meeting of the College Art Association in 2017. The excerpted roundtable discussion between Carrie Mae Weems, Sarah Elizabeth Lewis, José Rivera, and Jeremy McCarter, titled "Public Forum: 'Pictures and Progress,'" originally took place on April 7, 2014, and was first published in *Carrie Mae Weems: Strategies of Engagement*, ed. Robin Lydenberg and Ash Anderson (Boston: McMullen Museum of Art at Boston College, 2018), 67–70.

Dawoud Bey is a photographer and educator whose portraits of people, many from marginalized communities, suggest the reality of the subjects' own social presence and histories. Since his initial series *Harlem, USA* (1975), Bey has captured and collaborated with different types of communities in his practice, whether through the traditional exhibition format, educational initiatives, or engaged collective histories as exemplified by *The Birmingham Project* (2013). In addition, his critical writings on photography and contemporary art have appeared in various exhibition catalogs and journals, including *Contact Sheet*, *Aperture*, and *Third Text*. He is a Distinguished College Artist and professor of art at Columbia College Chicago, where he has taught since 1998.

Jennifer Blessing is senior curator of photography at the Solomon R. Guggenheim Museum, New York. She has organized numerous exhibitions, including *Photo-Poetics: An Anthology*; *Haunted: Contemporary Photography / Video / Performance*; *Family Pictures: Contemporary Photographs and Videos from the Collection of the Guggenheim Museum*; and *Rrose is a Rrose is a Rrose: Gender Performance in Photography*. Blessing has contributed to many other museum exhibitions and catalogs, including the 2014 New York presentation of *Carrie Mae Weems: Three Decades of Photography and Video*, an exhibition originated by the Frist Center for the Visual Arts in Nashville. She publishes and lectures widely on art and cultural practices involving photographic representation.

Kimberly Juanita Brown is an associate professor in the Department of English and Creative Writing at Dartmouth College. Brown's research examines visual material as a way to negotiate the parameters of race, gender, and belonging. Her first book, *The Repeating Body: Slavery's Visual Resonance in the Contemporary* (2015), examines slavery's profound ocular construction and the presence and absence of seeing in relation to the plantation space and the women who exist there. She is undertaking a book project that examines images of the dead in the *New York Times* in 1994 from four geographies: South Africa, Rwanda, Sudan, and Haiti.

Huey Copeland is the BFC Presidential Associate Professor in the History of Art at the University of Pennsylvania and the Andrew W. Mellon Professor at the National Gallery of Art (2020–2022). His research focuses on modern and contemporary art with an emphasis on articulations of Blackness in the "Western" visual field, as exemplified in *Bound to Appear: Art, Slavery, and the Site of Blackness in Multicultural America* (2013). His work has been published in numerous journals (including *OCTOBER*), exhibition catalogs, and essay collections. Copeland is at work on a manuscript that explores the constitutive role played by fictions of Black womanhood in Western art from the late eighteenth century to the present.

Kimberly Drew is a writer, activist, and cultural curator. Inspired by Toni Morrison's *The Black Book*, Drew is the editor of an anthology with Jenna Wortham titled *Black Futures* (2020), which examines how creativity relates to Black cultural identity in the age of social media. Additionally, she is the author of *This Is What I Know about Art* (2020), part of the Pocket Change Collective series.

Erina Duganne is an associate professor of art history at Texas State University. Her research focuses on three interrelated aspects: art and visual culture of the post–World War II period, transnational art and activism since the 1980s, and race and its representation. She is the author of *The Self in Black and White: Race and Subjectivity in Postwar American Photography* (2010) and a coeditor of *Beautiful Suffering: Photography and the Traffic in Pain* (2007). Her essay "*The Nicaragua Media Project* and the Limits of Postmodernism" was published in *The Art Bulletin* (2018).

Coco Fusco is an interdisciplinary artist and writer who explores the politics of gender, race, war, and identity through multimedia productions as well as performances that actively engage with the audience. Her performances and videos have been presented at many festivals, including two Whitney Biennials (1993 and 2008), and shown at the Tate Liverpool, The Museum of Modern Art, The Walker Art Center, and the Museum of Contemporary Art in Barcelona. She is the author of a number of books, including *Dangerous Moves: Performance and Politics in Cuba* (2015), as well as the recipient of numerous awards including a 2018 Rabkin Prize for Visual Arts Journalism. Fusco currently serves as professor and the Andrew Banks Family Endowed Chair at the College of the Arts at University of Florida.

Thelma Golden is director and chief curator of the Studio Museum in Harlem. As a recognized authority in contemporary art by artists of African descent and an active lecturer, Golden has organized numerous groundbreaking exhibitions, from *Black Male: Representations of Masculinity in American Art* (1994) at the Whitney Museum of American Art to *Freestyle* at the Studio Museum in Harlem (2001). She has received numerous honorary doctorates, appointments, and awards, including the 2016 Audrey Irmas Award and a 2018 J. Paul Getty Medal for curatorial excellence.

Katori Hall is a Laurence Olivier Award-winning playwright from Memphis. Hall has received numerous awards for her work, including two Lecompte du Nouy Prizes from Lincoln Center. She has been featured in publications such as the *Boston Globe*, the *Guardian* (UK), and the *New York Times*. In 2012 and 2016, her play *Children of Killers* was performed as part of the National Theatre's Connections Festival. Hall is a proud member of the Ron Brown Scholar Program and the Coca-Cola Scholar Program.

bell hooks is an acclaimed feminist theorist, cultural critic, artist, writer, and intellectual. Her publications include *Ain't I a Woman: Black Women and Feminism* (1981), *Feminist Theory: From Margin to Center* (1984), *Art on My Mind: Visual Politics* (1995), and *Writing beyond Race: Living Theory and Practice* (2013), for which she has received a number of awards. She holds a Ph.D. in literature from the University of California, Santa

Cruz, and has held a number of professorships across the United States, including at Yale University and the City College of New York. In 2014, the bell hooks Institute was founded at Berea College in central Kentucky with a mission to promote freedom and the end of domination by providing a space for critical thinking, teaching, and conversation.

Robin Kelsey is the Shirley Carter Burden Professor of Photography and Dean of Arts and Humanities at Harvard University. A specialist in the histories of photography and American art, Kelsey has published on such topics as the role of chance in photography, geographical survey photography, landscape theory, ecology and historical interpretation, picture theory, and the nexus of art and law. In 2016, he was named a Walter Channing Cabot Fellow, in recognition of achievement and scholarly eminence in the study of literature, history, or art, for *Photography and the Art of Chance* (2015).

Thomas J. Lax is the curator of performance and media art at the Museum of Modern Art, New York. He has organized or co-organized exhibitions, performances, and publications including *Steffani Jemison: Promise Machine* (2015), *Greater New York* (2015), *Maria Hassabi: PLAS-TIC* (2016), *Projects 102: Neïl Beloufa* (2016), and *Modern Dance: Ralph Lemon* (2016), among others. One of his most recent projects, *Judson Dance Theater: The Work Is Never Done* (2016), was an exhibition about the New York–based dancers, musicians, and artists who comprised the Judson Dance Theater group in the 1960s.

Sarah Elizabeth Lewis is an associate professor at Harvard University in the Department of History of Art and Architecture and the Department of African and African American Studies and affiliated faculty in American Studies and Studies of Women, Gender, and Sexuality. Her research, which focuses on the intersection of art, culture, and racial justice, has been published widely in exhibition catalogs and journals. Lewis is the author of *The Rise: Creativity, the Gift of Failure, and the Search for Mastery* (2014), *Vision and Justice* (forthcoming), and a book on race, whiteness, and photography for Harvard University Press. Her "Vision & Justice" issue of *Aperture* (2016) received the 2017 Infinity Award for Critical Writing and Research from the International Center

of Photography and launched the larger Vision and Justice Project. In 2019, she became the inaugural recipient of the Freedom Scholar Award, presented by The Association for the Study of African American Life and History, honoring Lewis for her body of work and its "direct positive impact on the life of African Americans." She is currently completing a manuscript on race and aesthetics in the era of Stand Your Ground Law.

Jeremy McCarter is a writer, director, producer, and executive producer of Make-Believe Association, a nonprofit production company. He is the author of *Young Radicals* (2017) and coauthor of *Hamilton: The Revolution* (2016) with Lin-Manuel Miranda. McCarter spent five years on the artistic staff of the Public Theater in New York where he created and ran the Public Forum series, which featured many of America's leading actors, writers, and community leaders who explore the intersection of arts and society.

Yxta Maya Murray is a professor of law and the William M. Rains Fellow at Loyola Marymount School of Law. She writes about community constitutionalism, criminal law, property law, gender justice, and law and literature, as well as the relationship between law and visual, conceptual, and performance art. She has published numerous articles in law review journals such as the *Columbia Journal of Gender & Law*, *Michigan Journal of Race & Law*, and *N.Y.U. Journal of Law & Social Change*. Murray is also a novelist and an art critic.

José Rivera is the first Puerto Rican screenwriter nominated for an Oscar for his work on *The Motorcycle Diaries*. Rivera is the author of numerous screenplays as well as twenty-six plays including the Obie Award-winning *Marisol* and *References to Salvador Dalí Make Me Hot*. His other awards include a Fulbright Arts Fellowship, NEA grant, Rockefeller Grant, and Whiting Foundation Award.

Gwendolyn DuBois Shaw is an associate professor of art history and affiliated faculty in Latin American and Latino studies, cinema studies, and gender, sexuality, and women's studies at the University of Pennsylvania. Shaw's research focuses on issues of race, gender, sexuality, and class in the art of the United States and the "New World." Her first

book, *Seeing the Unspeakable: The Art of Kara Walker*, was published in 2004. Her work has been published in exhibition catalogs, journals, and edited volumes on numerous topics within American and contemporary art, including "Creating a New Negro Art in America," in *Transition* (2012).

Salamishah Tillet is the Henry Rutgers Chair of African American Studies and Creative Writing at Rutgers University. Her book *Sites of Slavery: Citizenship and Racial Democracy in the Post-Civil Rights Imagination* (2012) examines how contemporary African American artists, writers, and intellectuals remember antebellum slavery within post-Civil Rights America in order to challenge the ongoing exclusion of African Americans from America's civic myths and to model a racially democratic future. Her work has appeared in numerous journals, including *American Quarterly*, *Callaloo*, and *Research in African Literatures*, among others.

Deborah Willis is University Professor, chair of the Department of Photography & Imaging at the Tisch School of the Arts, and director of the Institute of African American Affairs at New York University. As a leading scholar in the investigation and recovery of the legacy of African American photography, she has focused on both the African American photographer and subject in her more than twenty published works. They include texts related to and independent of exhibitions such as *Picturing Us: African American Identity in Photography* (1994), *Posing Beauty: African American Images from the 1890s to the Present* (2009), and *Out [o] Fashion Photography: Embracing Beauty* (2013). She received the John D. and Catherine T. MacArthur Fellowship and was a Richard D. Cohen Fellow in African and African American Art, Hutchins Center, Harvard University; a John Simon Guggenheim Fellow; and an Alphonse Fletcher, Jr. Fellow. Willis also pursues a professional career as a photographer.

From Here We Saw What Happened: Carrie Mae Weems and the Practice of Art History

Sarah Elizabeth Lewis

Huey Copeland got it right when he asked, "Have we all been sleeping on Carrie Mae Weems?" When my colleagues at *OCTOBER* invited me to edit this volume, Copeland's question came to mind. There was no need to deliberate. The answer was an immediate yes. His query came on the occasion of Weems's 2014 traveling retrospective, which was also the first solo show dedicated to an African American artist at the Guggenheim Museum. Given the timing, Copeland admitted that his "question might sound counterintuitive, considering the esteem with which the artist has been held since her emergence in the 1980s— if not altogether off the mark, given the successes she has enjoyed in the past year."[1] Similarly, one could imagine that it would be relatively straightforward to offer a compendium of some of the most salient publications on Weems's celebrated body of work. Yet the process of editing this volume excavated a publication pattern and sequence that only underscored the need to consider Copeland's query as a live question to be answered, and not a rhetorical strategy alone.

Consider first what the reader of this volume will notice: the publications centered on Weems create a significant temporal break and an elliptical arc. This volume includes two essays representing publications from the mid-1990s by bell hooks and Coco Fusco, followed by two publications featuring Weems's voice from the 2000s, bookended by landmark essays by scholars and curators including Copeland, Deborah Willis, Robin Kelsey, Salamishah Tillet, Jennifer Blessing, Thomas J. Lax, Erina Duganne, Yxta Maya Murray, Kimberly Juanita Brown, and

Gwendolyn DuBois Shaw, all representing scholarship published after 2011. Weems's work has been so prominent in exhibitions that such a temporal break might seem to be an editorial error. Yet during this period between 1996 through the mid- to late 2000s, articles and essays that mentioned Weems mainly included her in the context of larger discussions of Black artists, often Black women artists, or focused on her exclusively in the context of brief exhibition catalog essays.[2] In fact, when I mentioned that I would be editing this issue, Weems's first response was to ask if there were enough published articles on her work over the decades to support the endeavor. It was not mere humility. She knew. She also knew that the chronology in the scholarship made a precise critical argument of its own.

The elliptical emergences of the landmark, probing scholarship on Weems typify an emergent pattern for many artists of color, but specifically for Black artists: there are often stark gaps in the publication record even as the pace and rate of their inclusion in and selection for group and solo exhibitions increase. The result are oeuvres that may be celebrated, but are not fully documented or theorized, creating an asymmetry between acclaim and the development of a discourse surrounding the artist's work. This history exacerbates the structural inequities faced by artists of color, and by Black artists in particular. Weems reflected on these gaps in her conversation with Thelma Golden and me for this volume stating, "This is not something that just happens with me as a woman. It has happened consistently with African American artistic practice and I think it's one of the downfalls of the field to not really take it on." This volume takes it on.

The elliptical break in the scholarship on Weems also offers a unique methodology through which to trace three key shifts in the discipline of art history at large, all of which altered the reception of her work over decades of production. Briefly stated, the first is a development in the history of reception regarding African diasporic art history. As Krista Thompson has argued, two main scholarly interventions, the publication of Robert Farris Thompson's *Flash of the Spirit* (1983) and Paul Gilroy's *The Black Atlantic* (1993), centralized the discipline of art history at the time as a site for understanding the developing ideas of diaspora, and productively expanded and critiqued what qualified as an object of art historical study in the discipline.[3] During this period, art historians, curators, and cultural theorists including Suzanne Blier, Okwui Enwezor,

and Stuart Hall focused on framing the diaspora as a "process rather than a permutation of Africa," identified the syncretic nature of African cultural forms themselves, and challenged the cultural hegemony in the field of contemporary art.[4] A second important shift in this time period was cemented as scholars including Richard Powell and Kobena Mercer demonstrated and insisted on the imbrication of modernism with African American and African diasporic artistic practice through foundational texts such as *Black Art and Culture in the 20th Century* (1997) and *Rhapsodies in Black* (1997) by Powell and David Bailey, and Mercer's series of books, Annotating Art's Histories.[5] A third methodological shift during this time was occasioned by scholars including Martin Berger, Maurice Berger, Hal Foster, Édouard Glissant, Nicholas Mirzoeff, W. J. T. Mitchell, Toni Morrison, Shawn Michelle Smith, Michele Wallace, and Deborah Willis who focused on the polemics, process, and construction of vision, absence, and opacity in the history of racial formation and social power.[6]

If there is any "benefit" to this belated reception of Weems's work as these equally important shifts took place, it is that her focus and stage became not the marketplace, but the drama of history. Her non-market-oriented approach positioned her to fully occupy the role, as Kathryn Delmez has put it, of being "history's ghost."[7] What emerged was a practice defined by an aesthetics of reckoning, works designed to force a confrontation with the unspeakable, allied to those who had been forgotten, unnamed, unheralded, and marshaled to examine the subjective construction of beauty and the biased formation of the "history of power."[8]

So while this volume embraces the mission of OCTOBER Files to offer a compendium of some of the most salient writing on the artist's body of work to date, it is best read with a consideration of what shaped and structured the patterns surrounding the critical reception of Weems's work. It is with knowledge of these three methodological shifts—in the reception of African diasporic artistic practices as an object of study and as requisite for understanding the history of modernism, and expanded discourse on the history of visuality—that one can best understand the inevitable periodization of the scholarship on Weems in this volume. One is able to see the prescient and significant innovation by, for example, bell hooks in her 1990s scholarship on Weems addressing the political importance of Weems's anticolonialist aesthetic through

a "diasporic landscape of longing" in series such as *Sea Island Series, Gorée Island,* and *Went Looking for Africa.*[9] One, too, can better understand why the publication of the *Kitchen Table Series* came over twenty-five years after its initial creation, or why this volume treats Weems's interviews as particularly vital archival documents. Over time, the cauterization of the scholarship on her work early on turned her into one of the best analysts of her oeuvre.

It is possible to take Copeland's query even further and ask: Can one grasp the developments of intertwined fields of modernism, American contemporary, and African diasporic art without understanding the interventions of and scholarly patterns surrounding the work of Carrie Mae Weems? This volume is a salute to the work of a prodigious artist whose work has irrevocably impacted the discipline of art history and the humanities at large. It is a tribute as well, to the scholars, artists, and curators who knew this would be the case all along. It is a celebration of what together Weems and her interlocutors have achieved—a critical inquiry into her aesthetics that have occasioned a fundamental shift in envisioning the history of power so searing that her oeuvre can seem, as one of my students at Harvard put it, as if one has glimpsed "an oracle."

Notes

1. Huey Copeland, "CLOSE-UP Specters of History," *Artforum International* 53, no. 1 (September 2014): 342–345.

2. So that other scholars might benefit from a fuller list, see the following publications in English: Kathleen D. Adrian, "The Decentralization of Subject in African American Feminist Photography: Constructing Identity Based on Representation and Race in the Work of Lorna Simpson, Carrie Mae Weems and Clarissa Sligh," *disClosure: A Journal of Social Theory* 7 (1998): 11–39; Caroline A. Brown, *The Black Female Body in American Literature and Art: Performing Identity* (New York: Routledge, 2012); Lisa E. Farrington, "Conceptualism, Politics, and the Art of African-American Women," *Source: Notes in the History of Art* 24, no. 4 (Summer 2005): 67–75; Farrington, "Reinventing Herself: The Black Female Nude," *Woman's Art Journal* 24, no. 2 (Autumn–Winter 2003): 15–23; Amy Mullin, "Art, Understanding, and Political Change," *Hypatia* 15, no. 3 (Summer 2000): 113–139; Vivian Patterson, "Carrie Mae Weems Serves Up Substance," *Gastronomica* 1, no. 4 (Fall 2001): 21–24; Cherise Smith, "Fragmented Documents: Works by Lorna Simpson, Carrie Mae Weems and Willie Robert Middlebrook at the Art Institution of Chicago," *Art Institute of Chicago Museum Studies* 24, no. 2 (1999): 244–259, 271–272; Salamishah Tillet, "In the Shadow of the Castle: (Trans)Nationalism, African American Tourism, and Gorée Island," *Research in African Literatures* 40, no. 4 (Winter 2009): 122–141; Mary Drach McInnes, *Telling Histories: Installations by Ellen Rothenberg*

and *Carrie Mae Weems* (Seattle: University of Washington, 1999); Vivian Patterson, ed., *Carrie Mae Weems: The Hampton Project* (New York: Aperture, 2000); Eddie Chambers, "Carrie Mae Weems: Café Gallery Projects, London," *Art Monthly* 288 (July/August 2005): 30–31; Brian Wallis, "Black Bodies, White Science: Louis Agassiz's Slave Daguerreotypes," *American Art* 9, no. 2 (Summer 1995): 38–61; Coreen Simpson, *Interview of Carrie Mae Weems by Coreen Simpson* (New York: Hatch Billops Collection, 2005); Denise Ramzy and Katherine Fogg, "Interview: Carrie Mae Weems," in *Carrie Mae Weems: The Hampton Project* (New York: Aperture, 2000), 78–83; Adrienne Edwards, "Carrie Mae Weems," *Aperture* (December 2015): 102–111; Edwards, "Scenes of the Flesh: Thinking-Feeling Carrie Mae Weems's *Kitchen Table Series* Twenty-Five Years On," *Carrie Mae Weems: Kitchen Table Series* (New York: Damiani/Matsumoto, 2016), 9–15.

3. Krista Thompson, "A Sidelong Glance: The Practice of African Diaspora Art History in the United States," *Art Journal* 70, no. 3 (2011): 6–31. This incisive paper came out of a panel that Thompson co-chaired with Jacqueline Francis, "African Diaspora Art History: State of the Field," at the College Art Association's annual conference in 2010. See Robert Farris Thompson, *Flash of the Spirit: African and Afro-American Art and Philosophy* (New York: Random House, 1983); and Paul Gilroy, *The Black Atlantic: Modernity and Double Consciousness* (Cambridge, MA: Harvard University Press, 1993). The influence of scholarship by Henry Louis Gates Jr. on the methodologies for African diasporic analysis was key here. See Gates, *The Signifying Monkey: A Theory of African-American Literary Criticism* (New York: Oxford University Press, 1988).

4. Thompson, "A Sidelong Glance," 18. The exhaustive list of texts in this time period cannot be printed in full; however, key selections include Stuart Hall, "What Is This 'Black' in Black Popular Culture?," in *Black Popular Culture*, ed. Gina Dent (Seattle: Bay Press, 1992), 21–33; Hall, "Cultural Identity and Diaspora," in *Identity: Community, Culture, Difference*, ed. Jonathan Rutherford (London: Lawrence and Wishart, 1990), 222–237; Okwui Enwezor, "The Postcolonial Constellation: Contemporary Art in a State of Permanent Transition," in *Antinomies of Art and Culture: Modernity, Postmodernity, Contemporaneity*, ed. Terry Smith, Okwui Enwezor, and Nancy Condee (Durham, NC: Duke University Press, 2008), 207–234; and Suzanne Preston Blier, "Vodun: West African Roots of Vodou," in *Sacred Arts of Haitian Vodou*, ed. Donald J. Cosentino (Los Angeles: UCLA Folwer Museum of Cultural History, 1995), 61–87. As Thompson notes, James A. Porter offered a precursor to this work in his "The Trans-Cultural Affinities of African Art," in *Africa from the View of American Negro Scholars*, ed. John A Davis (Paris: Presence Africaine, 1958); Geoff Quilley and Kay Dian Kriz, eds., *An Economy of Colour: Visual Culture and the Atlantic World, 1660–1830* (Manchester, UK: Manchester University Press, 2003); Steven Nelson, "Diaspora; Multiple Practices, Multiple Worldviews," in *A Companion to Contemporary Art since 1945*, ed. Amelia Jones (Maiden, MA: Blackwell Publishing, 2006), 296–316; and Nelson, *From Cameroon to Paris: Mousgoum Architecture In and Out of Africa* (Chicago: University of Chicago Press, 2007).

5. Richard J. Powell, *Black Art and Culture in the 20th Century* (London: Thames and Hudson, 1997); and Richard J. Powell and David Bailey, *Rhapsodies in Black: Art of the Harlem Renaissance*, exh. cat. (Berkeley, CA: University of California Press, 1997). See also the following anthologies edited by Kobena Mercer: *Cosmopolitan Modernisms* (Cambridge, MA: Institute of International Visual Arts and MIT Press, 2005); *Discrepant Abstraction* (Cambridge, MA: Institute of International Visual Arts and MIT Press, 2006); *Pop Art and Vernacular Cultures* (Cambridge, MA: Institute of International Visual Arts and

MIT Press, 2007); and *Exiles, Diasporas and Strangers* (Cambridge, MA: Institute of International Visual Arts and MIT Press, 2008). For more, see John Davis, "The End of the American Century: Current Scholarship on the Art of the United States," *The Art Bulletin* 85, no. 3 (2003): 544–580, 570; and Michael D. Harris and Moyosore B. Okediji, *Transatlantic Dialogue: Contemporary Art In and Out of Africa*, exh. cat. (Chapel Hill: University of North Carolina at Chapel Hill, 1999).

6. Thompson, "A Sidelong Glance," 8, 19. See Martin A. Berger, *Sight Unseen: Whiteness and American Visual Culture* (Berkeley: University of California Press, 2005); Maurice Berger, "Are Art Museums Racist?," *Art in America* 78, no. 9 (1990): 68; Maurice Berger, *White Lies: Race and the Myths of Whiteness* (New York: Farrar, Straus, Giroux, 1999); Hal Foster, *Recodings: Art, Spectacle, Cultural Politics* (Port Townsend, WA: Bay Press, 1985); Édouard Glissant, "For Opacity," in *Over Here: International Perspectives on Art and Culture*, ed. Gerardo Mosquera and Jean Fisher (New York: New Museum of Contemporary Art, 2004); Toni Morrison, *Playing in the Dark: Whiteness in the Literary Imagination* (Cambridge, MA: Harvard University Press, 1992); Shawn Michelle Smith, *American Archives: Gender, Race, and Class in Visual Culture* (Princeton: Princeton University Press, 1999); Nicholas Mirzoeff, *Diaspora and Visual Culture: Representing Africans and Jews* (New York: Routledge, 2000); W. J. T. Mitchell, *Picture Theory: Essays on Verbal and Visual Representation* (Chicago: University of Chicago Press, 1994); Michele Wallace, "Modernism, Postmodernism and the Problem of the Visual in Afro-American Culture," in *Out There: Marginalization and Contemporary Cultures*, ed. Russell Ferguson, Martha Gever, Trinh T. Minh-ha, and Cornel West (Cambridge, MA: MIT Press, 1990), 39–50; Deborah Willis, *Picturing Us: African American Identity in Photography* (New York: New Press, 1994); Willis, *Reflections in Black: A History of Black Photographers, 1840 to the Present* (New York: W. W. Norton, 2000); Deborah Willis and Carla Williams, *The Black Female Body: A Photographic History* (Philadelphia: Temple University Press, 2002); Willis, *Constructing History: A Requiem to Mark the Moment* (Savannah, GA: Savannah College of Art and Design, 2008).

7. Kathryn E. Delmez, "Introduction," in *Carrie Mae Weems: Three Decades of Photography and Video*, ed. Kathryn E. Delmez (New Haven, CT: Yale University Press and the Frist Art Museum, 2012), 9. Claire Raymond has argued that the belated institutional reception of Weems's work in a consistent fashion allowed her to focus on a riskier strategy that the market does not necessarily reward, at least in the short term. See Raymond, "The Crucible of Witnessing: Projects of Identity in Carrie Mae Weems's From Here I Saw What Happened and I Cried," *Meridians: Feminism, Race, Transnationalism* 13, no. 1 (January 2015): 26–52. See also Robin Kelsey, "Tribute to Carrie Mae Weems," W. E. B. Du Bois Medal Ceremony, Hutchins Center Honors, Harvard University, September 30, 2015.

8. Weems cited in Dawoud Bey, "Carrie Mae Weems," *BOMB*, no. 108 (Summer 2009).

9. bell hooks, "Diasporic Landscapes of Longing," in *Carrie Mae Weems*, exh. cat. (Philadelphia: The Fabric Workshop, 1994), 29–39.

Specters of History

Huey Copeland

Have we all been sleeping on Carrie Mae Weems? The question might sound counterintuitive, considering the esteem with which the artist has been held since her emergence in the 1980s—if not altogether off the mark, given the successes she has enjoyed in the past year. Highlights include a MacArthur "genius" award, a magisterial display of *Museum Series* at the Studio Museum in Harlem, and the star-studded "Past Tense/Future Perfect" conference organized around her work at the Solomon R. Guggenheim Museum in New York, the last stop of *Carrie Mae Weems: Three Decades of Photography and Video*, the artist's traveling retrospective. In a word, Weems's profile has never been higher. But, arguably, we have yet to receive a full accounting of her recursive and affecting practice, which embraces an ever-increasing array of lens-based media in order to reactivate historical memory. Indeed, as *New York Times* critic Holland Cotter noted, the Guggenheim's showing was both a needed intervention and a "galling" "shame," offering a scaled-down version of an already partial survey that was infelicitously shoehorned into the museum's annexes rather than allowed to unfurl in Frank Lloyd Wright's coiled rotunda.[1]

Where black artists are concerned, such accommodating half measures on the part of "mainstream" New York institutions should come as no surprise—just think back to the Museum of Modern Art's hanging of Wifredo Lam's *The Jungle* (1943) next to the coatroom for decades. Still, it is unfortunate, if not unsurprising, that no venue in Weems's adopted city has thus far mounted a comprehensive exhibition of her

practice or shown the recent work that spurred my initial query, a production that holds its own alongside her most renowned photo-texts such as the *Kitchen Table Series* (1990), and *From Here I Saw What Happened and I Cried* (1995–1996). For, whether holding out eloquent fabulations of black intimacy or critiquing the visual construction of racialized subjectivity, Weems's art has consistently blended vernacular and high-cultural traditions from a uniquely feminist African-diasporic perspective that is nearly without parallel in the visual arts.[2]

The same might be said of the piece in question, *Lincoln, Lonnie, and Me—A Story in 5 Parts* (2012), which was commissioned by and debuted at the Mattress Factory in Pittsburgh as part of the exhibition, *Feminist And . . .* alongside other new works by Julia Cahill, Betsy Damon, Parastou Forouhar, Loraine Leeson, and Ayanah Moor. Weems's contribution was subsequently shown at LOOK3 in Charlottesville, Virginia, and at Chicago's Rhona Hoffman Gallery last fall in the context of a small but revelatory survey exhibition, *Slow Fade to Black* (its title a nod to Weems's photographic series from 2010) that featured a selection of the artist's recent work. *Lincoln, Lonnie, and Me* was located upstairs from the main gallery, sequestered in a room all its own. Yet in this case—as with the recent staging of Kara Walker's ghostly monument *A Subtlety* in a condemned Williamsburg sugar factory—such apparent spatial relegation was fitting, especially given the technical and experiential demands of the work, a complex video installation that mobilized old and new visual technologies to mesmerizing effect.

After brushing aside heavy blackout shades, you enter a darkened room—that ubiquitous mise-en-scène of contemporary image projection—only to immediately confront an environment more redolent of the nineteenth century: a theatrical stage framed by blood-red curtains and set off with velvet ropes. In the work's eighteen-and-a-half-minute video projection, life-size floating figures succeed one another on center stage, occasionally wreathed by falls of snow or whiffs of vapor that bring to mind the fog that enveloped artist Terry Adkins in Lorna Simpson's *Cloudscape* (2004). The procession of luminous apparitions in Weems's video—broken up at times by moments of silence during which the stage is empty—is accompanied by an equally varied array of sounds, beginning with Blind Willie Johnson's nearly wordless classic "Dark Was the Night, Cold Was the Ground," whose melancholic

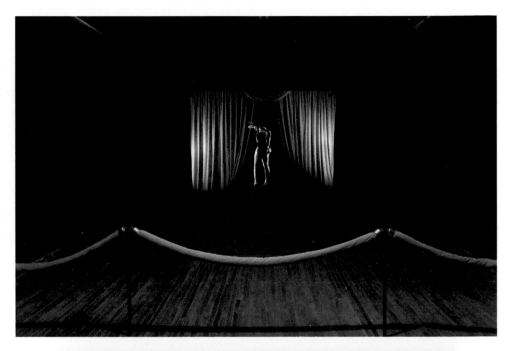

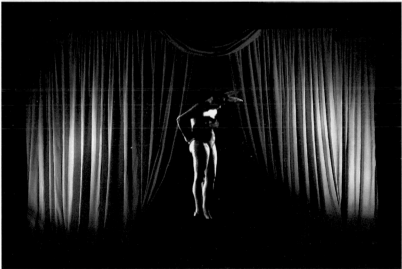

Carrie Mae Weems, stills from *Lincoln, Lonnie, and Me*, 2013. Digital video projection, stage, curtains, stanchions, Mylar, sound. Installation views.
© Carrie Mae Weems. Courtesy of the artist, Jack Shainman Gallery, New York, NY, and the Mattress Factory Museum, Pittsburgh, PA.

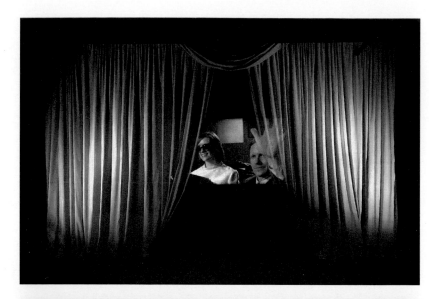

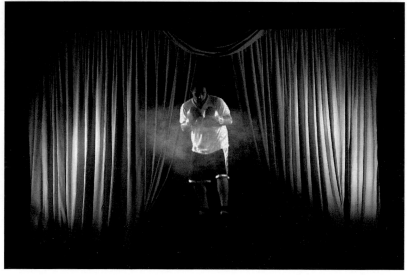

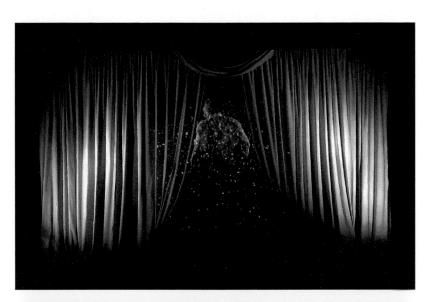

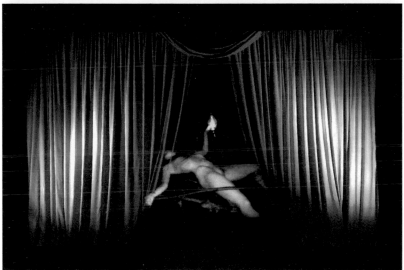

strains set the visuals in motion as a tap dancer materializes out of the darkness and lures you into the work's thrall.

As its title spells out, *Lincoln, Lonnie, and Me* is the artist's meditation on her relationship to history in general and to two figures in particular: the American president and Weems's sometime collaborator, the artist and activist Lonnie Graham. In the second of the work's loosely demarcated sections, Weems's impossibly resonant voice—part Kathleen Turner, part Eartha Kitt, but always inimitably her own—recites and revises Lincoln's Gettysburg Address, while fragments of her 2008 reenactment of John F. Kennedy's assassination, taken from her video *Constructing History: A Requiem to Mark the Moment* (2008), float above the stage. These images are succeeded in part three by archival footage of 1960s busing protests and a spoken commentary by Graham on the difficulty of effecting social transformation.

In so framing American history as a racialized theater of deadly repetition, the piece explores both the tragedies of the past and the ways in which their farcical returns might be negotiated. These pressures are indexed by subsequent figures who function as icons of black spectacularity, from the anonymous boxer plotting his next moves both in and out of the ring, to the artist herself, done up as a trickster whose seductive laughter in part four quickly transmutes into a demonic threat: "I am gonna destroy ya, because I want you to feel the suffering that I know. It's not gonna be pretty, Oh! Revenge is a muthafucka." The closing section of the video recasts these considerations by foregrounding questions of gender, holding out a retinue of images from art history and popular culture to the tune of Neil Diamond's "Girl You'll Be A Woman Soon," as performed by Urge Overkill on the *Pulp Fiction* soundtrack. Accordingly, in this chapter, Weems dons a Playboy Bunny costume, presents an artist and her female model in a send-up of the classic scenario, and shows off her own re-creation of the splayed female nude at the center of Marcel Duchamp's last work, *Etant donnés* (1946–1966).

Like Weems's practice more broadly, *Lincoln, Lonnie, and Me* cannibalizes aspects of her previous projects and remixes them with other sources so that they might be redeployed to flesh out the larger history to which they already belong. Although the piece purportedly represents a narrative—hence the subtitle *A Story in 5 Parts*—it is one that moves spirally, constantly looping back on itself to discover its own

difference. All this makes a certain sense in light of the historical and technical inspiration for the work, which does not merely refer to nineteenth-century performative traditions of an episodic bent, but actively extends them. In particular, Weems's project owes its eerie effect to the "Pepper's ghost" illusion invented by British civil engineer Henry Dircks and perfected in 1862 by John Henry Pepper, the director of London's Polytechnic Institute and a critic of spiritualist discourses, who used the device to show off and ultimately debunk the theatrical tricks exploited by all manner of hucksters.[3]

Pepper's namesake technique, which enables objects and actors to appear onstage as projected spectral images, trades on a deceptively simple optical manipulation: A plane of glass is placed at a forty-five-degree angle between the stage and a hidden adjoining chamber, or "blue room," located beneath it. When appropriately illuminated, objects and actors in the chamber appear on the glass and before the audience as dematerialized versions of themselves. As film scholar Laurence Senelick succinctly explains, the ghost effect relies upon the ability of glass to function transparently and reflectively at once, "just as in a brightly lit room at night one may see oneself reflected in a window-pane as far 'outside' the window as one stands before it in the room."[4] This illusion was enabled by the advances in glass-manufacturing technology that rendered modern cities sites of visual reflection and display, handily feeding into a Victorian investment in phantasmagoria that continues apace, from the "Ghosts in the Library" display at the Abraham Lincoln Presidential Library and Museum in Springfield, Illinois, to the appearance of an uncannily animated Tupac Shakur on stage alongside a live Snoop Dogg at the 2012 Coachella music festival.[5]

In Weems's hands, the illusion is likewise technologically updated—Mylar replaces glass, and a projected video image takes the place of live actors—but her work does more than make the immaterial manifest. Instead, it underlines how projections, absences, and the shapes we give to them remain central to the rescripting of the historical past and to the workings of the modern imagination itself, which is predicated on what literary theorist Terry Castle has called the "'ghostifying' of mental space."[6] These processes have been a key preoccupation of the artist's practice, yet in *Lincoln, Lonnie, and Me*, Weems emphasizes the critical possibilities of visual technologies still capable of undoing—and so making visible—the means of appearance within Western culture,

whose economies of thought and commerce are always haunted by the specter of blackness.[7]

Weems's turn to an actual theater of phantasms is thus particularly apt because it enables us to think anew about the culturally specific visual forms constructed to materialize the racial imaginary. Through its dramatic production of deep illusory space, so often enlisted in the maintenance of ideological ruses, the work highlights its own conceit, not only calling us back into the arena of political contestation, but also encouraging us to look more closely at the realms opened up by Weems's previous work in photography and video. Her art—all too often flattened into a caricature of its reparative content—always cuts deep into the space of representation, asking us to look hard *into* the image, even when it is patently two-dimensional. *Lincoln, Lonnie, and Me* freshly reveals how Weems's art draws our attention to worlds, both real and imagined, that continue to be haunted by apparitions who will be heard only if we now awake.

Notes

This essay, originally published without footnotes in the September 2014 issue of *Artforum*, owes much to the insights and research assistance of Claire-Ellen Flannery at Rhona Hoffman Gallery; Michelle Kuo, Jackie Neudorf, and Prudence Peiffer at Artforum; and my colleague Krista A. Thompson at Northwestern University. They have my sincere thanks as do the editors of the current volume.

1. Holland Cotter, "Testimony of a Cleareyed Witness," *New York Times*, January 24, 2014, 25.

2. Although still partial in its approach to Weems's oeuvre and its visual logics, I have found the following volume to offer useful frameworks for thinking her practice on these scores: *Carrie Mae Weems: Social Studies* (Junta da Andaluciá: Centro Andaluz de Arte Contemporáneo, 2010).

3. Tom Gunning, "To Scan a Ghost: The Ontology of Mediated Vision," *Grey Room* 26 (Winter 2007): 113.

4. Larry Senelick, "Pepper's Ghost Faces the Camera," *History of Photography* 7, no. 1 (January 1983): 69.

5. On developments in glass-manufacturing technology, see Gunning, "To Scan a Ghost," 113.

6. Terry Castle, "Phantasmagoria: Spectral Technology and the Metaphorics of Modern Reverie," *Critical Inquiry* 15, no. 1 (Autumn 1988): 29.

7. For a further elaboration of how blackness matters to the Western visual field, see Huey Copeland, "Flow and Arrest," *Small Axe: A Caribbean Platform of Criticism* 48 (November 2015): 205–224.

Diasporic Landscapes of Longing

bell hooks

We take home and language for granted; they become nature and their underlying assumptions recede into dogma and orthodoxy.

The exile knows that in a secular and contingent world, homes are always provisional. Borders and barriers, which enclose us within the safety of familiar territory, can also become prisons, and are often defended beyond reason or necessity. Exiles cross borders, break barriers of thought and experience.

—Edward Said, *Reflections on Exile*[1]

When I was a little girl in the rural South, we would sometimes go to country churches. Traveling down narrow, dusty, unpaved roads, past fields and fields of crops and chewing tobacco, we would ride into a wilderness of nature, arrive late, and yet be welcomed into a hot, crowded sanctuary full of holiness and grace. To awaken a spirit of ecstatic reverie, the choir would sing this song with a line that just made folks shout and cry out with joy, "I wouldn't take nothing for my journey now." This line affirmed a vision of life where all experience, good and bad, everything that happened, could be retrospectively seen as a manifestation of divine destiny. It called on believers to lay claim to an inclusive spirit of unconditional acceptance that would enable all of us to see every path we had taken in life, whether chosen or not, as a necessary one—preparing us for that return to a home we could only dream about. The multilayered vision of life's journey celebrated in this

old-time black church song, where every bit of history and experience is seen as essential to the unfolding of one's destiny, is rearticulated in the artistic practices of Carrie Mae Weems.

Traditionally trained in mainstream art schools where there was little or no awareness of the way in which the politics of white supremacy shaped and informed academic pedagogies of photographic practice, Weems made a conscious decision to work with black subjects. This choice preceded contemporary academic focus on decentering Western civilization, which necessarily requires that attention shift from a central concern with white subjects. Ironically, for the most part, cultural criticism that calls for acts of intervention that would decenter the West tends to reprivilege whiteness by investing in a politics of representation that merely substitutes the central image of colonizing oppressive whiteness with that of a newly reclaimed radical whiteness portrayed as liberatory. Whiteness then remains the starting point for all progressive cultural journeying—that movement across borders which invites the world to take note, to pay attention, to give critical affirmation. The much-talked-about discourse of postcoloniality is a critical location that, ironically, often maintains white cultural hegemony. The less recognized discursive practices of anticolonialism, on the other hand, decenter, interrogate, and displace whiteness. This discourse disrupts accepted epistemologies to make room for an inclusive understanding of radical subjectivity that allows recognition and appreciation of the myriad ways individuals from oppressed and/or marginalized groups create oppositional cultural strategies that can be meaningfully deployed by everyone. This constructive cultural appropriation happens only as shifts in standpoint take place, when there is ongoing transformation of ways of seeing that sustained oppositional spheres of representation.

The work of Carrie Mae Weems visually engages a politics of anticolonialism. Concretely decentering the white subject, she challenges viewers to shift their paradigms. Although her work encourages us not to see the black subject through the totalizing lens of race, it is often discussed as though the sign of racial difference is the only relevant visual experience her images evoke. This way of seeing actively reappropriates the work and reinscribes it within the dominant cultural hegemony of Western imperialism and colonialism. By choosing to concentrate attention on black subjects, Weems risks this oversimplification of her artistic practice. However, in her work she consistently invites us to engage the

black subject in ways that call attention to the specificity of race even as we engage an emotional landscape that challenges us to look beyond race and recognize the multiple concerns represented. Unfortunately, the failure to move beyond a conventional practice of art criticism that consistently confines black artists within a discourse that is always and only about racial otherness characterizes much critical writing about Weems's work. Transforming ways of seeing means that we learn to see race—thereby no longer acting in complicity with a white supremacist aesthetic that would have us believe issues of color and race have no place in artistic practices—without privileging it as the only relevant category of analysis. Carrie Mae Weems's photoworks create a cartography of experience wherein race, gender, and class identity converge, fuse, and mix so as to disrupt and deconstruct simple notions of subjectivity.

While Weems's decision to concentrate on black subjects was a challenge to white cultural hegemony, it signaled, more importantly, the emergence of a lifelong commitment to recover and bring to the foreground subjugated knowledge relating to African American experience. Although Weems was initially captivated by mainstream documentary photography, learning from the work of photographers from Henri Cartier-Bresson to Roy DeCarava, she critically engages a process of image making that fuses diverse traditions and engages mixed media. Early in her artistic development, she was particularly inspired by DeCarava's visual representations of black subjects that invert the dominant culture's aesthetics, in which, informed by racist thinking, blackness was iconographically seen as a marker of ugliness. DeCarava endeavored to reframe the black image within a subversive politics of representation that challenged the logic of racist colonization and dehumanization. Moving among and within the public and private worlds of poor and working-class black experience, which mainstream white culture perceived only as a location of deprivation and spiritual and emotional "ugliness," DeCarava created images of black folks embodying a spirit of abundance and plenty; he claimed blackness as the aesthetic space of ethereal beauty, of persistent, unsuppressed elegance and grace.

Such work fits most neatly into the category of the critic Saidiya Hartman identified as artistic practice aimed at "rescuing and recovering the black subject" via a "critical labor of the positive. It is a resolutely counterhegemonic labor that has at its aim the establishment of other standards of aesthetic value and visual possibility. The intention of the

work is corrective representation."[2] Weems extended DeCarava's legacy beyond the investment in creating positive images. Her images problematizing black subjectivity expand the visual discursive field. Weems's journey, beginning with this "critical labor of the positive," is fundamentally altered and refigured as her relation to the black image is transformed by a politics of dislocation. In her early work, Weems's perception of black subjectivity departed from a concern with the positive and refigured itself within a field of contestation, wherein identity is always fluid, always changing.

Weems is engaged in a process of border crossing, of living within a social context of cultural hybridity. Her understanding of black subjectivity is informed by what Paul Gilroy identified as "the powerful effects of even temporary experiences of exile, relocation, and displacement."[3] Indeed, it is the effort to recover subjugated knowledge within the realm of visual representation that brings Weems face to face with the limitations of essentialist constructions of black identity.

Contrary to critical discussion that sees Weems as laying claim to an "authentic" black experience, her explorative journeys of recovery and return merely expose how reality is distorted when a unitary representation of black subjectivity is reinscribed rather than consistently challenged. When Weems made the decision to focus on black subjects—as she put it, to "dig in my own backyard"—she was motivated by a longing to restore knowledge, not by a desire to uphold an essentialist politics of representation. (A distinction must be made here between the critical project that seeks to promote a notion of authentic blackness and efforts to reclaim the past that are a gesture of critical resistance and remembrance.) While Weems drew on her family history in the series *Family Pictures and Stories*, her narrative deflects any one-dimensional construction of these works as "positive" images deployed to challenge racist stereotypes. She not only named her location as that of the outsider who has journeyed away from family and community of origin to return with new perspectives, she juxtaposed and contrasted her memories of people with the present reality. Balancing image making that commemorates the past while highlighting the ways in which the meaning of this past is changed by interrogations in the present, Weems celebrated what Roger Simon called "processes of collective remembrance." He explained: "Central to these processes is a procedure within which images and stories of a shared past are woven together with a person (or

group's) feelings and comprehension of their embodied presence in time and space. These processes of remembrance are organized and produced within practices of commemoration which initiate and structure the relation between a representation of past events and that constellation of affect and information which define a standpoint from which various people engage such representations."[4]

Commemoration is central to Weems's artistic practice. From early work that focused on constructing images and narratives of families, she moved into an exploration of the journey from Africa to the so-called New World. There she looked at African American ideas of home, community, and nation, particularly as expressed in vernacular, working-class culture. Visually revisiting slavery, the Middle Passage, Reconstruction, the civil rights era, and on to militant black power activism, Weems has created images that chart the passion of rebellion and resistance. Commemorative plates remind us of the nature of that journey. Simon called this process "insurgent commemoration" that "attempts to construct and engage representations that rub taken-for-granted history against the grain so as to revitalize and rearticulate what one sees as desirable and necessary for an open, just and life-sustaining future."[5] In the series *Ain't Jokin*, Weems used wit and satire to exorcise the power of racist representation. Referencing racist iconography, as well as highlighting folklore used to perpetuate white supremacy in everyday life, making it appear matter-of-fact, while contrasting these images with narrative statements that problematize, Weems deconstructed these ways of knowing. Throughout her work, she has relied on strategies of deconstruction to challenge conventional perceptions created by our attachment to fixed ways of looking that lead to blindspots.

In the installation *and 22 Million Very Tired and Very Angry People*, Weems created an assemblage of carefully chosen political narratives—the declarative confessions of working-class activities, the lyrical prose of the novelist—and placed them with specific images. No fixed, authentic black subject is represented in this piece. The common bond is not race or shared history, but rather an emotional universe inhabited by individuals committed to ending domination, oppression, and injustice around the world; who are linked together across the boundaries of space, time, race, culture, nationality, and even life and death, by a shared commitment to struggle. As this installation makes clear, rage against injustice, as well as the weariness that comes with protracted

struggle, is not the exclusive property of black people. As the image of the globe suggests, it is present wherever oppression and exploitation prevail in daily life.

In this installation, Weems laid claim to a diasporic vision of journeying in search of freedom and strategies of resistance and fulfillment. She stakes her claim by inhabiting the space of blackness in the United States, but also by refusing to stay in her place and rejecting a narrow identity politics imposed by systems of domination. The radical black subjectivity mirrored in this installation audaciously unites that particularity with a universal transcendent emotional landscape wherein the desire to be free is the tie that binds and creates continuity in the midst of discontinuity. Within the emotional landscape of this work, the *Sea Island Series*, and the images of the *Slave Coast* series, Weems established a commonality of longing, of yearning for connection, for home. Here home is not a place but a condition—felt only when there is freedom of movement and expression. It is the seeking that is shared, not what is found.

The will to search out spaces of recovery and renewal led Carrie Mae Weems to Africa. Articulating with satiric wit and contemplative significance of that search in *Went Looking for Africa*, she problematized this dream of exile and return, of homecoming. She found in the Sea Island African cultural retentions that link blackness in the diaspora, that create an imaginative world wherein Africa can be represented as present yet far away, as both real and mythic. To distinguish this search for subjugated knowledge from nostalgic longing for the mythical, paradisiacal homeland—so often the imperialist vision imposed by contemporary Afrocentric black neonationalism—Weems presented images of specific locations. She arranged these sites to compose a ritual of seduction that evokes an emotional connection between Africans and African Americans, even if that common bond cannot always be documented with visual proof of African cultural retentions in the United States. Her work offers documentary "proof" even as it tells us that this is ultimately not as important as the abiding sense of emotional and spiritual connection that imperialism and colonialism have not been able to suppress.

Within a political context of anticolonialism, Weems positions her work on Africa as a counterhegemonic response to the Western cultural imperialism that systematically erases that connection. To do this she decenters the West by abandoning notions that reason is the only way to

apprehend the universe. This serves to promote alternative means by which we can know what connects us to distant places, to folks we have never seen but somehow recognize in our hearts as kin. Jane Flax challenged progressive thinkers to resist investing "in the primacy of reason," to prevent it from occupying "a privileged place within our subjectivity or political hopes."[6] With her images of African sites, Weems has insisted on rituals of commemoration that can be understood only within the context of an oppositional worldview, wherein intuition, magic, and dream lore are all acknowledged to be ways of knowing that enhance our experience of life, that sweeten the journey. When Weems looks to Africa, it is to rediscover and remember an undocumented past even as she simultaneously created a relationship forged in the concrete dailiness of the present. For example, in the *Slave Coast* series, captivity is evoked by the depiction of spaces that convey a spirit of containment. A cultural genealogy of loss and abandonment is recorded in the words Weems stacked on top of one another: "Congo, Ibo, Mandingo, Togo." These markers of heritage, legacy, and location in history stand in direct contrast to those words that evoke dislocation, displacement, dismemberment: "Grabbing, Snatching, Blink, And You Be Gone." Whereas the *Sea Island Series* marks the meeting ground between Africa and America, the *Slave Coast* images articulate a decolonized politics of resistance. They represent a return that counters the loss of the Middle Passage, the recovery that is made possible because of revolution and resistance, through ongoing anticolonial struggle.

Weems is not attempting to create an ethnographic cartography to document diasporic black connections. Her work does not record a journey to unearth essential, authentic black roots, even though it will likely be critically discussed and arranged by curators in a manner that makes this appropriative reinscription possible. Weems is most concerned with ways such knowledge remakes and transforms contemporary radical black subjectivity. A spirit of contestation that emerges with the *Went Looking for Africa* series exposes the way Western imperialism informs the relationship of African Americans to Africa. Yet the failure to embrace a progressive, anticolonial standpoint as the perspective that might enable everyone in the West, including black folks, to see Africa differently in no way delegitimizes the longing to return to Africa as origin site, as location of possible spiritual renewal. The Africa Weems visually represented in the *Slave Coast* series is both a site for insurgent

commemorative remembrance and a contemporary location that must
be engaged on its own terms, in the present.

Weems has centralized architectural images, linking traditional
dwellings with modern space. In these images, Africa is both familiar
homeland and location of Otherness. Fundamentally, it is a place that
awakens the senses, enabling us to move into a future empowered by
the previously subjugated knowledge that we cannot allow reason to
overdetermine constructions of identity and community. As Bernard
Tschumi declared, we have an experience of space that is registered in
the senses, in a world beyond words:

> Space is real for it seems to affect my senses long before my reason.
> The materiality of my body both coincides with and struggles with
> the materiality of space. My body carries in itself spatial properties,
> and spatial determinations. . . . Unfolding against the projections of
> reason, against the Absolute Truth, against the Pyramid, here is the
> Sensory Space, the Labyrinth, the Hole . . . here is where my body
> tries to rediscover its lost unity, its energies and impulses, its rhythms
> and its flux.[7]

Weems seeks such reunion in her imaginative engagement and remem-
brance of Africa—past and present. Her visual quest to recover subju-
gated knowledge is fulfilled in a process of journeying that, as Mary
Catherine Bateson proclaimed, makes learning a process by which we
come home: "[T]he process of learning turns a strange context into a
familiar one, and finally into a habitation of mind and heart. . . . Learn-
ing to know a community or a landscape is a homecoming. Creating a
vision of that community or landscape is homemaking."[8] In her art
practice, Weems imagines a diasporic landscape of longing, a cartogra-
phy of desire wherein boundaries are marked only to be transgressed,
where the exile returns home only to leave again.

Notes

1. Edward Said, "Reflections on Exile," in *Out There: Marginalization and Contemporary Cultures*, ed. Russell Ferguson, Martha Gever, Trinh T. Minh-ha, and Cornel West (Cambridge, MA: MIT Press, 1990), 365.

2. Saidiya Hartman, "Roots and Romance," *Camerawork* 20, no. 2 (Fall/Winter 1993): 34.

3. Paul Gilroy, *The Black Atlantic: Modernity and Double Consciousness* (Cambridge, MA: Harvard University Press, 1993), 19.

4. Roger I. Simon, "Forms of Insurgency in the Production of Popular Memories: The Columbus Quincentenary and the Pedagogy of Coutercommemoration," in *Between Borders: Pedagogy and the Politics of Cultural Studies*, ed. Henry A. Giroux and Peter McLaren (New York: Routledge, 1994), 130.

5. Ibid., 131.

6. Jane Flax, *Disputed Subjects: Essays on Psychoanalysis, Politics and Philosophy* (New York: Routledge, 1993), 32.

7. Bernard Tschumi, *Architecture and Disjunction* (Cambridge, MA: MIT Press, 1994), 39.

8. Mary Catherine Bateson, *Peripheral Visions: Learning along the Way* (New York: Harper Collins, 1994), 213.

Carrie Mae Weems

Coco Fusco

I visited Carrie Mae Weems's installation in the Museum of Modern Art's project room twice before sitting down to write about it. Without having planned to do so, I experienced the work under radically different conditions that demonstrated the extent to which that institution and black art within it are still deeply implicated in this country's racial divide. One's position in relation to that schism still determines how the image of Africa will signify, how it will resonate, and as a result, what an environment such as Weems's will conjure to the one who views it.

My first visit was on opening night. Surrounded by a majority black crowd, I followed the onlookers around the space, watching each person as they attentively read the texts and studied the photographs of African dwellings and sculptures representing gender archetypes. Weems pulled a characteristic move and invited musicians, a singer and a poet to perform, which elicited immediate physical and vocal responses from the visitors, and lent a sense of ritual to the place. Against the classical modernist bent of isolating artforms and compelling viewers to absorb "pure" genres in contemplative silence, Weems offered a synesthetic and theatricalized encounter. I left with a sense that the African images and objects had not only finally arrived, so to speak, at MoMA, but that Weems had succeeded in Africanizing the space in a distinctly American way, if only for a moment.

When I returned several weeks later during the Christmas holiday season, the museum was overrun with tourists stepping over each other to get to the Mondrian exhibit. Inside Weems's installation, however,

the atmosphere was hushed. Perplexed out of towners wandered in and out without blinking, some taking pictures of their children sitting on turn-of-the-century wooden stools from Ghana, while hipper, younger downtown-looking whites emerged one by one from behind Weems's screen, *The Apple of Adam's Eye* (1993), smugly acknowledging the piece's punchline. I could not help but wonder how accustomed they were to a sensibility that so deftly combines sultry beauty and biting wit.

A quality of warmth, handsomeness, and harmony envelops one upon entering Weems's space. Whereas placement in the conventional white cub would have stressed the images have been extracted and

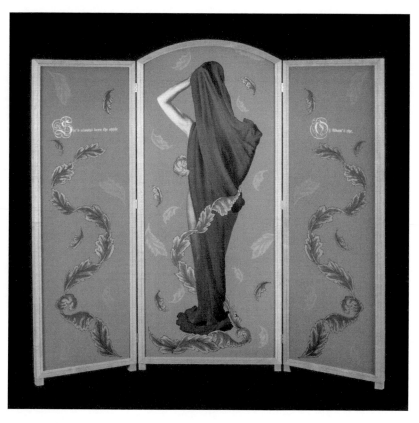

Carrie Mae Weems, *The Apple of Adam's Eye* (front), 1993. Folding screen, pigment, and silk embroidery, 75¼" × 81½" × 1¾" in collaboration with the Fabric Workshop. Photo: Will Brown. © Carrie Mae Weems. Courtesy of the artist and Jack Shainman Gallery, New York, NY, produced in collaboration with the Fabric Workshop, Philadelphia, PA.

abstracted, Weems's layering of the photographs with texts, sculptures, patterned wallpaper, and burnt orange walls and ceiling, created a sense of their being reconfigured into an environmental pattern and a symbolic field. Their being arranged in triptychs, an anagram–like circle around a square, or as mirror images meeting at two of the room's corners, suggested the enigmatic punning and doubling compositions characteristic of dreamwork.

The dominant themes of the installation, that of gender relations, their implication in the structure of myths of origins, the impossibility of complete and eternal union between them, and the status of Africa as a symbolic source of life and of cultural identity for its diasporic peoples, are enhanced by the dialogues that unfold between and among the works. Representations of archetypal male and female powers, *He Had His Throne* (1995) and *She Had Her Keys to the Kingdom* (1995), sit opposite each other at the room's midway point, between one side that asserts female power, and the other that tells a story of her betrayal and punishment.

At the onset, one encounters two pieces that celebrate feminine power and agency, stressing that Weems made her mark by tipping the scales to strike the balance between male and female she sees as

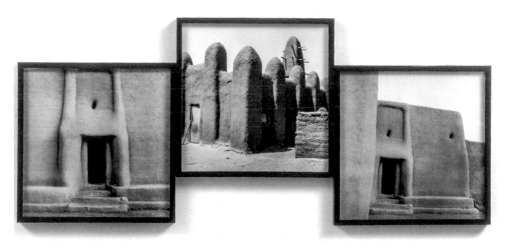

Carrie Mae Weems, *The Shape of Things*, from the *Africa* series, 1993.
© Carrie Mae Weems. Courtesy of the artist and Jack Shainman Gallery, New York, NY.

fundamental to an Africanized world view. The first piece, opposite the entry, is the screen with a luminous image of a woman with her back coyly turned, a rich blue mantel draped over her shoulder. The embroidered golden words, retracing those of the Bible and Stevie Wonder, begin with a reiteration of the patriarchal notion of feminine passivity and Christian morality: "She'd always been the apple of his eye . . ." Still, they close on the other side with a defiant revision that asserts female agency and complicity: "Temptation my ass, desire has its place, and besides, they were both doomed from the start." The other work in the entryway, *She Danced Circles Around Him* (1995), consisting of eight circular chromogenic color prints of female sculpture floating in a field of blue, arranged in a circle around a square print of male sculpture set in a pool of black, reinforced Weems's championing of feminine desire through the use of the characteristically black vernacular cultural strategy of the literalized pun.

On the other side of the male and female archetypes, at the far end of the room, are photo-text pieces that intertwine religious and popular cultural representations of Adam and Eve's encounter and fall from Grace, with images of dwellings and cultivated landscapes in Mali, one of the countries Weems visited on an extended trip to Africa in 1993. With *In the Garden* (1993), Weems launches her retelling, and subverts a traditionally straitlaced Christian account with her references to Allah and cowrie shells, her making an African garden the stage for a mythical drama, and her use of a poetic language that exudes sensuality and pleasure.

The crowning moment of spiritual and physical union, recounted in *Climbing the Stairway to Heaven* (1993), which is another dual reference to pop music—the O'Jays—and the Bible, is represented by black-and-white images of hand-carved wooden ladders propped against African dwellings. Two similar ladders, together with a stool, stand before those representations in the gallery. The fact that Adam and Eve's story reaches its endpoint ultimately with betrayal and separation in *A Place for Him, A Place for Her* (1993), does not deter from the power of that moment of coupling, nor does it detract from the breadth and relevance of Weems's statement. For at the moment, it becomes crystal clear that the artist's project reaches beyond an evocation of cultural difference to confront the position of Africa within the modernist discourse of "the primitive" that MoMA has sustained.

West African sculptures posed so as to exude exotic premodern-ness have appeared within the walls of MoMA in the past. Institutions such as MoMA are notorious for the decontextualized presentation of such objects, repeating the fetishizing gestures of the early Moderns, and retracing, according to the postcolonial critique of these moves, Western culture's negation of radical alterity. While these modes of representation are understood as evidence of a fear of real difference as an encounter with Western subjectivity's limit point and symbolic death, Weems decenters this paradigm with her recasting the objects in a network of allusions to *le petit mort* of orgiastic pleasure, and through an imaginative healing of the brutal separation from origin that is the condition of black diasporic existence through a representation return to the cultural womb. Thus, the objects, and by extension the place they evoke, are restored, if not returned. Relocating within the imaginary landscape of a displaced, Africanized cultural identity, Weems reinfuses them with a philosophical and spiritual significance that reveals in the hybrid character of its enunciation.

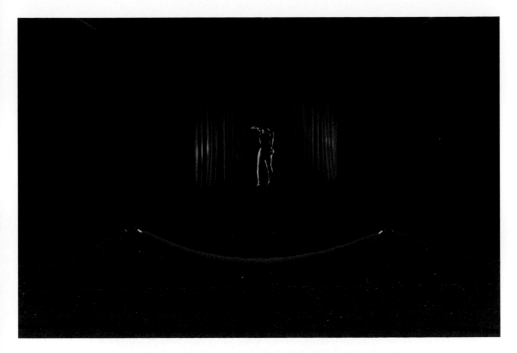

Carrie Mae Weems, stills from *Lincoln, Lonnie, and Me*, 2013. Digital video projection, stage, curtains, stanchions, Mylar, sound. Installation views.

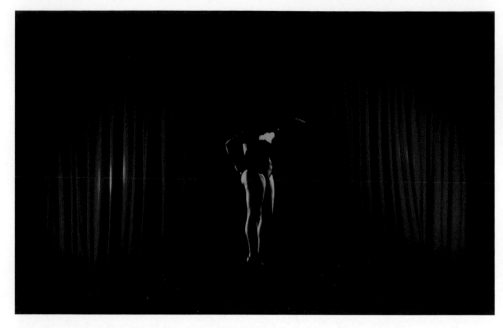

Carrie Mae Weems, stills from *Lincoln, Lonnie, and Me*, 2013. Digital video projection, stage, curtains, stanchions, Mylar, sound. Installation views.

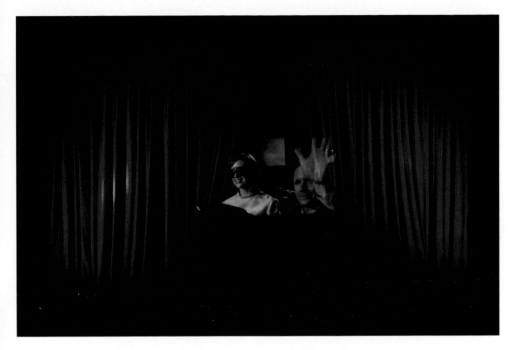

Carrie Mae Weems, stills from *Lincoln, Lonnie, and Me*, 2013. Digital video projection, stage, curtains, stanchions, Mylar, sound. Installation views.

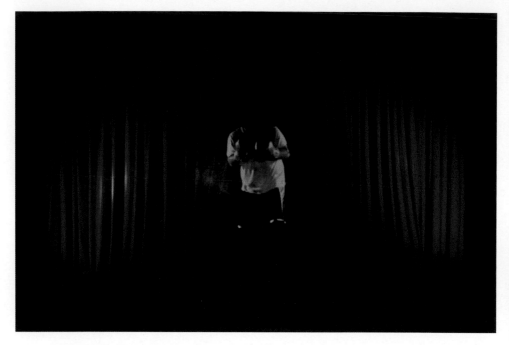

Carrie Mae Weems, stills from *Lincoln, Lonnie, and Me*, 2013. Digital video projection, stage, curtains, stanchions, Mylar, sound. Installation views.

Carrie Mae Weems, stills from *Lincoln, Lonnie, and Me*, 2013. Digital video projection, stage, curtains, stanchions, Mylar, sound. Installation views.

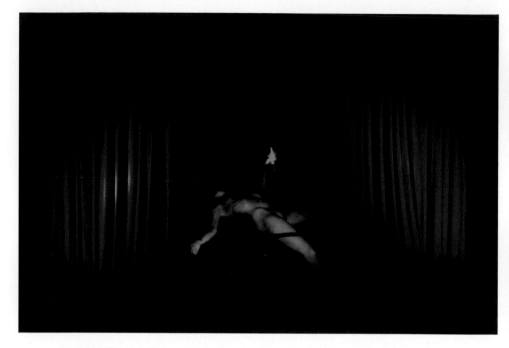

Carrie Mae Weems, stills from *Lincoln, Lonnie, and Me*, 2013. Digital video projection, stage, curtains, stanchions, Mylar, sound. Installation views.

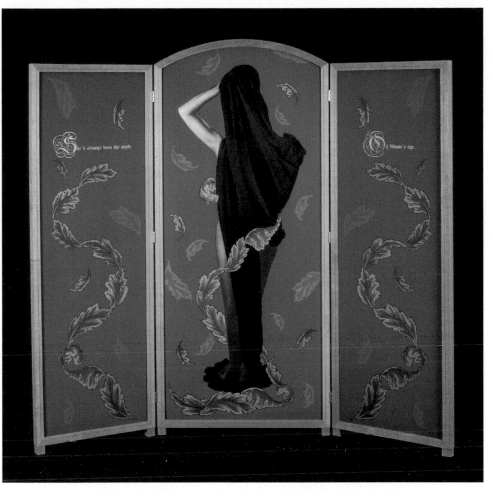

Carrie Mae Weems, *The Apple of Adam's Eye* (front), 1993. Folding screen, pigment, and silk embroidery, 75¼″ × 81½″ × 1¾″ in collaboration with the Fabric Workshop. Photo: Will Brown.

Thelma Golden, Carrie Mae Weems, and Sarah Elizabeth Lewis, 2018.

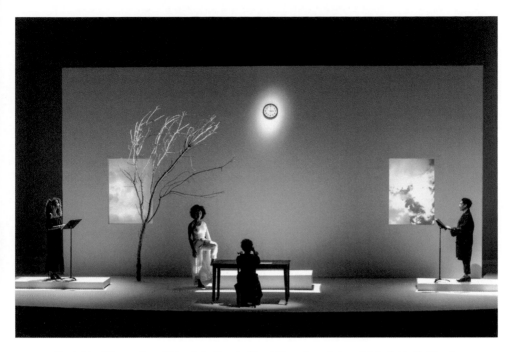

Carrie Mae Weems, *Grace Notes: Reflections for Now* (still; performers from left to right: Aja Monet, Francesca Harper, Carrie Mae Weems, and Carl Hancock Rux), 2016. Photo: William Struhs.

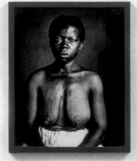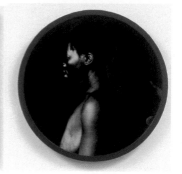

Carrie Mae Weems, *Delia*, from *Sea Island Series*, 1992.

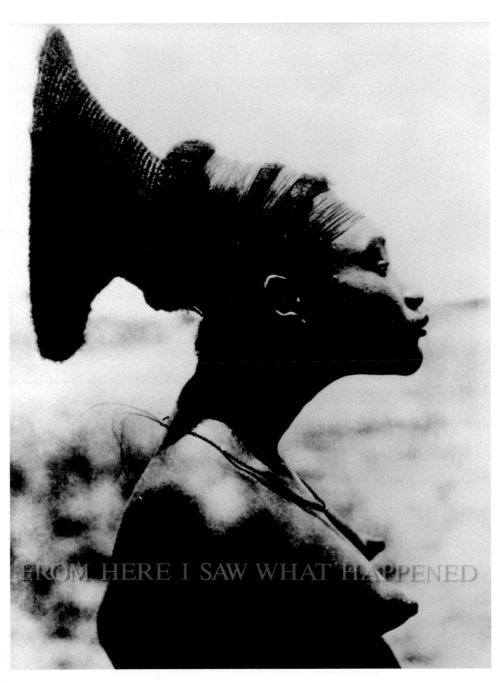

Carrie Mae Weems, *From Here I Saw What Happened . . .* , from the series *From Here I Saw What Happened and I Cried*, 1995–1996.

Carrie Mae Weems, *You Became A Scientific Profile, A Negroid Type, An Anthropological Debate, &*
A Photographic Subject, from the series *From Here I Saw What Happened and I Cried,* 1995–1996.

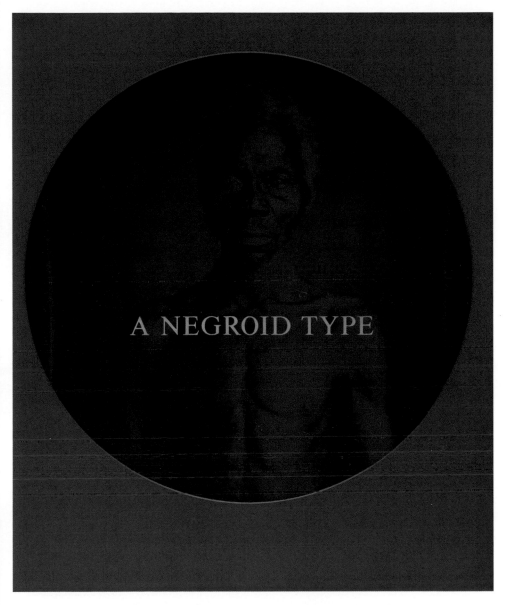

Carrie Mae Weems, *You Became A Scientific Profile, A Negroid Type, An Anthropological Debate, & A Photographic Subject*, from the series *From Here I Saw What Happened and I Cried*, 1995–1996.

AN ANTHROPOLOGICAL
DEBATE

Carrie Mae Weems, *You Became A Scientific Profile, A Negroid Type, An Anthropological Debate, &
A Photographic Subject*, from the series *From Here I Saw What Happened and I Cried*, 1995–1996.

& A PHOTOGRAPHIC SUBJECT

Carrie Mae Weems, *You Became A Scientific Profile, A Negroid Type, An Anthropological Debate, & A Photographic Subject*, from the series *From Here I Saw What Happened and I Cried*, 1995–1996.

Carrie Mae Weems, *Blue Black Boy*, from the *Colored People* series, 1989–1990.

Compassion

Carrie Mae Weems

My work just gets talked about in the narrowest possible way. I think that it's really so difficult: black women photographer, Carrie Mae Weems. Yes, always yes, the work has absolutely touched on race. But there are so many avenues of exploration in the work, and I know that people haven't done their homework if that's the first thing that they talk about. There is the performative nature of my work. There are ideas about beauty, how beauty functions in the work. There is the idea of construction. And yet you can still slice through to get to the heart of the thing, the heart of the subject. I think this is really kind of wonderful, that all that stuff doesn't get in your way; it simply frames where we are. And the idea of framing, really a Renaissance idea, that the frame would carry the emblem that had to do with the profession of the person in the image, so the frame tells us who that person is. There are all of those points that I think could be and should be explored in the work but, because we are so profoundly troubled by race and because we're so caught in the quagmire of race, my work has been stuck in the discourse around race and only that for a very long time.

A part of my work that interests me most and that I've come to understand more in recent years is that it's very important for me to really use this body as a barometer of a certain kind of knowledge—to take the personal risk of exposing my own body in a certain kind of way. I can't ask anybody else to do something that I don't do first myself. I have to know what it means to be naked and exposed first, and then I can ask you, perhaps, to participate with me. But I have to know the

depths of the vulnerability first. And so most of the work really is very performative, and that is true almost from the very beginning.

I'm getting older. I think about this question of desirability, of being looked at. Who wants to look at this fifty-five-year-old woman? How much of myself do I need to expose at fifty-five, as opposed to when I was thirty-five? What are the risks you take at thirty-five that you *don't* take a fifty-five because the game has changed, the world has changed, *you've* changed? Putting yourself through certain kinds of paces has changed. Do I need to do that anymore? I'm not really sure—sometimes yes, sometimes no. This raises a very deep question about mature women and about how one looks at mature women. I think that recently there was a part of me that for a moment felt frayed and very vulnerable about revealing myself, and also concerned about who would be interested in looking because I'm making work that I'm hoping other people will look at, that I don't want people to turn away from. Will people turn away from me? Am I not the thing that causes them to look?

If we use beauty as the crutch, and I think that we often do, as a sort of gateway to exploring other kinds of issues, then I felt as though I was beginning to bump up against that wall in trying to figure out an authentic way (not a clever way, but an authentic way) of getting around that. And so some of the work that I'm working on now looks at just this idea of looking at older women in their sense of self, desirability, desire, their sense of compassion, but really looking at this aging body in a way that for the most part I don't think really gets looked at, examined, pictured, and imaged very often.

I spend a great deal of time thinking about what something looks like. It concerns me deeply. I'm very interested in how I map something, how I enter it—literally the porthole through which I can enter into the space of making the work. What does it need to have? What does it need to feel like? Conceptually, what is it trying to do? Even when I'm not completely sure, at least I'm starting with a set of ideas and questions about entering that porthole. And then, I'm always aware that I need to take somebody with me, that I don't want to experience any of this by myself. That's the experience of my romp through Rome. That experience has to be shared. My way of sharing is to be as thoughtful as possible about how the entire thing is constructed so that you will enter this experience along with me, and so that there is something that

we can share in contemplation of the sublime (which is sometimes very much about what the photographs are) and of confrontations of power (because I think that the work is about that as well). So if there is a beauty and elegance that allows myself and the viewer to be engaged, then I have a sense that you'll be more willing to enter the terrain and ask the difficult questions once you're there. I think a certain level of grace allows for the entry. It's sort of interesting that I work in this really down and dirty way and yet the work is really quite exquisite. It's really nurtured and cared for and tender, but getting to it, doing it, is really sort of rough. I'm just interested, ultimately, in the emotional terrain—the beautiful surface and the emotional terrain—and that I get close to the emotion that I think the work is about and allow the viewer to experience at least some element of that along with me. Did I get close? That's the question that I'm always asking myself. And have I posed this beauty for no real reason? Is it just pretty or does it point to something that has deeper meaning, that is more useful than beauty?

There was a period of time when I just had to get off the wall. I just couldn't take it. I just didn't want to make one more 16 × 20 black-and-white photograph that was matted with the black frame around it. I needed a larger format for expressing certain kinds of ideas and a certain kind of work. So I started printing on cloth—on sheer, diaphanous cloth—and hanging those. There'd be rows and rows and rows of cloth with images printed on them, hanging in the gallery space. And often (because I love working with musicians, composers, and writers and poets) there would be a sound component as well, something that would hopefully envelop you in the space and something kinetic that you were aware of, no matter where you were, always another level of sound or voice or music or noise.

I've done several projects that looked at issues of appropriation and I've always thought that it was a legitimate use of material, though I can certainly understand that artists would be upset about that. So I've had to negotiate for the use of material. I've had controversies around my work, always, and I think it's actually really important. Harvard University was going to sue me at one point for using the images of slaves. And I thought, "This is really fascinating. I think you should sue me. This issue of who owns the rights to these images of slaves would be a very interesting thing to play out in public debate. You may be right legally, but I think this is perhaps also a moral question. And maybe we might

have to talk about the moral questions that surround your issue of copyright of these particular images." It was fascinating. . . .

And there are ideas about compassion—what you sacrifice for compassion, what you give up, what you choose not to live with so that you can express that. But we all sacrifice something for our compassion in some way. We're giving up something so that something else larger can happen, so that something bigger than *you* can take place. Sometimes we sacrifice our families. Sometimes we sacrifice other levels of interpersonal communication so that we have that larger relationship with questions that move and shape the world. And so (and I don't think that I'm being naïve or sentimental or dramatic about it) I think that I've sacrificed an enormous amount of interpersonal comfort to pursue aspects of compassion, to pursue them, to look at them and to say, "Yes, I will step up to this. I want this too. And if I want this in this time, in this moment, then certain things have to be sacrificed (because I don't know how to do it all)." Sometimes you sacrifice too much. You find yourself out on a limb and not knowing really quite how to get back down the tree. But it's the space that you're in because you have taken the risk. I'm not unaware of the sacrifices and, at times, whom your compassion hurts. It's complicated, as the work is complicated.

One of the reasons the exhibition *Constructing History: A Requiem to Mark the Moment* (2008) came about was in actually dealing with the issue of appropriation. I didn't want to have to appropriate anybody's material; I just wanted to revisit this history. And so I thought, "I have to make it myself and I have to make it in my own way. I have to rise above all of those restrictions and make something that I really want to make—giving a nod to all of those photographers who have come before me."

I've spent a very long time digging in the complex soil of race and racism. I've spent so much time looking at it, thinking about it, troubled over it, obsessed by it. And it still matters to me in a profound way. I really do wonder about this new movement that we're in—what it might mean to have an African American man become the president of the United States—particularly given that the lives of black people in the United States have been shattered in an extraordinary way. That's simply the truth of the matter—that the brutal effect of racism on blacks,

on people of color, but on African Americans particularly, has been astounding. It's horrific what has happened to us here, and I know that it still matters and will always matter to me. Yet I know that somehow I have to also free myself from the yoke of it, from the despair of it—that somehow I have to put that aside for the moment because there are indeed other parts of life and other parts of my existence that also really matter, that need to be explored, and that to a certain extent allow me to retool and face the horror of what has happened with renewed energy and renewed understanding and possibility.

I knew that *Requiem* was going to be really demanding, and I wanted to concentrate on building the image and allowing myself the room to do that without trying to wear six different hats. I just didn't want to tax myself in that way. What was important was to find the appropriate stand-ins who could physically deliver in the way that I thought might be important and necessary. And for the first time I discovered another body and a type that understood gesture and movement in a certain way—and there are literally photographs that I have where I couldn't quite tell if it was she or I standing in that photograph. It's like, "Oh, wait a minute, is that *me*?" It was really wonderful to discover that, yes, actually I can have somebody stand in not just for me but for the archetype that I'm trying to get across.

Recapping the last forty years of my own life—beginning with 1968 and ending with 2008, and all those amazing and horrific things, assassinations, brutal acts—has implications and great significance for all of us. Now, part of that can be closed for me. I've gone back and I've revisited those assassinations, the civil rights movement. I have looked at it in any number of ways through any number of pieces. And for me this piece, while certainly not perfect, is a very interesting place to pause. It's beautifully articulated—both the video and the twenty photographs that accompany it. It's compassionate but not sentimental, because there is nothing sentimental about reviewing the assassination of King or Evers, or the Kennedys, Bobby and John. There's something really tough about it, and I'm happy that I was able to move across that emotional terrain and say, "If I can just finish this, if I can cap this part of my life off, I think I might be able to move forward." And maybe we've all reached a kind of threshold and a new gateway to pass through. I think that Obama's election offers us another way of imagining ourselves as a people and as Americans. And maybe it's in that juncture that I could

begin to imagine that all the horrific things that have happened to black people are reconciled through this one swift act. Do you understand what I'm trying to get at? That all of this has been in vain; that indeed there are some other ways to *be*—and that maybe it really points to the declining significance of race. And so what we're really up against is not so much race any more as the main issue that needs to be negotiated, but rather the question of class that needs to be more illuminated. Race and class have always, for me, been deeply linked.

Carrie Mae Weems and the Field

Sarah Elizabeth Lewis, Carrie Mae Weems, and Thelma Golden

SARAH ELIZABETH LEWIS: It is such a pleasure to be here with you both. Carrie and Thelma, I thought we could begin by considering the program, "Carrie Mae Weems Live," held in conjunction with the retrospective of your work at the Guggenheim in 2014. In that convening, Thelma, there was an excerpt of your remarks that I wanted to quote back to you, and ask you to expand upon. At the event, you recalled that you were a curatorial assistant for Kellie Jones when you first came across Carrie Mae Weems's work, and immediately recognized Carrie in her photographs as "the woman I did not know but thought I should." I wonder if you might now—however many years later—reflect on why that is the case.

THELMA GOLDEN: When Carrie asked me to be a part of that day in 2014, she had already told me the idea she had to make this convening a day of other artists. I was immediately compelled by the politics of it, because I knew exactly what she was saying: "I am having this exhibition, but I am going to bring everybody else up in this museum with me." When she first called, I thought she was calling to talk to me about artists. Carrie said, "I want you and Okwui [Enwezor] to be a part of it." I think I said yes to her on the phone, simply because, how was I going to say no? I remember calling Okwui and saying, "Okay, wait a minute. I'm not sure it even makes sense for us to be there."

CARRIE MAE WEEMS: Exactly. That's what you said. You said, "What? What?"

Thelma Golden, Carrie Mae Weems, and Sarah Elizabeth Lewis, 2018.
Courtesy of the editor, Sarah Elizabeth Lewis.

TG: I didn't think it made sense because I thought what Carrie was doing was beautiful, including artists that I admire—it sounded fantastic. It felt like nobody needed two curators to give them a lecture that day. But Okwui said, "No. Of course, we should be there." Then we began talking about what we might do. I wanted to do something that somehow explored my relationship to Carrie's work, not just as a curator, but also as a person. It meant going back to the first paragraphs from a piece that got cut out of George Preston's book back in 1998, which described the fact that I actually saw Carrie when I was a sophomore at Smith College in Northampton. Carrie was teaching at Hampshire College but living in Northampton. I saw Carrie on Main Street. This would have been 1985–1986. I was definitely shocked, and I'm sure I stared. In Northampton at that moment I did not expect to see a Black woman that looked like Carrie, and certainly not one who was dressed like Carrie. That in and of itself made me think, "Who could this be?" This is profound because I was at Smith, a student of art history and African American studies, and it never occurred to me that Carrie was an artist. At that time, I was not being taught about Black artists. When I came to work for Kellie, I encountered Carrie's work in reproduction—the *Kitchen Table Series*—but it wasn't until some years later that I found out why this woman was so familiar. I believe it came from a conversation we had about James Baldwin, who was in the Pioneer Valley at that time. We established this geographical connection and then it all came together; this was Carrie in her work, this was the person who I had encountered in Northampton. I believe you told me that some of the *Kitchen Table Series* was shot in Northampton.

CMW: All of it was.

TG: This was the biggest mind-blow ever—that I was there in Northampton. Fast forward then, we get to 1993 as I'm organizing *Black Male: Representations of Masculinity in Contemporary Art*, which opens at the Whitney in 1994. When I began thinking about *Black Male*, I was very clear that it was not an exhibition of work by Black male artists. It was an exhibition that took on conceptual practices that looked at Black masculinity. Central to that was Carrie's *Kitchen Table Series*.

CMW: Then you decided to develop your talk that night for the Guggenheim based on that reflection.

TG: That reflection got us to *Black Male*. I had never read the reviews of *Black Male*. I had avoided reviews in the moment and decided that day (in 2014) that I was going to read the Michael Kimmelman review out loud.

CMW: That was the way of rediscovering your own practice and thinking about the ways in which it had been understood, unpacked, and critiqued during that moment. Then, Okwui followed up with a brilliant talk . . .

TG: . . . where he unpacks the Museum of Modern Art (MoMA). We knew that you were saying, "I want to populate this museum with the ideas of a certain kind of Black radical tradition through the voices of artists and other thinkers."

The other thing is, I first came to know about Okwui during the time of *Black Male*. Carrie, you were teaching at Hunter College, and said to me, "I know this amazing Nigerian brother, can I get him an invitation to the opening?" He was at the opening, but we didn't meet that night in the haze of the 4,000 other people.

CMW: Yes, it was an amazing event.

TG: That's what linked us together. He came. That's what began our relationship.

SEL: We are speaking about space broadly defined—institutions, museums, and the encounters that happen in these spaces. In retrospect, I see your interrogation of the construction of space as one of the main developments in your work. This is also what brings you both together as artist and curator. The *Kitchen Table Series*, for example, is about negotiating space, power, and intimacy.

If we see your work develop over time, it is radial—you engage with space in an expansive sense, whether through the outdoors as in the *Roaming* series, in the archive through *The Hampton Project*, or by taking on the space of a museum such as the Guggenheim and the Armory to create your work. I wonder what you might say about the function and role of the site of museums in your artistic practice as it relates to power, which I know is essential for you.

CMW: Well, I've been doing this work for so long. I think it's critical to consider how we occupy space, what spaces we are invited into, what

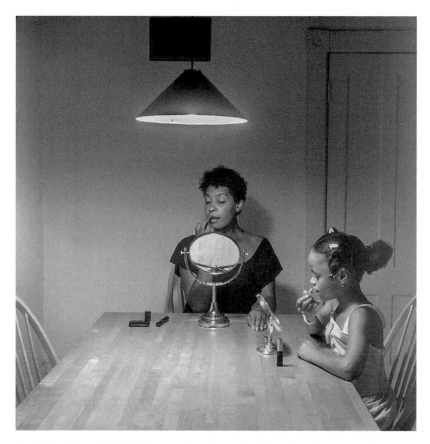

Carrie Mae Weems, *Untitled (Woman and Daughter with Makeup)*, from the *Kitchen Table Series*, 1990.
© Carrie Mae Weems. Courtesy of the artist, Jack Shainman Gallery, New York, NY.

spaces we are barred from entering—the dynamics of space and the politics of space, who belongs in what spaces. I think that I've just been thinking about this for so many years and probably of us in one way or another. It's part of our historical condition that we consider space in certain kinds of ways. Also, thinking about ways that you begin to have a critical understanding and critical unpacking of space, of what is inside and what is outside of a space, and what does that mean.

These spatial investigations have been a part of my work for a very long time—again, whether you're thinking about how one occupies

domestic space and spaces of domesticity, or public space. I started doing this particular kind of work standing in places—standing in spaces—in Cuba. Cuba was the first place that I started acting out, trying to figure out a way of being in that place, and understanding that place, and functioning as a kind of witness.

Through it, I learned a lot about how to act by making that first work in a place like Cuba and not wanting to be the reportage photographer or the documentary photographer. I knew I had to engage the space differently. If I'm going to be photographing here, then I have to be in the picture. How can I be in the picture? How can I mark this moment in this particular way? Cuba was very important in that way—in my re-articulation of understanding spaces and the politics of space and the culture of space. Of course, there are things in the *Sea Island Series* that do the same thing; the *Africa* series does the same thing.

From Cuba there was the *Beacon* series (2005), then *Roaming* (2006), and finally the *Museum Series* (2006–present). Being in Rome was very interesting because a number of people wondered why I might be there—again, going back to the idea of who occupies space, who has a right to be in a certain kind of space. I ran into many of my colleagues—people that I've known for many, many years in all kinds of situations. I would see them in Rome. I would say, "This is fabulous to see you here." They would say, "What are you doing in Rome?" The thing that was fascinating about being at the American Academy was that out of all the people that had been there for any number of years, I was probably one of the only people that ever really worked in the city. Artists, archeologists, or architectural theorists only stayed at the Academy and rarely ventured into the city to use it as a source for work. My work was very much about working in the city of Rome and then working in Cinecittà—Fellini's famous studio—because I wanted to be in that space—really push at that space. The last day that I was finishing up the Rome project, I photographed the National Museum of Rome. It was like all the light bulbs went off: "Oh wow."

All roads lead to Rome. All those roads led to finally looking at the function of museums and who exists inside and outside of those spaces practically, culturally, historically, politically, and contemporarily. I think that has been really important for my work. You're there unpacking ideas about the power of space and what space is, what space means, and how we view the subject at any given moment. How do you

negotiate that space based on who you are, what you believe, what you were trying to do in your own work? That's how those pieces came about. I think that these ideas about architecture and architectural space have been constant themes for a very, very long time in the work.

TG: As an artist, you have insisted that the presentation of your work has a relationship to institutions, right? I have watched as the different presentations of your work have shifted institutions—the acquisition and then hanging of your work changes the nature of the relationship to other works. Works you've done, like the Getty project, reflect on a body of work, but that then changes the way everyone has to look at that body of work. I will never forget the opening of the *Africa* series at MoMA. I remember the night of Solange Knowles's performance at the Guggenheim and all the young children were proposing that this was the first time that there had been this kind of takeover of space—shift of it, movement of it—with us and our bodies. No, no, no, no, no. Carrie Mae Weems—MoMA. What year was that?

CMW: It was '95. It was amazing. We brought jazz musicians and dancers. We decided to do a procession into the museum.

TG: At a point, because people were playing, some people just sat on the floor. You remember that?

CMW: Drummers coming in, riding in, Craig Harris playing the didgeridoo.

TG: Exactly. Remember Craig playing on the floor in MoMA?

CMW: Rob Storr called me six months later. He said, "We're doing an opening and this artist who we're showing said, 'We want an opening, sort of like the way Carrie Mae Weems did hers.'" He said, "Well if you do that, you need Carrie."

TG: Exactly. It made context for your work, and it elevated the context from which your work comes. That's the thing that I think you do brilliantly, and time after time. It then changes institutions.

CMW: This is possible.

TG: As a curator, that has always been incredibly inspiring to me, because I understand the way in which this is happening formally in the work. It's also happening . . .

CMW: . . . within the context from viewing the work as well. This is something that really interests me right now in the *Museum Series*, which I started in 2006. It's only now with the *Museum Series* thirteen years later I think, "Oh, okay. Got it."

SEL: Thelma's comment reinforces how you have also used the structure and material of the museum itself as a way to create a new aesthetic utterance. I have a daily reminder of how you do this as I teach at Harvard. A quartet from *From Here I Saw What Happened and I Cried* is part of the permanent collection at the Harvard Art Museums and is often installed on the ground floor galleries. What people don't often remember is that the Harvard Art Museums is built on the site of Elizabeth and Louis Agassiz's former home, the naturalist who received those daguerreotypes by Joseph T. Zealy to try to prove polygenesis—the very images that your series transforms. Harvard initially was going to sue you for using those images without permission, but ultimately acquired the work. So the museum is built on the foundation of the very history that you've excavated, reframed, and then repudiated. Now, the museum displays your work as a counternarrative on its walls, which is fantastic. When I teach and walk through the building, I am presented with a reminder of how your work radically re-shifted this conversation. It is moving for me to have that work in my midst.

CMW: Yes, and your observations are so important. It's really wonderful to hear you all talk. I don't see myself the way you see me. Do you know what I mean?

TG: Carrie, this is how you always have been, right? As you've been making the work, you've also been stewarding the work. So, you're not just making the work in the present, but you've taken a lot of responsibility for your work in the past. You have welcomed the opportunity to allow successive generations of institutions, curators, art historians, other artists to discover your work and bring it into conversations of the moment, the way the *Kitchen Table Series* was important to *Black Male*. There are bodies of your work that, when we consider what they've done, were attached to larger conversations. Perhaps at the time they were made there wasn't necessarily language but it is emerging.

CMW: Yes. I think that's true. For you, what would be an example of that?

Carrie Mae Weems, *Galleria Nazionale D'Arte Moderna*, from the *Museum Series*, 2006.
© Carrie Mae Weems. Courtesy of the artist, Jack Shainman Gallery, New York, NY.

TG: Certainly the *Kitchen Table Series*. The way I entered into it in 1994 felt like a whole new way of talking about Black visuality and family. That work spoke so much to the sociological ways in which we understand that now.

I think there's a way we understand desire throughout your work, but there wasn't always language attached to it. There are also so many different formal gestures that you've made that demand revisiting and demand re-contextualizing.

CMW: You know, the one thing that I've been disappointed about for many, many years is the way in which the work is always so deeply located, for writers, in race. That many of these other kinds of questions haven't been fully explored at all. The formal qualities and the aesthetic qualities of the work have not been deeply explored. This idea about an architecture of space has never been seriously explored. Ideas about invention and levels of invention have never been seriously explored. For the most part, there have been ways that the writing, and therefore the work, has really suffered.

This is not something that just happens with me as a woman. It has happened consistently with African American artistic practice and I think it is one of the downfalls of the field to not really take it on in a thorough way. I think this is why somebody like Sarah is so important to the field. There are only a few of you. Generally, art history has failed to really teach and negotiate what African American artists have actually produced. I asked Richard Powell, "among your graduate students, who are some of the best young people that are writing? Who would you recommend that I talk to?"

SEL: I think there is an opportunity for us. For example, I have a student who just worked with Theaster Gates this summer and is also doing research on Dave the Potter (David Drake) for a show at the Metropolitan Museum and the Museum of Fine Arts, Boston. He came to me in his freshman year and wanted to focus on African American art history. So, I do everything in my power to make sure that he is supported. We have to continue the field by giving emerging scholars support. It takes ceaseless work, including, yes, working on Saturdays—as we are right now—and having these conversations.

TG: We have to create a greater infrastructure to make this happen. It's not about individuals, it is about an infrastructure that makes this

possible. And what that requires, again, goes back to a conversation about the institutions: the Academy and museums.

SEL: Yes, but then there is an intervention through conversation like this to reframe the structures with which people are entering the work. I envision—and I hope years from now—a young student will read this conversation and say, "yes, there are aspects of Weems's body of work that have not been taken on and need to be." I've spent two years doing a deep dive on every piece of writing that has come out about your work, Carrie, and what you just expressed about the cauterizing impact of focusing on race, as well as the obvious cinematic qualities of your work—as you, Thelma, put it in a Charlie Rose interview from 1995— have not been fully addressed. These examples are a reminder that there is so much more work to be done in terms of scholarship.

CMW: Right and this is the beginning. This is one of those beginnings. What I hoped we would accomplish is highlighting what we're talking about right now—really going into the essays. A part of my mandate—my charge—is to talk about these ideas in every situation that I find myself in, and hopefully in a way that's clear enough that it starts to echo. There are questions that need to be asked. Not just for African American art historians, but for contemporary art historians who care about contemporary art practice and contemporary culture.

SEL: Yes, because it is a structural issue to do with how the discipline of art history has developed. The discipline did not pay careful enough attention to critical race theory for quite a long time. So African American and African diasporic art history began to develop as a corrective move and there is still so much work to be done. And of course, these issues have occurred for indigenous artists and many others. It's not isolated.

CMW: . . . Have you seen this report that came out just recently? Charlotte Burns did research on Black women artists and reception and the market for Black women's work. It's interesting that they are finally paying attention to this for all kinds of reasons.

TG: I think what it says—*the topline*—is something we've all known, but it's important for it to be out there: *the work of the Black woman artist is undervalued in the market.*

CMW: Yes, we know.

TG: I also think there is also something important about framing when we talk about your work, Carrie. Many artists can say to their audience, 'here are moments that are singular, here are the moments that came from them.' Yet chronology does not always clarify things. Thinking about points in your career where your work was looked at thematically versus moments when singular bodies of your work were presented, I am very curious about your feelings on what framing serves your work best.

CMW: What is interesting to me are all these structural overlaps of ideas and these various entry points to the work. How do you enter this circle now? The central question is always looking at aspects of power. What are those relationships? You can talk about that in relationship to the body or the state. You can talk about it around gender and domesticity—between men and women—around questions of desire. You can talk about it in relationship to architectures. There are different ways to enter the work or where you can enter this ongoing, sustained, troubled space.

When I'm thinking about the work, particularly when I'm thinking about an exhibition, usually I am thinking about it in relationship to how I have to unpack that idea of power. The project that is at Boston College, which is more of a retrospective and also very illuminating and very interesting, is very different than the work right now that's at Cornell University. At Cornell, I thought that what I really wanted to spend most of my time thinking about was the surveillance of the body—questions of surveillance and how we interact—how subjects interact with and engage violence. In one way or another, there are all these planes of violence, right? So, I thought that I'll construct a room where the subject, my audience, has a choice. Since violence is always a choice—how you act in the world is always a choice—you (the viewer) can come into my considered space of habitation: you can read, you can look at magazines, you can look at *Ebony*, you can look at *Life*, you can look at *Jet*, you can look at the magazines that lay out the assassinations that I think have defined the country. Or you can watch television on an old monitor, or you can go to the computer at a desk and you can decide to play two video games. One is the video game *1979: Revolution*, which is based on the Iranian Revolution, which is about moral authority and moral choice. The other one is *Fortnite*, which is probably

one of the most popular video games trending right now which has that sort of visceral experience of shooting and killing. I mean, that's what it is, right? Shooting and killing and being agile while you are doing so. You have these choices.

But all of that work comes out of the same work as *Constructing History* or *From Here I Saw What Happened and I Cried*. They're all interconnected, and they could all be used in the same exhibition space.

TG: But if you had to pick three exhibitions that have let you understand your work more and that you think have changed the sense of your work in the public arena, what would they be?

CMW: Well, the *Kitchen Table Series* is seminal, *From Here I Saw What Happened* is seminal, and the 2014 Guggenheim exhibition. Bringing all of that together has also been seminal. So those are, I think, the three pulses. Though, it's really a work like *Constructing History* that interests me more. When you make a work, like when you do great writing, it starts to be beyond you. It starts to come from something—from another kind of place. It's not completely up to you anymore. There are all these other spirits and entities that are guiding you towards the making. When I look at the *Kitchen Table Series*, I'm always surprised by it. When I look at the work *From Here I Saw What Happened and I Cried*, I'm always surprised by it. I never think about it in relationship to myself. I think about them as being these pieces that simply exist in the world and I have a chance to witness them and to know them and to learn something from them. And then something like *Constructing History* has so much to do with the orchestrations of reality in a very particular kind of way. That becomes the center to the kind of work that I am most interested in.

SEL: *Grace Notes* is an example of this.

CMW: *Grace Notes* came right out of *Constructing History*.

SEL: Yes, and it's also an example of how creation happens in ways that we can't fully articulate. A quick example about *Grace Notes*—Nigel Redden of the Spoleto Festival contacted me to commission or identify an artist to honor the Emanuel Nine after the Charleston shooting. I will never forget where I was standing when I received the call. I was researching at the Museum of the Confederacy (now the American Civil

Carrie Mae Weems, *Grace Notes: Reflections for Now* (still; performers from left to right: Aja Monet, Francesca Harper, Carrie Mae Weems, and Carl Hancock Rux), 2016. Photo: William Struhs. © William Struhs, 2016.

War Museum in Richmond, VA) and I had to take a break from looking at that material. I stood under this tree next to Jefferson Davis's mansion and received this call. He asked if I needed time to deliberate. He gave me a few weeks. I said no. I didn't need to think about it. I said, "Carrie is who you need. Her aesthetics of reckoning can tackle this reign of racial terror." It resulted in *Grace Notes*, which I believe hasn't been theorized and discussed fully.

CMW: No, it has not. Not yet. I'm so glad that you brought that up, Sarah. I think that's another one of those pieces. It's sort of wonderful because again, it's the ideas, the concepts, the material, the meditation on this ongoing threat of violence. The trauma of Black bodies is central to the work—it is the through line. The through line is there and it's the only thing that I think about. How can I bring myself along with my audience into a deeper, more sensitive, more probing, more honest, and more beautiful investigation of a trauma that most of us would choose not to look at? How do we do that? It was Sarah's flash of an idea—a flash of the spirit—to bring me into the project, and it's been a wonderful, wonderful exercise.

And then, in keeping with my practice, it allowed me to bring together other artists who could meditate on the same thing. Whether it's the singers Alicia Hall Moran, Eisa Davis, Imani Uzuri, the composers Craig Harris and James Newton, the poets Carl Hancock Rux and Aja Monet, or the dancer Francesca Harper, et cetera. It was a dynamic way to bring together a group of people who are all thinking about the same thing. I must send you this little piece that I made last week where Terri Lyne Carrington is playing the drums. I brought together a small group of African American dancers, and said, "Okay, so you know, I know that you know." Terri is going to respond to this moment, and you're going to interpret it.

SEL: Was it amazing?

CMW: It's incredible. I mean, it really is. She just developed this amazing shotgun pattern. It's extraordinary.

SEL: Going back to Thelma's initial encounter with your work, Carrie, it's profound how your practice has developed in such a way that it catalyzes voices in others. You are able to give people a platform and voice to articulate their response to a particular moment. It is extraordinary, really. I think that this is one of the ways in which your work also has not been fully theorized; you've catalyzed and created a new language for others to consider the historic and current threat to and celebration of Black bodies in the context of historical space and power. It is a part of why I wanted to also bring you two together for this conversation.

CMW: Maybe that's something that all three of us do. All three of us are aware of the platform. Right? Of course, Thelma, your extraordinary generosity, your commitment and the work that you've done, endlessly surprises me.

TG: Well, thank you, but part of it is about the infrastructure that is necessary. We have always had individual practices of genius and brilliance—no question. What we haven't had is the infrastructure that supports them. To me, the curatorial act creates a space where artists can present their vision and their voice. You use the word "generosity," and that is the heart of it. Unfortunately, the nature of the field can be very singular: my work, my show, my book. That singularity can create a lack of generosity.

SEL: Generosity begets generosity. You embody this idea.

What also made your description of the 1985 moment so important, Carrie, is that it was the moment when you found the authentic resonance of your voice, as Franklin Sirmans recalled in his Frist exhibition catalog essay. You had this recollection while hearing yourself over the phone one day, and, as you put it, understood what you were here to do on this earth.

CMW: Oh yes, right. I think you may know the story. As you know, I was working on the *Kitchen Table Series* and really struggling to make the work. Not struggling to make the *Kitchen Table Series* but struggling to make work by trying to decide *how* to work—just how to do it. One morning, Meg Scales called me; of course, we've known each other for many, many years. I answered the phone with a voice that was so like my mother's that I put the phone down and I walked around my room. I mean, it was just incredible, it was like, "That came from me? That's what I sound like?" It was this sort of wonderful epiphany, discovery, and awakening. I had arrived at a certain point on the journey with a clarity and understanding about what it means to be authentically true to yourself, and to your own voice. That for the most part, it's something that most of us spend our lives just trying to be authentic to who we are. What do we sound like? What do we *really* sound like? And then claim it and use it. That was the moment.

SEL: And to Thelma's point, it didn't become something that is solely focused on your own work, it became generative—inspired.

TG: I also think that was an incredible moment generally. A lot was happening to create a seismic shift in the space in which you and many other artists of your generation would exist. In many ways, there was a before and an after. When did it all change? When did it become possible to even speak to the idea of a Black voice? One that would be bound around concept that could engage formally; that could create a language that was its own, but also could speak the language of our history by having space to do so? The generation before had done that beautifully. They just have been ignored. It was you all that made this possible. That's also why, the day of your Guggenheim event, I put the artist list from *Black Male* on the screen, because that list now seems to make complete and total sense to everybody.

CMW: Yes, all those forces came into play. It was a great cultural moment.

TG: I believe that some of what buoyed the sense of real possibility in that moment was that you were present in the work. For example, you are an incredible convener, creator, and curator. Other artists were also deeply engaged on multiple levels. For example, Glenn Ligon is a phenomenal writer. The number of artists who come from your generation—and the next—and have created institutions does not shock me in any way. In that moment, it felt like you understood what that possibility could be and then did the work that allowed it to happen.

CMW: Yes. We were freer. We were freer, right? We've been given and allowed into space. We've been allowed into these spaces in a certain way that previous generations could not fit in. We had a sense of what to do.

TG: When we got there, we also claimed it in a different way.

CMW: Right, but there was a profound idea that a cultural shift was taking place. New ideas about diversity were taking place.

SEL: Yes, and there was also a shift in terms of the field of photography too.

CMW: There was so much. For instance, one of the things that I had learned in the '80s from the President of Bank of America was that by the year 2025 or so this would be a majority-minority country. That was one of the things that stuck with me. There were these ideas about aesthetics, and African American aesthetics, and African American practices. You know the practices of women, this idea of the Other, ideas about diversity. The idea of the Other was a part of a huge conversation at that moment. Everyone was trying to describe themselves in relation to this idea. Stuart Hall had come on the scene with some of the most important ideas. He's probably one of the greatest writers and thinkers of our time—outside of Baldwin.

TG: I think in the visual arts, Stuart really gave us . . .

CMW: . . . the platform. He was the voice. He was the articulated voice around us. I went to his first lecture in 1984. I was mesmerized. Have you seen the Dawoud Bey photograph of him?

TG: Oh, I have, it's beautiful.

CMW: It's one of his great photographs.

TG: I also have to say, in Lyle Ashton Harris's biennial piece—those informal photographs that were taken after Isaac Julien's first show here—everyone was there, and there was Stuart in the midst of that, which is how I remember him from those moments. I didn't meet Stuart until the late 1980s, but that's what first got me to London. Stuart began my relationship to all of those ideas.

CMW: The dynamic relationship between Europe, and London, and the United States . . . it was incredible.

TG: Yeah, exactly. Stuart was the one who brought us in to think about Black public culture.

CMW: There was all this stuff that was going on, there were all of these incredible publications that were suddenly available to us that weren't available before in an organized way because Stuart had institutional support.

TG: He created institutions. He was at the Open University. He then created what has since become Autograph ABP and InIVA (Institute of International Visual Arts), even though they didn't have those names then.

SEL: Stuart Hall's work is what brought me to the UK. I understood that I needed to be on the ground of what was happening and shifting there.

In this particular moment there is a sense of the arts leaders focusing on justice and racial equity. Your convening at the Armory, Carrie, is such a great example of the visionary leadership that can come through the creative arts at large. And, of course, when I was asked to edit the special issue of *Aperture*, which became "Vision & Justice," you were the first person I went to as I started to consider how the issue might well impact the institution of Aperture itself.

CMW: I remember that phone call, yes.

SEL: I called Deborah Willis, too, of course. Frederick Douglass became the kind of armature for the entire project. But our conversation inspired me to reconsider what an institution could do. That to me was no surprise—that you would be a visionary in that sense.

CMW: It seems to me that, for the most part, institutions don't know what to do with themselves. I think we also get stuck. You're stuck in certain patterns, and your relationships have been formed for many years with the same people, and you have the same conversation and you're comfortable in those spaces. Occasionally, somebody comes along who sort of pushes it slightly differently. Somehow—miraculously for some reason—people have been willing to give me space, to allow me to assume these spaces. I think that I have developed a track record at this point of being able to do certain kinds of things—kinds of work. People trust me to do it—or to give me enough rope to hang myself. It's going to be one or the other, right? I think that these opportunities are really important. They feed me in very important ways. Usually I do them for myself. I start with what I need to know and then assume that everybody else needs to know the same thing.

Now it's really time to do the next part of this convening, which is a major exhibition that will open in two years. One of the great things that happened out of both convenings—or the Guggenheim and for the Park Avenue Armory—is that Richard Armstrong (director of the Guggenheim), said, "Carrie, we never even imagined that we could do this in this space." Never imagined it, never thought about it. Rebecca Robertson (executive producer and president of Park Avenue Armory) said exactly the same thing. "We never thought of it, you have shown us a way to use our building in a completely different way. We just would not have thought about it." That I think is extraordinary. Simple, but extraordinary.

TG: Carrie, can you talk about your relationship to the public?

CMW: Often I function as a participant observer. I am my audience. I'm always very surprised that the work has been so fully embraced by so many different people from so many different places around the world. I remember showing in South Africa when Okwui did the biennale there in 1997. I was showing the *Sea Island Series*. The men who were helping me, South African, all thought that the project was about South Africa. Having the *Kitchen Table Series* in some place like Rome, or Spain, or in Japan, where both men and women engage it in the same kind of way, asking the same kinds of questions. That's been important for me. I think that you're asking me something else about my public, and my relationship that I don't quite understand.

TG: You have not created a lot of distance between yourself, your prac-
tice, your work, and its presentation. I imagine that you think about
how the public engages.

CMW: The greatest compliment is that people see themselves in the
work, and that they see me as someone that they relate to. That they
understand I am like a sister, or an aunt, a mother, a cousin, a girl-
friend—a *something*. There's a way that the work has really broken down
a number of barriers where people really feel as though they know me.
Now sometimes that's a problem because they don't. Of course, one of
the more interesting things that happened in the 1990s was that every
time an interview would appear in the newspaper, prisoners would write
to me. I would receive these amazing letters from incarcerated men,
who again, sort of felt a certain kind of identification. I was like, you
know, the figure of Angela in *The Capture of Angela* might free them on
a certain level, or at least participate with them in some sort of way. It's
an interesting kind of experience to have. This has been dynamic
because people perceive me as being very open; but then they also per-
ceive the work in that way as well. It provides an openness and an open
space for them to project themselves inside the work, and there's some-
thing deeply rewarding, and satisfying about that.

SEL: I'm so glad you asked the question, Thelma. It sounds as if in your
answer, Carrie, you're also describing the way in which your work cre-
ates publics that institutions themselves have not yet imagined are possi-
ble. When you came up to Harvard to speak about this upcoming
project, it gave me the sense of how one can address to students as a
different kind of public. They very much saw you as an oracle, as one of
my students put it. You ask questions that others have in their mind's
eye. Since you've also spent so much time and care considering your
answers, your offerings feel like gifts for others.

Note

This interview took place on Saturday, October 6, 2018, in Soho, New York City.

Photographing between the Lines: Beauty, Politics, and the Poetic Vision of Carrie Mae Weems

Deborah Willis

Weems's work is an inspired partnership of vision and voice. . . . Each body of her work poses a question and then, through the work, image and text, answers it.

—Thelma Golden

Weems's [work] exists at the intersection of photography and race, image and text.

—John Pultz

Beauty is a central theme in the photographs of Carrie Mae Weems. She uses historical and personal memory, biography, music, art historical references, and reenactments to stage, perform, and create beauty. Beginning with her early work in the 1970s, Weems's photographs inform and remind us that the black woman's body is central to the discussion of modernity and beauty. Weems consciously speaks for the unnamed black females who have been "a photographic subject" or "a scientific subject" and those who "became Mammie, Mama, Mother & then, Yes, Confidant—Ha."[1] She knew it was important to show the art world that, although frequently pictured, the black woman has not been seen as complex and a beautiful subject of desire. Weems herself embodied that message to the worlds of art and culture, informing them through her presence in the photographs as she began sitting at the kitchen table, gazing into the mirror, turning the pages of art historical

texts, and thumbing through exotic postcards, that black women had multifaceted relationships to the images of them.

> Belying the myth that conceptual artists disdain the old-fashioned notion of aesthetics, Weems has long been consumed and galvanized by the idea of beauty. The notion of beauty encompasses and reaches beyond aesthetics. It is not a simple concept, as often there are unspoken political implications in her use. . . . Beauty is a powerful adjective in her hands and an important tool in her work. Her work is always about beauty and purposely so. She seduces the viewer through the very process of creating luscious prints, or beautiful images, without ever using beauty purely to seduce. . . . But no matter what one encounters within the text or within one's own revelations about what the texts ultimately say, the religion of beauty always undergirds Weems's vision and informs her work.[2]

For more than three decades, Weems has focused her lens on her own body and used her writings to extend the conversation. Each of her series has a different narrative: there is a story of black womanhood in the *Kitchen Table Series* (1990), of art history in *Not Manet's Type* (1997), and of anthropology in *From Here I Saw What Happened and I Cried* (1995–1996), as well as narratives of place and memory, which she constructs in Rome, Cuba, and New Orleans. In others in which she is not pictured, she reproduced daguerreotypes, tintypes, and other historical (or appropriated) photographs to disengage the old, empowered stereotypes and to change the dialogue found in fairy tales that had young black girls believing that their beauty was unimaginable or unattainable. In these works her image is projected through her voice; text provides a narrative structure in which to read both the Ghana *Slave Coast* series (1993) and the South Carolina *Sea Island Series* (1991–1992). "'The [historical] photographs were made for very, very different reasons originally,' explains Weems. 'At least, most of them were. They were intended to undercut the humanity of Africans and of African Americans in particular. This way of looking at the African as subject says a great deal more about Anglo-American photographers than it does about the African subject. When we're looking at these images, we're looking at the ways in which Anglo-America, white America, saw itself in relationship to the black subject.'"[3]

Carrie Mae Weems, *Woman in Shorts* from the *Boardwalk, Santa Monica* series, 1980–1982.
© Carrie Mae Weems. Courtesy of the artist and Jack Shainman Gallery, New York, NY.

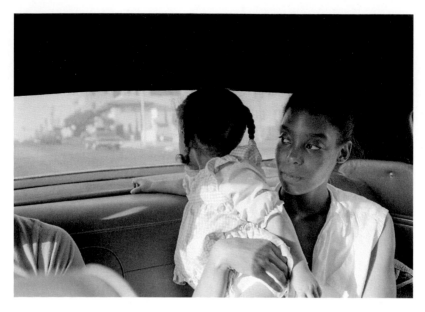

Carrie Mae Weems, *Meg and Coco*, c. 1980.
© Carrie Mae Weems. Courtesy of the artist and Jack Shainman Gallery, New York, NY.

I have always appreciated Weems's fearless demeanor, her smooth-relaxed voice, her beauty, intellect, and sophistication. As an artist, she uses personal experiences of being black, seeing injustices, and analyzing events in popular culture to introduce to a viewing public the concept that her art matters. Even if you didn't know her work before, you will walk away from seeing her art with it on your mind; in a sense her work both subverts and converts. She says, "There was a fear on the part of visual artists to take control of our bodies, our sexuality. I was trying to respond to a number of issues: woman's subjectivity, woman's capacity to revel in her body, and woman's construction of herself, and her own image."[4] One of the most remarkable visual rearrangements or riffs on Nina Simone's song "Four Women" is Weems's four-panel portrait entitled *Peaches, Liz, Tanikka, and Elaine* (1988). The photographs include text that "frame" four idealized and typed black women who lived during the post–civil rights era and at the beginning of the Black Power movement. Peaches, fashionable in a leopard-pattern strapless bra and wrap skirt, wears her Afro with pride; Elaine wears a leather coat, sunglasses, and beret, fist raised in a prideful Black Panther pose in

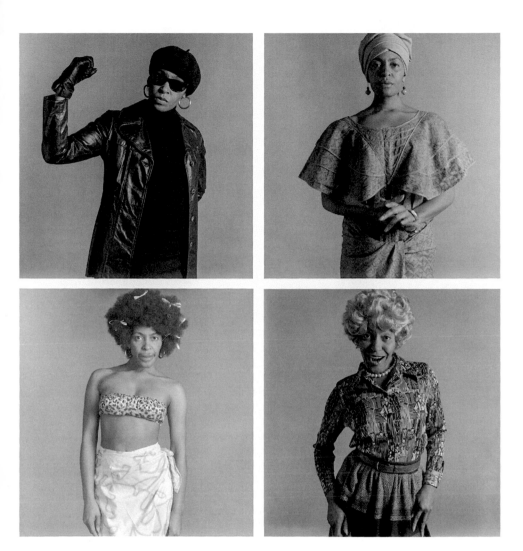

Carrie Mae Weems, *Peaches, Liz, Tanikka, and Elaine*, 1988.
© Carrie Mae Weems. Courtesy of the artist and Jack Shainman Gallery, New York, NY.

homage to former Panther Elaine Brown; Tanikka wears her head wrapped and an Afrocentric-style dress; and Liz, a smiling middle-aged woman, sports a blonde wig askew on her head, fake pearls, and patterned dress. Weems successfully transforms herself from teenager to middle-aged matron. The images are magnetic, and the text is a stunning portrayal that reveals Weems's sensitivity to what it means to disembody a stereotype, feel the collective pain of generations of women, and revel in the re-creation of the construction of the self. I teach a course called "The Black Body and the Lens," and I often use this work to provide ways to discuss how, referring to the black female image, prejudice is ingrained in American visual culture. Weems's context for this piece is inscribed below the images:

> No, really I am shocked. I mean the images of black women are just downright strange. In some cases the images are so monstrously ugly that they scare me! Indeed, if I were as ugly as American culture has made me out to be I'd hide my head like an ostrich in the sand. . . . In some cases like that pickaninny or beautiful African queen mess. These images are so unlike me, my sisters or any other women I know—I didn't know it was supposed to be me. No really in history, in media, in photography, in literature. The construction of black women as the embodiment of difference is so deep, so wide, so vast, so completely absolved of reality that I didn't know it was me being made fun of. Somebody had to tell me. . . . To lift the voice in laughter is saying something. I don't always know exactly what, but saying something nonetheless. We don't laugh to keep from crying, we laugh to keep from slapping the inventor of these crazy-ass images upside his head, [because] you can bet they're made by men. And though not completely voiceless in her construction— even the hands of women are dirty—these images like a noose about the neck, dangle from thin threads of desire wrapped around fingers owned by men; some White, some Black. No really!![5]

It's hard to put Weems into one category. In writing about her *Kitchen Table Series*, a set of twenty photographs and fourteen text panels, Peg Zeglin Brand says, "[Weems] invites us to look at the representation of woman as she is situated *in context*: a context in which her beauty— and the value-laden concept of 'beauty'—operates historically, culturally

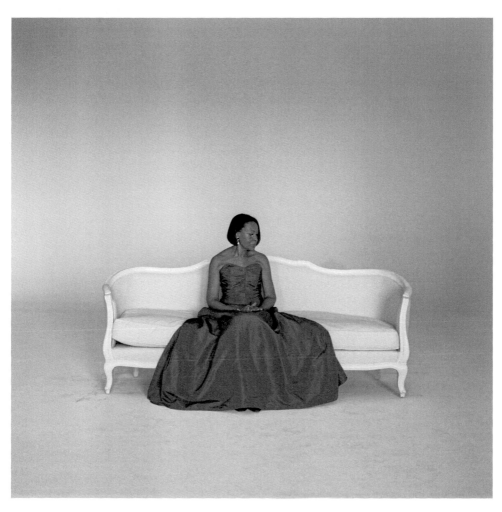

Carrie Mae Weems, *Joyce Haupt*, from *Black Women*, 2010.
© Carrie Mae Weems. Courtesy of the artist and Jack Shainman Gallery, New York, NY.

and politically."[6] As I consider this observation, I am struck by the restaging of the insular space of the kitchen, what it means to family life and social life in girl culture. A skilled narrator, Weems contextualizes how the kitchen table, for many of us, is a place for dialogue. Family members, friends, and children are drawn to the table when food is cooking, and also when seeking comfort and a place of solitude. Weems, who serves as her own model, reenacts scenes and photographs them with such precision that viewers feel as if they have joined the table. In *Untitled (Woman Brushing Hair)*, a single lamp hangs above a wooden table as Weems's hair is caressed and brushed by a female friend or family member. As she leans into the brush, Weems represents all women who enjoy the moment of freedom to be cared for, to relax and respond to a healing moment. In *Untitled (Mother and Daughter with Makeup)*, Weems instills a sense of maternal pride in an intimate moment as both look into the mirror, coming face to face with enhancing their beauty by putting on lipstick. It is a moment seldom experienced in public, but one observed closely as one imitates the other. Brand describes the photograph as "simple, stark, yet stunning."[7] Weems's props in both photographs from the *Kitchen Table Series* are well considered. *Untitled (Woman Brushing Hair)* includes highball glasses filled with spirits; a lit cigarette in Weems's relaxed hand rests near an ashtray. The artist sees this as a moment when two women share a cocktail and chat. Is the prepubescent child wearing barrettes and a ponytail in *Untitled (Mother and Daughter with Makeup)* ready for the experience? Perhaps Weems sees this as a magical moment for the young girl as she explores ideas of beauty. Or is this an intervention? Weems interweaves in this series a narrative of black female subjectivity, black beauty, and the gaze. Brand argues that Weems's image is "not only an instance *of* beauty but it is also *about* beauty—the adornment and display of the female body."[8] Thus, Weems's photographs are performing beauty through lighting, posing, acting, and fashion.

Born in Portland, Oregon, in 1953, Weems confronts historical depictions and restages them with "what if" questions. In her series *Not Manet's Type*, Weems critiques the white male art "masters" and how beauty is defined through their paintings. The ironic series of five self-reflexive photographs with text questions not only Édouard Manet but also Pablo Picasso, Willem de Kooning, and Marcel Duchamp. The posing reveals her formal training as a photographer—she studied at

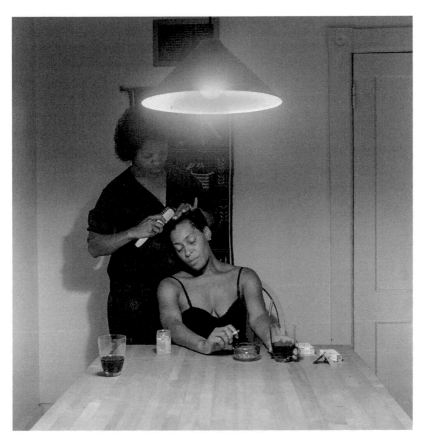

Carrie Mae Weems, *Untitled (Woman Brushing Hair)*, from the *Kitchen Table Series*, 1990.
© Carrie Mae Weems. Courtesy of the artist and Jack Shainman Gallery, New York, NY.

University of California, San Diego—and her choice of props is influenced by her sharp sense of observation as a builder of ideas. The series' power lies in her narrative voice and her ability to create a scene. At first glance, it looks as if the photographs are all the same; they share the square format and the centered Art Deco–style vanity dresser. The setting is the bedroom, a private but inviting space. We, the viewer, peer through the square mat into the round mirror that frames Weems's body, which lends an effect of peeping at a private moment. The time of day, the lace on the brass bed, the large white vase holding dried flowers, and the framed artwork on the wall offer a sense of reality, while the

bright sun bleaches the lower half of her body and the bed. Weems stands with her back to the viewer; the bold red text reads: "It was clear, I was not Manet's type . . . Picasso—who had a way with women—only used me & Duchamp never even considered me." The series' text clearly shows her vulnerability as she attempts to empower her image. The text further states: "Standing on shakey [sic] ground I posed myself for critical study but was no longer certain of the questions to ask." It is always exciting to see women artists like Weems, Barbara Kruger, Cindy Sherman, Lorna Simpson, Carla Williams, and Mickalene Thomas challenge ideas of beauty and desire, both of which are critical components in Weems's work. She dares her viewers to rethink their understanding and the positioning of art today.

Mirrors are often found in Weems's self-portraits; she's holding or gazing into one, or her statuesque frame is reflected in one. Such reflective objects are used to subvert. Weems is searching, exploring, and examining, looking for answers and asking questions. There's also a materiality found in the sets, scenes, and images that Weems constructs. *Mirror, Mirror*, from the 1987–1988 series *Ain't Jokin'*, confronts the racism of defining Snow White as the ideal beauty, which has been instilled in American culture through children's books, movies, and animated films. The photograph is complex and openly aggressive. Elvan Zabunyan has described *Mirror, Mirror* as a "caustic parody" of the children's fairy tale, saying that the piece "criticized racism within the Black community where different tones of skin color play an important role, the lightest often being the most respected."[9] *Ain't Jokin'* is a jarring but appropriate title for this series, which examines racist language found in various types of literary expressions such as joke books, fairy tales, news sources, novels, and history books. *Mirror, Mirror* focuses on the construction of beauty in childhood storytelling. The photograph is both contradictory and sardonic. Even as black beauty is denied, it is affirmed because of the existence of the mirror. Weems is clearly looking at the power of self-representation and subjectivity. However, what I find fascinating is Weems's refusal to accept the admonishment: the black woman's eyes look away from the mirrored reflection, which is dressed in a white veil and holding a jeweled starfish, implying a magic wand.

LOOKING INTO THE MIRROR, THE BLACK WOMAN ASKED,

"MIRROR, MIRROR ON THE WALL, WHO'S THE FINEST
OF THEM ALL"
THE MIRROR SAYS, "SNOW WHITE, YOU BLACK BITCH,
AND DON'T YOU FORGET IT!!!"

The subtext to *Mirror, Mirror* is Weems's desire to show the holder of
the mirror other avenues through which to recognize beauty. The pho-
tograph reads as a counternarrative to the history of racist images.

Performance art is central to Weems's *The Louisiana Project* (2003),
commissioned by the Newcomb Art Gallery at Tulane University in
New Orleans to commemorate the two-hundredth anniversary of the
Louisiana Purchase in 2003. The mixed-media installation included
works focusing on race, beauty, class, style, fashion, the land, and
architecture. In looking at the photography in the installation, I am
reminded of Nicole Fleetwood's statement, "The camera loves the
black subject whose struggles for equality represent the possibilities of
American democracy."[10] Weems's narrative is performed as both wit-
ness and actor/interpreter as she explores the democratic ideal referring
to beauty. *I Looked and Looked and Failed to See What So Terrified You* is
a photograph frozen in time. Weems looks into the mirror; she looks
good, is reassured of her beauty, she's flawless; however, she is com-
pelled to ask the titular question: "I looked and looked and failed to
see what so terrified you." Weems's posed images focus on her own
gaze, a troubling historical gaze that forces the viewer to reflect on the
title. Weems is seeking to control both the collective black female image
and her own reflection. A reviewer summed up his experience with the
exhibition in this way:

> The exhibition was a gargantuan undertaking—[to] make the
> viewer aware of a more objective history (one they may not have
> originally learned), tackle cultural constructions, relate the legacies
> of a particular place, explore power relationships between race and
> gender, and wake us up to various infectious notions of false libera-
> tion. Remarkably, Weems accomplishes all of these things handily
> while also managing a high degree of artistry; and her work is tre-
> mendously intellectual, but never pedantic. Word, image, and con-
> cept rarely go together so well.[11]

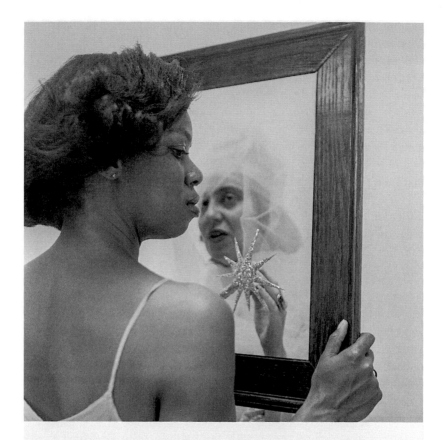

**LOOKING INTO THE MIRROR, THE BLACK WOMAN ASKED,
"MIRROR, MIRROR ON THE WALL, WHO'S THE FINEST OF THEM ALL?"
THE MIRROR SAYS, "SNOW WHITE YOU BLACK BITCH,
AND DON'T YOU FORGET IT!!!"**

Carrie Mae Weems, *Mirror, Mirror*, from *Ain't Jokin'* series, 1987–1988.
© Carrie Mae Weems. Courtesy of the artist and Jack Shainman Gallery, New York, NY.

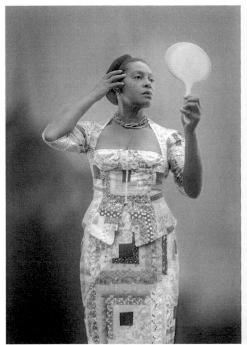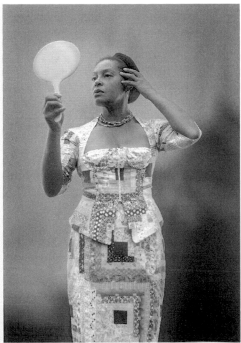

Carrie Mae Weems, *I Looked and Looked and Failed to See What So Terrified You,* from *The Louisiana Project,* 2003.
© Carrie Mae Weems. Courtesy of the artist and Jack Shainman Gallery, New York, NY.

One of the many attractions of Weems's work is her use of cinematic techniques. For example, *Slow Fade to Black #1 (Eartha Mae Kitt)* (2009–2010) is about process and subject. Weems uses publicity stills of universally known black actresses and vocalists to remember and reevaluate these stars from the past. Weems reimagines their images through the soft-focus representation of their sensual, iconic, and constructed poses, evoking the past. By doing this, she reminds us of the power these women exercised in exploring their professional careers. These dreamlike photographs create an element of drama and mystery. We are suspended in time and our own memories as we attempt to recognize these cultural icons. At first glance, the image of Eartha Mae Kitt is unrecognizable, but there's just enough detail from historical visual references (album covers, books, photographs) that, based on the gesture, one might think it is the sultry singer.

In her 1992 *Sea Island Series*, Weems appropriated the famous slave daguerreotypes that Louis Agassiz commissioned from J. T. Zealy, re-photographing them using monochromatic chromogenic prints, cropping the photographs, and reframing the frontal portrait as a high-contrast, black-and-white image in a rectangular frame. She put the repeated profiles, their color altered to blue, in round frames. These alterations use the emotional impact of color to evoke sympathy for the subjects and draw attention to the abuse they suffered through the forced photographic act; they are now literally black and blue. Weems "declares a centeredness with her installation for an audience posed for a visual experience. . . . She frees these captured icons and she reinvents their purpose by declaring them her images with their inclusion into the framework of the gallery installation as art objects."[12]

Weems puts these women's bodies in her own historical perspective, adding text panels with the heading "Went Looking for Africa," thus prompting the viewer to question the visual assumptions Agassiz and Zealy made. Weems and, by implication, the slave women "found" Africa in the paradoxical nuances of black culture. "Went looking for Africa and found uncombed heads acrylic nails & Afrocentric attitudes Africans find laughable," reads one of the panels. The text points to both the superficial and profound cultural separation that slavery imposed on black bodies. Her commentary is deliberately ironic, however, because the subjects of the photographs lacked control over how they presented themselves to the camera.

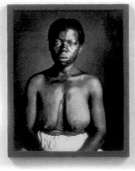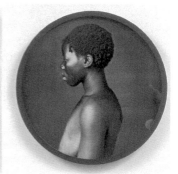

Carrie Mae Weems, *Delia*, from *Sea Island Series*, 1992.
© Carrie Mae Weems. Courtesy of the artist and Jack Shainman Gallery, New York, NY.

The art critic Holland Cotter believes that "Weems understands that political art is about asking questions, not delivering answers."[13] However, Weems found ways to allow her viewers to define their own answers or to imagine new solutions to some of the questions and riddles found in her work. Before the use of digital media became widespread, Weems not only discovered ways in which to incorporate text with her images, but she also challenged traditional ways of making a self-portrait by inserting sound, installation, and performance. It is Weems's collective narrative that informs this exhibition—that is, narratives of history, slavery, family memories, history of beauty, and the history of photography. The art historian Elvira Dyangani Ose argues, "artists like Weems interrogate American history, and regularly call into question the visibility (or invisibility) of history's contributors and players. . . . Artists like Weems unveil those silenced stories. Artists who, as Weems indicates, 'are really engaged in the art of the appropriation, who think that there is a larger story to tell.'"[14]

Notes

Epigraphs: Thelma Golden, "Some Thoughts on Carrie Mae Weems," in *Carrie Mae Weems: Recent Work, 1992–1998*, ed. Thelma Golden and Thomas Piché Jr. (New York: George Braziller Publisher, in association with Everson Museum of Art, Syracuse, 1998), 32; John Pultz, "Photography since 1975: Gender, Politics, and the Postmodern Body," in *The Body and the Lens: Photography, 1839 to the Present* (New York: Harry N. Abrams, 1995), 155.

1. Quoted from the series *From Here I Saw What Happened and I Cried*, 1995–1996.

2. Golden, "Some Thoughts on Carrie Mae Weems," 33.

3. Quoted in Ian Epstein, "Why Am I Looking at 'Pictures by Women'?," August 12, 2010, http://hyperallergic.com/8490/pictures-by-women/.

4. Quoted in Dana Friis-Hansen, "From Carrie's Kitchen Table and Beyond," in *Carrie Mae Weems: The Kitchen Table Series* (Houston: Contemporary Arts Museum, 1996), unpaginated.

5. Artist's statement from 1988 republished in Deborah Willis and Carla Williams, *The Black Female Body: A Photographic History*, (Philadelphia: Temple University Press, 2002), 190.

6. Peg Z. Brand, "Introduction: How Beauty Matters," in *Beauty Matters*, ed. Peg Z. Brand (Bloomington: Indiana University Press, 2000), 4.

7. Quoted in ibid., 1.

8. Ibid.

9. Elvan Zabunyan, *Black Is a Color: A History of African American Art* (Paris: Éditions Dis Voir, 2005), 206.

10. Nicole Fleetwood, *Troubling Vision: Performance, Visuality and Blackness* (Chicago: University of Chicago Press, 2011), 33.

11. Larry M. Taylor, "Carrie Mae Weems: *The Louisiana Project*," *Reconstruction: Studies in Contemporary Culture* 6, no. 2 (Spring 2006), https://web.archive.org/web /20081122103727/http://reconstruction.eserver.org/062/taylor.shtml.

12. William T. Dooley, introduction to *These Islands: South Carolina and Georgia by Carrie Mae Weems* (Tuscaloosa: University of Alabama, Sarah Moody Gallery of Art, 1995), 10, quoted in Deborah Willis and Carla Williams, "Colonial Conquest," in Willis and Williams, *The Black Female Body*, 24.

13. Holland Cotter, "Art in Review: Carrie Mae Weems—'The Hampton Project,'" *New York Times*, March 23, 2001.

14. Elvira Dyangani Ose, "The Artist as Intellectual," in *Carrie Mae Weems: Social Studies* (Seville: Centro Andaluz de Arte Contemporaneo Consejeria de Cultura, 2010), 12.

Foreword to *Carrie Mae Weems: Kitchen Table Series*

Sarah Elizabeth Lewis

To call this a foreword to Carrie Mae Weems's *Kitchen Table Series*, a now iconic body of work in the history of photography created over thirty years ago, is a misnomer. This landmark set of images punctuates the foundational period of the career of an esteemed, now canonical artist garlanded with honors from the MacArthur Foundation "genius" grant to the U.S. State Department's Medal of the Arts presented by Hillary Clinton and a Gordon Parks Award. What follows may offer a brief introduction to those just now viewing the series. For many more, it would be best to call this an afterword, a reflection of the imagistic and textual force of Weems's acclaimed series published here in its entirety for the first time.

One could consider Weems's acclaimed *Kitchen Table Series*, her fifth series, to be her "most important body of work to date," as Franklin Sirmans wrote, and, too, the "hallmark of an era." Why is this so? A work of art gains altitude over time if it gestures to a universal horizon. At the heart of the *Kitchen Table Series* is an answer to an eternal question: how do we find our own power? The photographic suite of twenty images with fourteen text panels seem to be about relationships—between lovers, friends, daughters, and mothers. Yet the animating focus is about coming into our own, how any quest for sovereignty is shaped not just by longing, but by striving toward a newly enlarged vision of one's self in the world. There are some works of art that seem to capture the synoptic arc of life and how it is that we develop. The *Kitchen Table Series* is one such enduring work.

The first image, laid out like a cinematic storyboard, sets the domestic stage for the drama of a woman on a journey to becoming herself. Weems sits seductively smiling in front of a round mirror on a stand set on the kitchen table in a white-walled room, as a man standing behind her bends down for a caress. In this series, Weems is the protagonist. She has a lover who adores her, challenges her, drives her into the arms of her mother and friends, and ultimately, deeper into herself. Like the light in Pablo Picasso's *Guernica*, a work compositionally indebted to photography in its superimposition of film stills, Weems includes the overhead bulb in every frame. This light is one of both exposure and illumination on her timeless subject—the eternal stages of development of the self in combat with and surrendering to love in all its forms. By the end of the series, the constant mirror on the table is gone and Weems stands alone under this light. She stares confidently, almost defiantly, in one frame; then is relaxed with a cigarette, in a negligee tending to a bird in the next; then naked, head thrown back in a state of self-made ecstasy; then, finally, self-possessed and at ease playing solitaire with a box of chocolates, perhaps a symbol of pleasure and the chance of life.

Kitchen Table Series is a modest title for a body of work that probes the depths of our development: how it is that we become. Yet it is the only appropriate one, signaling the domestic spaces that house the irreplaceable rituals that take us from one threshold to another—a shared conversation among women, romantic relationships, and coming to terms with one's relationship with one's self. Like an écorché, the Renaissance tradition of fileting a figure to learn how to draw its form, the series splays the raw anatomy of our own process toward self-possession.

How were women going "to image themselves"? This was Weems's guiding question during the earliest moments of conceiving the *Kitchen Table Series* as she reflected on the corpus of photographic images of women up to the 1980s and what wasn't there. We have images of women in states of arresting beauty—a force of a certain kind; women in states of maternal focus—another form of authority. Yet there are few images that depict the journey toward an inner sanctum.

The *Kitchen Table Series* remains one of the few narrative works in the history of photography to cast a black female protagonist in a journey toward utter empowerment. It has intervened in the history of photography (and, one might argue, the history of performance) by emphasizing the black female form as "central to discussions of identity

and beauty," as Deborah Willis argues. For the African American experience, the early history of photography was an evidence-based enterprise—at best, documenting black lives for one's home and used as a public corrective to "craft a new public image of black life," as Henry Louis Gates Jr. would state about the New Negro movement, and at worst, confirming stereotypes and bias. The evidentiary thrust of photography of the African American experience permeated the field at the expense of what Weems's work both represents and heralds—the lens turned on "the black interior," as Elizabeth Alexander might aptly call it. Yet, as Weems declaims, "black experience is not really the main point; rather, complex, dimensional, human experience and social inclusion . . . is the real point."

Weems's penetrating, incantatory, directorial voice is nearly audible in the text panels of the *Kitchen Table Series*. This is not merely an incidental, stylistic observation. Coming into her own, literally hearing her own voice, as if for the first time, catalyzed the series. She was living in New England at the time, teaching at Hampshire College, "the only black woman around." The question on her mind was not one of experience. She had just worked for Garry Winogrand as a printer, learned from Dawoud Bey, "one of her first teachers," taken classes at the Studio Museum, and studied folklore at UC Berkeley. The question was one of voice: "What or where was my voice?" she recalled asking herself. "I would just cry." One day, Weems says a friend called her and when Weems spoke, her voice came from another place. The text of the series came from that foundation-setting one-hour conversation. Weems's use of her voice is present in each bi-directionally staged document. In each image, she is both participant and guide, in the scene and directing it, a performer and operator breaking down the fourth wall and engaging directly with us.

Around the time that I was asked to write this piece, I had the good fortune to sit in front of Weems's camera, directed by her vision and voice. I stood with a group of others in the still-chilled spring air in the sculpture garden at the Museum of Modern Art in New York where I used to curate. We become silent as she stated, "I want you to give me your brightest . . . clearest . . . focus." She drew out each word, pausing between them, pinching the air as if to indicate the precision she mentioned—a penetrating focus capable of making visible what the eye alone cannot see. Weems writes about "seeking clarity and purpose" in

the text panels of the *Kitchen Table Series*. That day was a reminder: her quest for imagistic clarity is an outgrowth of what she calls out of her subjects and embodies.

If Thelonious Monk is correct that a "genius is he who is most himself," Weems's *Kitchen Table Series* offers a visual and textual demonstration of this fact, and not merely because she extends the gendered notion of his insight. The work is not only an investigation of sovereignty—utter command of one's self. It also dexterously shows the artist's mastery of every facet of her own form—her voice, her insights, her body, and a keen grasp of the constitutive networks and relations that make her who she is. "At 38 she was beginning to feel the fullness of her woman self," states the text in a panel of the series, Weems's own age at the time. Over three decades later, the *Kitchen Table Series* has become a landmark series not only for what it shows us about development, but also for what it shows about the artist's own—Weems has long been the chronicler of how inner landscapes of longing shape our ability to function as a force in the world.

Robin Kelsey, Katori Hall, Salamishah Tillet, Dawoud Bey, and
Jennifer Blessing

For the 2016 special issue of "Vision & Justice," *Aperture* invited
voices from the fields of theater, photography, and art history to
reflect on one of her most iconic projects.

Robin Kelsey on *Untitled (Man Smoking)*

Kitchens and streets. You could write a history of the twentieth century
through that pairing. If the city street is a place of random encounter,
of hustle and protest, the kitchen is a place of intimate habit, of sharing
and aroma. Emotional distance is routine on the street, but excruciat-
ing in the kitchen. Yet if such a history is worth writing, it is because
these two places are by no means discrete. The street presses into the
kitchen, stocking shelves and burdening conversations. The kitchen
is a delicate sanctuary, vulnerable to the threat of violence, and to the
prejudice and fear that abound outside. But the kitchen has a subtle
power of its own. It bears an improvisational capacity to bind subjects
in shared experience and to restore and refashion them in the midst of
struggle.

In the *Kitchen Table Series*, Carrie Mae Weems takes these issues on
with verve. The second photograph in the sequence depicts the protag-
onist drinking and playing cards with a man. A bottle of whiskey, a pair
of mostly emptied tumblers, a dish of peanuts, some discarded shells, and
a cigarette pack: these things constellate into a still life, lit by the glowing

bulb above. The peanuts, cigarettes, and whiskey tie the kitchen into a larger economy and its history. As agricultural products grown mainly in the South, they mix into this leisurely moment signs of labor, suffering, and migration. A history of many streets, of rural South and urban North, has seeped into the scene, which recalls, in smoky black and white, earlier meditations on exodus and hope.

The streets of New York also arrive via the photographs on a back wall. At the center is an image of Malcolm X at a rally. The photograph was taken in 1963, but the popular poster featuring it dates to 1967. To the right is a familiar photograph from 1967 by Garry Winogrand,

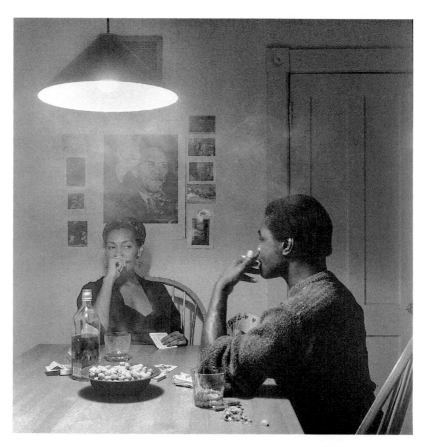

Carrie Mae Weems, *Untitled (Man Smoking)*, from the *Kitchen Table Series*, 1990.
© Carrie Mae Weems. Courtesy of the artist and Jack Shainman Gallery, New York, NY.

showing a light-skinned woman and a dark-skinned man in Central Park carrying chimpanzees dressed like children. Using racism and fears of miscegenation to make a joke, the Winogrand photograph exemplifies the troublesome role that humor plays in both exposing and perpetuating stereotypes. These icons of the 1960s, blurred in the kitchen by a cigarette haze, elicit memories of turbulent race relations on New York streets. By enfolding these icons in a Roy DeCarava-esque 1950s mood, Weems layers the photograph with traces of formative decades.

Invoking these layers in 1990, Weems raises questions concerning their legacy for art and life. Consider the subtle play of mouths and hands linking the central poster to the foreground figures. While Malcolm X points toward the unseen crowd and seems on the verge of forcefully speaking, the protagonist holds her cards in her left hand while curling her right in front of her mouth. Her male companion offers a mirror image, cards in his right hand, his left holding a cigarette to his lips. In the kitchen table scene, the blazing public oratory of Malcolm X has turned inward. With cards held close, canny glances directed sidelong, mouths hidden, these players work the interior. The politics of the street have folded into a private circuit, an exchange predicated on a shared history and bound by the rules of a game. Although we can read the signs, we remain at the far end of the table, uncertain of the rules, and not privy to this intimacy and its unspoken content.

Katori Hall on *Untitled (Woman Brushing Hair)*

In my world, the kitchen table ain't never been just for eating. Friday night "fish frys" segued into Saturday night hair fryings on the weekly. Till this day, I still have nightmares about the hot comb. I remember Mama would tell me to hold my ear down, and my body would just recoil, bracing for my skin's possible kiss with a four-hundred-degree iron. The worst was when she told me to duck my head down so she could snatch my "kitchen." Honey, let me tell you, it is a brave girl who submits the nape of her neck to that fire. Perhaps it is the reason why the delicate hairs that stake claim there have themselves been called "the kitchen," as they are often tortured into submission in the space that bears their name.

As barbaric as this nighttime ritual of singed hair may seem to some, it is the tenderness served up to us tender headed that has left its indelible mark. The kitchen is a place to be burned, but it is a space to be healed as well.

In this image from the *Kitchen Table Series*, Carrie Mae Weems gives viewers the privilege to witness this remarkable, ordinary-extraordinary ritual. Playing that everywoman we all have been at one time or another, the photographer herself sits in a black slip, cigarette just a-dangling, head cocked to the side, seeking solace against the belly of a kitchen beautician. Is it a sister? A mama? An auntie? A lover? Whoever we imagine, this image of blissful domestic intimacy reminds us all of the women who, while scratching that dandruff right on out, offered an ear as a cup for our tears. We couldn't afford to sit on a therapist's couch, and—even for those who could—Vanessa down the way could give you a mean Kool-Aid tip and advice on how to give that usher cheating with-a yo' husband *Heyell.* The beautician's chair in that kitchen was a healing throne. Fixing food . . . fixing hair . . . fixing poor souls.

Salamishah Tillet on *Untitled (Woman and Daughter with Makeup)*

When my daughter, Seneca, was a nine-month-old, she would crawl over to the mirror every morning. There, she greeted herself with a wide, near toothless smile marked by such gusto that I wasn't quite sure if she knew who was staring back at her.

In 1949, French psychoanalyst Jacques Lacan famously diagnosed this moment of child self-recognition as the "mirror stage," that critical phase of human development in which the baby sees herself as distinct from—not, as she previously assumed, one with—her mother. He theorized it was the collapse of the human ego, our first real trauma, that led us to forever construct everyone else as the "other" as we learned to live as fractured selves.

But what if Lacan was wrong? At Carrie Mae Weems's kitchen table, we witness another mirror stage: a mother with a lipstick in hand fixed on herself, her young daughter in a miniature version of the same pose. Even without looking at each other, they synchronize this gender performance. A mother who teaches her girl-child the fragile ways of femininity even as the mother does not fully embrace or embody these same terms of womanhood for herself.

But that is my cursory read. Weems's genius has always been to reveal, consistently and with newness, in familiar and foreign settings, what poet Elizabeth Alexander calls "the black interior," a vision of black life and creativity that exists "behind the public face of stereotype and limited imagination." To tap "into this black imaginary," Alexander writes, "helps us envision what we are not meant to envision: complex black selves, real and enactable black power, rampant and unfetishized black beauty."

In this context, then, their self-gazing is a reparative act. A mother and a daughter (and we, always we) learning a far more valuable lesson: to be able to see each other, their black woman and black girl selves, in spite of the gendered and racial invisibility into which they both were born.

I see glimpses of Weems's radical vision when my now three-year-old daughter looks in the mirror, not every day and without a toothless grin; she has a slyer, wiser smile. Reflected back is a child who hasn't been taught to un-love herself, who hasn't yet been asked, as W. E. B. Du Bois once wrote of his boyhood, "How does it feel to be a problem?"

Instead, she is in process, an unfolding subjectivity, still waiting to live out the many possibilities of black interiority that Weems's *Kitchen Table Series* has already given us.

Dawoud Bey on *Untitled (Eating Lobster)*

> Oh, the blues ain't nothin'
> But a woman lovin' a married man
> Oh, the blues ain't nothin'
> But a woman lovin a married man
> Can't see him when she wants to
> Got to see him when she can
> —Georgia White, "The Blues Ain't Nothin' But . . . ???"

Looking at this photograph, one can almost hear it. And what one hears is the blues by way of the harmonica being played. The harmonica wasn't always considered a blues instrument, you know. It was originally a German instrument, used to play traditional waltzes and marches of a decidedly European persuasion. But once the small instrument

found its way to the southern part of the United States, and the black communities and musicians there, well . . . you *know* what happens when black folks get their hands on something. It becomes something else, molded to the idiosyncratic, emotional, and cultural shape of black southern tradition. In this case, an extension of black expressivity of a vernacular kind, played within the context of a music that came to be called the blues. Originally meant to be played by blowing into it, the harmonica, when it reached the black South, underwent a transformation. Instead of simply blowing, black southern harmonica players

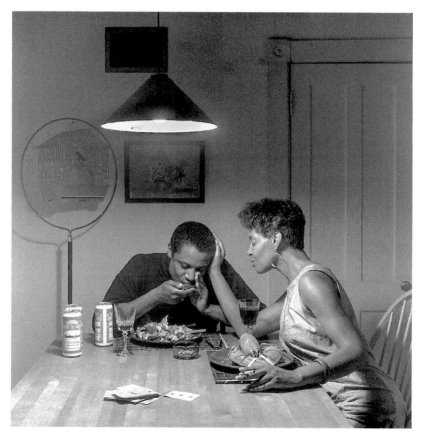

Carrie Mae Weems, *Untitled (Eating Lobster)*, from the *Kitchen Table Series*, 1990.
© Carrie Mae Weems. Courtesy of the artist and Jack Shainman Gallery, New York, NY.

realized that sucking at the instrument, and the reeds within, yielded a more plaintive sound and a different pitch, one more akin to the bending of notes on a guitar—the better to exact a more human, expressive tonality from the instrument. In so doing, black blues harmonica players found yet another way to bring an individual sense of black vocality to an instrument not necessarily made to speak that particular musical language.

The blues, of course, are about finding the good in the bad, playing through the pain to extract the joy and the lesson within. The scenario presented in this Carrie Mae Weems photograph from the *Kitchen Table Series* contains all of the tensions and dualities embedded in the blues: His succulent lobster is completely eaten, while hers remains untouched. His glass is almost empty, while hers is full. Eyes closed, they are both lost in the shared moment. As he plays, she sings and touches his face tenderly, cigarette dangling from her free hand. A man and a woman, lost in a beautiful, poetic, and forever enigmatic moment.

Jennifer Blessing on *Untitled (Woman Playing Solitaire)*

Carrie Mae Weems's landmark *Kitchen Table Series* opens with a photograph of a woman caught between her reflection and a faceless phantom of a man. The final chapter of that unfolding story, the denouement after a violent off-camera climax, begins with a woman directly addressing the viewer, no longer surrounded by her lover, her friends, or her daughter. Weems's grand finale, the last word of chapter and verse, is a woman playing solitaire. Having liberated herself from a bad relationship and the social constrictions of motherhood, her protagonist relaxes with a smoke, a glass of wine, and some chocolates—perhaps a valentine from a new suitor? Placed just before this picture, the closing text panel in the series announces, "Presently she was in her solitude." Though her bird has literally and figuratively flown the coop, the woman seems unconcerned rather than lonely, defeated, or abandoned.

The *Kitchen Table Series*, however, is not a story about simply justice served. The teller of this tale is neither saint nor sinner; the moral is not black or white but rich shades of gray. The measured photographic chronicle is countered by the raucous accompanying texts, which describe a far darker narrative echoing with a chorus of voices—those

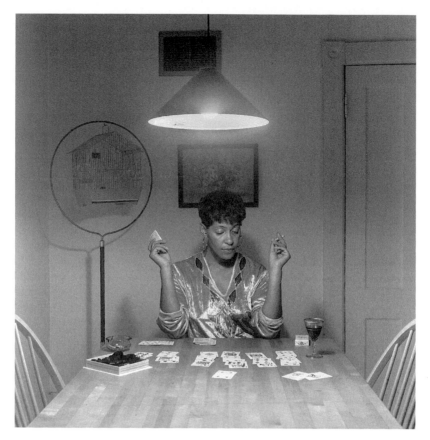

Carrie Mae Weems, *Untitled (Woman Playing Solitaire)*, from the *Kitchen Table Series*, 1990.
© Carrie Mae Weems. Courtesy of the artist and Jack Shainman Gallery, New York, NY.

found in vernacular expressions, rhymes, and lyrics—coalescing into that of the imperfect heroine. The last text panel features lines from "Little Girl Blue," a song immortalized by Ella Fitzgerald and Nina Simone, whose vocal shadings, we can imagine, provide a ghostly sound track for the woman playing solitaire, who is also a lady singing the blues about a man who done her wrong. She's a little girl blue looking for a blue boy, who can only ever count on raindrops, who tells it like it is.

The woman is playing the game of solitaire, but is she also playacting as solitaire, a character like a jester, a harlequin, a domino? Just as the mute image is haunted by Nina Simone's voice, its monochrome

tonality calls for us to imagine the color of Weems's costume, perhaps a shimmering gold blouse festooned with a regal purple trompe l'oeil jewel necklace. Is she a clairvoyant, a light seer (as well as a light writer/photographer), reading the cards to foretell her future? The text panel tells us finding a man will "have to come later." This picture suggests she is in no hurry, she holds all the cards, she's testing her luck before making her next move.

Carrie Mae Weems's Convenings

Thomas J. Lax

In 1995, when Carrie Mae Weems was featured in the Museum of Modern Art's *Projects* series, she kicked off the exhibition opening with a procession into the midtown museum. In doing so, she marshaled an expression of collectivity into a format typically reserved for the solemn recognition of a singular genius. In fact, her installation had already smuggled its context with it: she had transformed the institutional space into a domestic one by covering the museum's white walls with a bold graphic wallpaper and by placing an artwork on a folding three-paneled screen support in the middle of the floor as if the viewer had entered a stranger's living room. This spatial shift from museum to home was extended into real time and beyond the gallery walls during the evening's celebration as the performance connected the show with the city street. Jazz musicians and dancers occupied 53rd Street as the drummer Craig Harris played his didgeridoo while seated on the gallery floor.[1] *Not only am I here*—Weems's installation proclaimed—*but* we *have arrived.*

Weems has continually considered the museum as a site to stage performative actions and to create unlikely occasions for her and others to stay awhile. In her black-and-white photographs from the *Museum Series* (2006–present), she stands stolidly—her back to the camera and wearing a full-sleeved, floor-length black dress—and looks at the world's leading museums and cultural institutions: the Galleria Nazionale D'Arte in Rome, the Pergamon in Berlin, and Project Row Houses in Houston. Her physical presence is emphatic and expectant, placed at once outside the seats of symbolic and cultural power and yet in

immediate, majestic proximity to them. Each image suggests that meaning can be generated in the intimate slip between the veneer of an institution's architecture and the people who make its insides usable everyday. In addition to museums, Weems has steadily focused her eyes on other vital sites of memorialization also presumed to be inert. In *Boneyard* from her *Sea Island Series* (1991–1993), for example, three photographs of graveyards taken off the coast of South Carolina are paired with a text that details African American customs for the deceased: *If people die waiting to see someone, they will stay limp and warm for days. They are still waiting.* Weems shows us that graveyards, like museums, are not only places where the dead are cared for; they are also ritualized spaces where the dead are still alive and where, in coming together, we commune with those who have come before.

In 2014, Weems co-hosted the pivotal convening *Past Tense/Future Perfect* with the musician and composer Carl Hancock Rux at the Solomon R. Guggenheim Museum. Weems organized the event on the occasion of her retrospective (the first for a Black artist at the museum) as a refusal to occupy this impossible position and stand in as The Only One. Instead, she brought the rest of us into the museum with her. Weems's convening was an assembly of interdisciplinary makers—musicians, poets, dancers, visual artists, and writers—that offered shared opportunity for study and inspiration aiming to create a space where "form is mapped and levels of invention are simply unpacked."[2] Since then, she has organized these events and nonevents in other august institutions such as the Park Avenue Armory, where in 2017 she organized *The Shape of Things.* Importantly, she has also located these ensembles and choruses within self-made sanctuaries initiated by Black artists, including Theaster Gates and Eliza Myrie's Black Artists Retreat on the South Side of Chicago,[3] and Julie Mehretu, Paul Pfeiffer and others' pastoral Denniston Hill residency that they founded in upstate New York.[4] Each convening organized by Weems and refracted into other contexts creates an infrastructure that acknowledges both predecessors and heirs.

While Weems's exhibition at the Guggenheim may have been called a first, her emphasis on the convening positions it within a long history of collective self-institutionalization that has occurred within the Black radical tradition. During the second half of the nineteenth

century, for example, African American women novelists such as Frances Harper and Pauline Hopkins paired their writing with opportunities for speaking in women's clubs and congresses as well as abolitionist societies and social reform unions.[5] And during the Great Depression, visual artists Augusta Savage and Gwendolyn Bennett formed the Harlem Community Art Center, a Works Progress Administration-sponsored community space in operation from 1937 to 1942 that offered art instruction free to all, in particular children who famously included a young Jacob Lawrence.[6]

Artists have continued to incorporate public teaching and group work into their aesthetic innovations, demonstrating how all creative genius is relational, processual, and takes time. Starting in the mid-1970s, Linda Goode Bryant organized "Brunch with JAM," five-dollar meals that included lectures on art for non-specialists modeled on the Black Panther Party's Free Breakfast for School Children Program at her Just Above Midtown Gallery in which collaboration, performance, and experimentation flourished.[7] More recently, Simone Leigh along with Rashida Bumbray and Black Women Artists for Black Lives Matter have organized holistic health programs under the cover of art. There, women from schoolgirls to elders have screened their blood-pressure, closely read writing by Hortense Spillers and Saidiya Hartman, and taken modern dance classes.[8] To convene, this history of women intellectuals and practitioners suggests, is to understand context and community as the condition of possibility for the making of form and formlessness.

On the appointed Friday afternoon at the end of April, poet Elizabeth Alexander grounded Weems's *Past Tense/Future Perfect* by offering an invocation, appearing on high in the rafters of the museum's new international style theater in a wash of purple light. She called roll of the names of artists who were with us, although some of them were no longer physically present. And then she read from her poem "Black Poets Talk about the Dead":

> After she left us, we felt Mom close
> She had passed but not crossed—and those were good weeks
> Her soup in the freezer, perfume in her handkerchiefs
> Half-empty cups of her tea had grown cold
> But bit by bit, she left and then was gone

They do that so we can mourn; they do that so we believe it
It is what it is: wretched work
That we who the dead leave behind must do.[9]

Over two and a half days, the participants performed more wretched work, basking in readings, performances, eulogies, and celebrations. What brought this interdisciplinary group together was perhaps best described in terms artist John Outterbridge offered in a recorded interview Weems had made with him in his Los Angeles home. "Some people pay dues and develop calluses," he said. "We call them, sometimes, artists." Artists develop calluses by smelling the perfumed handkerchiefs and eventually discarding the half-empty cups of tea in Alexander's poem, Outterbridge described this work in his own words as scavenging objects and using them as a medium for crossing.

> . . . the only thing I make is rearranging the debris of my burden. When I pick up rags, when I pick up metal that was in my father's backyard, when I hear in the old engine run again that has a kind of audacity about it because it's not supposed to run any more. It has a way of cranking itself and running itself. And my father rides along. . . . It's difficult what they might have been because all those things are within us and beyond us."[10]

When it was my turn to speak, I read from an interview I had conducted with my Aunt Marion: Marion Parsons, born Marion Brown, who was my maternal grandfather's eldest-born sister. She had passed in the weeks preceding Weems's convening and in reflecting on Aunt Marion's beliefs in the hereafter, I recounted her skeptical experience of life's cycle. In my oral history with her, she had spoken of the uncertainty out of which faith can be reborn, a paradox that seems both impossible and everywhere present.

> I often wonder. I wonder if you are there in physical being, like we say *I'll see you in Heaven*. I don't know if we are re-formed or re-developed into a body. I really don't know. I would hope that it would be a place with no wars, where people were friendly to each other, that you didn't have to worry about sickness and death. I would hope it's that way, but I really don't know."[11]

Notes

1. See the interview "Carrie Mae Weems and the Field" in this volume.

2. Conversation with the artist, January 26, 2019.

3. These two audiences in fact overlapped during the Guggenheim convening when younger artists working with Gates were first invited to meet at the Studio Museum, where there was a concurrent exhibition on view featuring Weems's *Museum Series* organized by Lauren Haynes.

4. This structure has been borrowed by curators too, including the time John Akomfrah and I organized a convening at MoMA following the acquisition and presentation of his video installation *The Unfinished Conversation* (2012), which takes as its subject the British cultural theorist Stuart Hall, who had passed away just as Akomfrah was finishing his work. "An Evening Celebrating Stuart Hall Featuring John Akomfrah, with Cameron Bailey, Tina Campt, Kobena Mercer, and David Scott," The Friends of Education, Museum of Modern Art, March 17, 2017.

5. See Hazel V. Carby, *Reconstructing Womanhood: The Emergence of the Afro-American Woman Novelist* (New York: Oxford University Press, 1987).

6. See Leah Dickerman, "Fighting Blues," in *One-Way Ticket: Jacob Lawrence's Migration Series*, ed. Leah Dickerman and Elsa Smithgall (New York: Museum of Modern Art, 2015), 10–31.

7. See Rujeko Hockley, "Just Above Midtown Gallery" in *We Wanted a Revolution: Black Radical Women, 1965–1985: A Sourcebook*, ed. Rujeko Hockley and Catherine Morris (Brooklyn Museum, 2017), 134–138.

8. See Helen Molesworth, "Art Is Medicine," *Artforum International* 56, no. 7 (March 2018): 164, 166–168, 170.

9. Elizabeth Alexander, "Black Poets Talk about the Dead," April 25, 2014, from *Carrie Mae Weems Live: Past Tense/Future Perfect, Roll Call*, https://www.youtube.com/watch?v=m7BhThDh7eM.

10. Carrie Mae Weems, "John Outterbridge: Sculptor," April 25, 2014, from *Carrie Mae Weems Live: Past Tense/Future Perfect, Roll Call*, https://www.youtube.com/watch?v=m7BhThDh7eM.

11. Marion Parsons, personal interview with the author. May 18, 2002.

Carrie Mae Weems: The Legendary Photographer on Becoming and Exploring Personhood through Art

Kimberly Drew

Carrie Mae Weems is one of the most important image-makers of our time. Her work in photography, social practice, performance, and video has grounded our understanding of the power of visual storytelling and investigated subjectivity in domestic and public spaces. This April, nearly thirty years since she produced her ambitious and revelatory *Kitchen Table Series*—a collection of twenty photos, all shot in her kitchen, and fourteen text panels—the first monograph celebrating the project was finally published. . . . When we spoke, she had just returned to New York after being honored by the Anderson Ranch Art Center for her extraordinary contributions to the field.

KIMBERLY DREW: When did you first start taking photographs?

CARRIE MAE WEEMS: Well, you know, actually I started taking photographs when I was about eighteen. My boyfriend at the time gave me a camera for my birthday. I'd always been interested in art in some sort of way, but the moment that I started taking pictures . . . everything kind of clicked. Every facet of me said, "Yes, this is what I am going to do. This is my way forward. This thing, this instrument, is going to lead me into my life." The first person I photographed was a black woman, a friend of mine who I knew. I wasn't interested in doing anything fashion oriented, but I wanted to immediately work with black women. I knew that that was important.

In addition, I had become familiar with these incredible volumes of black photographers' work. The *Black Photographers Annual* was produced by an incredible man named Joe Crawford, who has since passed away, but he worked with people like Roy DeCarava and the Kamoinge Workshop. Ming Smith was one of the only women involved in the Kamoinge Workshop. The Kamoinge maybe had twenty, twenty-five, thirty men and this one lone woman. Of course, I immediately started looking at her very closely and looking at photography very closely. The *Black Photographers Annual* showed me that black people needed to be engaged and described through this medium.

KD: Wow, I'm so glad that our dialogue begins with the *Black Photographers Annual* and Kamoinge as part of this conversation because I feel like those are two important pieces of art history that are often left out of the conversation. I know that before photography, you studied dance. Could you tell me more about that? Does it connect to your photographic work?

CMW: Oh yes. It really wasn't my intent to be a dancer. It was just a natural part of my makeup. I had joined Anna Halprin's company. She was a very progressive, interesting, dynamic dancer—who is still dancing to this day in her 90s. In 1970 she was already really interested in bringing [diverse] people together in order to have them experience one another, [as a way to be] in touch with the deeper humanity of the people around you that may look different from you.

What I think dance also gave me was a sense of how one can use the body and how the body can be used as an expressive tool. I started doing self-portraits. I always thought about the pictures of myself as not necessarily of myself but as an entity, a form that could express something that needed to be expressed. I started using myself very, very, very early on.

KD: Ah, yes, this is a great segue into talking about the *Kitchen Table Series*. One thing that I find really interesting is that you were able to use your body as a performative element to express something much broader than your singular experience in the world. Could you speak a little bit about the origin for the piece? I know that you shot it in Northampton, Massachusetts, correct?

CMW: I did, I did. I always say that if you get out of the way of your work, your work will tell you exactly what it needs. Usually your work is much more forward-thinking than you are. Half of what we do, we're doing almost intuitively. It's later that we really understand what we've actually done or why we've done something a certain way or for that matter what something even needs.

For example, spaces are very unique. Not every space can provide you with the richness of the subject that you need or the background, the ambience, the feeling, the mystery. Places, spaces really carry weight with them. Often women use their homes as their site of production as opposed to men, who rarely do, which is very interesting. I think that often women work in this way.

KD: Could you tell me more about what was going on in your personal life as you embarked on the series?

CMW: Back then I was teaching—working with a number of young people at Hampshire College. It was one of those volatile moments—seminal texts on feminism were being produced, discussed, talked about. Laura Mulvey's very important essay "Visual Pleasure and Narrative Cinema" on the gaze had been produced, and everybody was referencing that and talking about that. The assignments that I often gave my students, I always asked them to make a portrait of somebody else and then a portrait of themselves, because I wanted them to see the differences in terms of how they represented themselves as opposed to how they represented others. The way in which men photographed themselves was deeply frontal. Women always photographed themselves turned to the side and slightly obscured. Their faces were never quite open and flat to the camera. They were always hidden behind hair, hidden behind objects, hidden behind things. It's sort of a vulnerability of revealing the self.

I was thinking about the ways in which my students were working and I was also thinking about the way in which the dialogue had taken place and how it had very much excluded the black female body. It was just not a part of the discussion. Those things came together to really form the initial impetus for the *Kitchen Table Series*. I knew that I wanted to be involved and bring together a group of people to examine monogamy, polygamy, the structure of family, the structure of the relationship between men and women, the structure of the relationship between

women and their children. There's also a structural relationship between women and other women.

All those things just came together in sort of like this compression of ideas. . . . I worked on it constantly! I made photographs every day. I would process them every day. I would print every day. I would look at my mistakes. I would come home and I would photograph again. I'd go back to the lab. I'd process again, print again, process my mistakes until it all started to come together.

Then the text just came in this extraordinary burst of energy and insight and meaning and meeting with people, with two men that I was very, very, very, very close to. I pulled out a tape recorder after leaving one of them and just recited it to myself. . . . In a more concise way, in that moment, I needed to speak to and across the ways in which women had been discussed in film, theater, and photography. I needed to speak of representation and systems. In the text, I aimed to unpack systems of private property, systems of relationships that keep us tied to them and make us accomplices in our own victimization, or ones that manage to free us somehow. Understanding the complicated relationships that we are involved in. The work comes about because it needs to speak to something that's happening in the larger world.

KD: As a person who is so much a digital child, I think about selfie culture and how it's really rapid. . . . You didn't know what your final result would be instantaneously.

CMW: Conceptually, trying to figure out how to make, how to produce, how to design, how to overcome the objectification of the female form—How do you do that? How do we do that? It was a question that I think we were all asking at various levels of our career and answering, of course, very differently. . . . The historical writing, the art-historical writing, the art criticism, the art reviews haven't kept pace with the art. It's really lagged behind. It has taken thirty years to take the *Kitchen Table Series* and place it in its proper context. . . . it took a lot of time for it to reach publication in a significant way. This sort of systematic undermining and devaluation of what women do is pretty profound. . . .

KD: . . . On another note, a thing that I really admire about your work is that text plays such a major role in all of it. I think a lot of younger artists who are coming up now don't understand the importance of

holding your own voice within the work. At the end of the day, the artist is their own best advocate. The artist is the only one who is fully aware of the social history and the intention of an artwork. I think about you, Lorraine O'Grady, and Coco Fusco as women who are really doing the work for the work.

CMW: The notion of representation is really key to the work. At one point in my forties and fifties, I thought, 'How do I want to work now and who do I want to represent? What can this body stand for now?' Asking myself that question. What can this body, this body of mine and this skin, what can the skin do now that it couldn't do when it was thirty or maybe can't do because it isn't thirty? I'm thinking about age. I'm thinking about the way my body changes and therefore how to use it differently.

I realized at a certain moment that I could not count on white men to construct images of myself that I would find appealing or useful or meaningful or complex. I can't count on anybody else but me to deliver on my own promise to myself. I love Fellini. I love Woody Allen. I love the Coen brothers, but they're not interested in my black ass. They're simply not interested. . . . We don't even occur to them as subjects. We don't even occur to them as a viable fucking subject. Not to even say hi to. That's how distant we are from their fucking imaginations. I can't count on them to do my job. I just can't count on them. I can't count on them to play fair. I can't count on them to think about me in any sort of serious way, because it's clear that they don't.

I look at it as unrequited love. You know? I love them, but they ain't thinking about me. It's not really a complaint. It's just the reality. I build a form for myself that doesn't exist anyplace else. I don't see me represented in any other serious way anyplace else for the most part. . . . I do think that you have to make what you want to see in the world. That is basically your obligation if you're an artist. For that matter, even if you're a plumber. You really have to make your reality meaningful for you, and you can't necessarily rely on anybody else to do it. That is, I think, the great liberty that the arts and letters and music give us . . . the ability to create meaning in our lives.

Family Folktales: Carrie Mae Weems, Allan Sekula, and the Critique of Documentary Photography

Erina Duganne

Beginning in the 1970s, Allan Sekula, along with a group of other artists and critics in the United States, initiated a trenchant critique of documentary photography. This critique developed largely in response to the position that documentary photography—a practice that had traditionally functioned as a potent form of political and social critique—found itself at this time. In the photography world, this practice was being put to largely subjectivist ends, as exemplified by John Szarkowski's influential 1967 exhibition *New Documents* at the Museum of Modern Art in New York, in which he sought to redirect "the techniques and aesthetic of documentary photography" away from social reform "to more personal ends."[1] In turning documentary photography away from its reformist beginnings, Szarkowski sought to elevate the subjectivity of the photographer at the expense of the medium's social function and in so doing ensure that photography was accepted as fine art. Concurrent with Szarkowski's effort to privilege authorial creativity, conceptual artists in the 1960s art world were mining documentary photography for its, ironically, non-art or style-less properties.[2] For these artists, documentary photography's assumed banality, anonymity, and vernacular associations offered a way to overcome, among others things, the very subjectivism that Szarkowski was trying so hard to align with a fine-art documentary practice. For Sekula, however, both of these uses of documentary photography were equally problematic, since both sought to disengage and distance the medium from its potential for political and social critique.

In response to this situation, Sekula deemed it necessary to reinstate the practice of documentary photography. But, in so doing, he argued that it was not sufficient to merely restore this practice as it had existed in the past; instead, the tradition itself needed to be reinvented. This is because, while traditional documentary photography had been effectively used as a vehicle of political and social critique, it was done so mostly in an uncritical and even voyeuristic manner since, rather than question the assumed objectivity and neutrality of this practice as well as the power relationships enacted in its depiction of victimhood, these characteristics were seen as implicit and unproblematic to the medium. To overcome and, more importantly, make viewers aware of these false assumptions about documentary photography and thereby engage with the medium as a form of social and political critique, Sekula sought, mostly through the strategic use of text, to call attention to the contingency as opposed to autonomy of photographic meaning and in so doing challenge and even negate the role of authorial creativity in determining that meaning. In this essay, I consider what Sekula's reinvention of documentary photography meant for artist Carrie Mae Weems who, while indebted to this critique, nonetheless shared a complicated relationship to its repudiation of authorial voice given that, as an African American woman, she had historically been denied agency or a voice with which to speak.

Family Pictures and Stories

Carrie Mae Weems began her photographic career believing that documentary photography, as she explains, could function as "a vehicle for expression, as a political tool. It was a way of capturing the human condition. Documentary is a very potent vehicle." Yet, Weems quickly came to realize that "a photograph can be slanted. How do you ensure that it is understood within your intended context?"[3] Her realization of the contingency of this practice developed in part from her graduate studies in the early 1980s with artists Fred Lonidier and David Antin at the University of California, San Diego (UCSD). It was there that Lonidier, as curator Andrea Kirsh explains, "forced her to address a series of questions about documentary photography," which included, "Who makes the images? Who are the subjects? Who is the intended audience?"[4] In raising these questions about the assumed objectivity

of documentary photography and its ability to produce social change, Lonidier—who was a graduate student and then teacher at the same time that Sekula was completing his graduate studies at UCSD in the early 1970s—echoed the critique of this practice discussed above.[5] In coming into contact with these ideas through Lonidier, then, Weems realized, as Brian Wallis writes in his important 1988 essay "Questioning Documentary," that she could not use documentary photography as "an unquestioned process of representing;" instead, she needed to figure out how this practice could become the basis of an investigation of "the institutional formations, means for exchange, and social stereotypes that position subjects in photography."[6] One of the first works in which Weems attempts to take on this proposition is her *Family Pictures and Stories*.

Weems began this work in 1978.[7] At this time, Weems was living bi-coastally between New York and San Francisco and trying to figure out, as she explains, "how to study and be connected to the art of photography."[8] As part of this struggle, she sought to situate her practice—primarily of photographs that she took in the streets of New York City and Portland as well as in Mexico and Fiji—within a tradition of African American photography. While the history of African American photography had yet to be adequately recovered, identified, and even preserved at this time, some early notable models for Weems included Roy DeCarava and Langston Hughes's acclaimed 1955 photography book *The Sweet Flypaper of Life* as well as the *Black Photographers Annual*, which was published in four editions between 1973 and 1980 and included images by black photographers who worked in the early parts of the twentieth century as well as in the contemporary period.[9] From these publications as well as her connections with other African American artists, primarily through the community provided by the Studio Museum in Harlem, Weems developed an important sense of what had not only been realized in the field of African American photography but also what she in turn might contribute herself: "I truly saw the possibility for myself—as both subject and artist."[10]

As an African American woman, understanding her potential both as a subject and an artist was exceedingly significant. At this time, there was a general dearth of representations of African Americans both in the mainstream mass media and in the fine art world. In addition to this invisibility, when African Americans were represented, especially within

the tradition of documentary photography, these images tended to depict African Americans, as Weems elucidates through the example of European American photographer Bruce Davidson's controversial 1970s exhibition and book *East 100th Street*, "as hopeless, powerless victims who are socially and economically depressed."[11] In addition to these kinds of disparaging and largely one-dimensional photographic representations of African Americans that circulated in the 1960s and 1970s, another set of images to gain widespread attention at this time was that of the pathological nature of the mother–dominated African American family.[12] While this pathologization of the African American family extended back to E. Franklin Frazier's 1939 sociological study *The Negro Family in the United States*, its authority became pervasive with the publication of Assistant Secretary of Labor Daniel J. Moynihan's controversial 1965 report, *The Negro Family: A Case Study for National Action*, popularly known as the "Moynihan Report."[13] In this report, Moynihan posited a causal relationship between the relative education and professional achievements of African American women and the failure, including criminal behavior and emasculation, of African American men. In short, Moynihan argued that since slavery, African American women have controlled and dominated their men and are thus responsible for the instability and deterioration of the African American family currently living in poverty in the urban centers of the United States. Though published more than a decade before Weems began *Family Pictures and Stories*, the findings of the "Moynihan Report" and particularly its myths about the black family remained ubiquitous, as is evident in Michele Wallace's provocative 1979 book *The Black Macho and the Myth of the Superwoman*, in which she attributes the internalization of the stereotypes about black men and women perpetuated in this report as having brought about the reclamation of black masculinity in the Black Power Movement to the exclusion and detriment of black women who had supposedly emasculated them.[14]

Weems also used her work *Family Pictures and Stories* to respond to the legacy of the "Moynihan Report" and its denigrating depiction of the gender politics of the black family. This is not to say that the montage of 35mm photographs in *Family Pictures and Stories*—which depict members of Weems's own family and are presented in the format of a family album—are positive images intended to counter the negative pathologies of the "Moynihan Report." Instead, Weems sought a more

difficult task, namely how to expose the myths and stereotypes of the black family perpetuated in this report and in so doing bring about a more critical and complex understanding of the social world and the ideologies that inform it. Weems uses several strategies to accomplish this task, including appending narratives in the form of written captions and two audiotapes to her collection of photographs. In bracketing her images with language, Weems sought not to fix or even close down the meaning of her photographs but rather to open them up, so that, as Weems explains, there "is no one meaning that you walk away with from this show, but you engage in a trilevel experience—interacting with the images, reading the text, and listening to the audio portion."[15]

In *Alice on the Bed*, for instance, Weems depicts a black woman lying on her side with the curves of her body snugly covered by a white sheet. Upon first glance, one might think that the woman, with her hair still in curlers, is napping on this otherwise made-up bed. But in looking closer, one realizes that her eyes are open and that she is smiling affectionately at the camera. Consequently, the image suggests a kind of familiarity, tenderness, and even sensuality, at least between photographer and subject, which encourages one to interact with the woman in seemingly humanistic terms. At the same time, this intimacy and even pleasure is abruptly disrupted by the typed text that Weems appends immediately underneath the photograph. It reads:

> Alice is the oldest and as the oldest—when momma wasn't home— cooked our food, washed our clothes and us, cleaned the house, when necessary even whipped our behinds. She's a no jive kinda woman; taking no slack from nobody for no reason. And the thing I like about her is her profound commitment to family. Girl will do whatever to hold it together. Tough cookie.

In this text, Weems offers a different account of Alice that in many ways seems to contradict the softness and informality suggested by the photograph alone. Whereas in the photograph Alice appears affectionate and welcoming, she now comes off as rather strict and unyielding. One might even say she has become a kind of emasculating black matriarch perpetuated by the "Moynihan Report." Yet, the consistency of this reading is quickly undermined by the audiotape that projects oral interviews that Weems conducted with various family members as well as

Carrie Mae Weems, *Alice on the Bed*, from *Family Pictures and Stories*, 1978–1984.
© Carrie Mae Weems. Courtesy of the artist and Jack Shainman Gallery, New York, NY.

hearsay about their individual backgrounds and generational experiences
sharecropping in the South and migrating north in the 1950s as well as
specifics about their family dynamics and personal encounters with
racism and poverty as well as miscegenation and racial passing. With this
audiotape, Weems provides an additional sociohistorical as well as inter-
personal context that serve to further complicate the meaning of her
photograph as well as to draw attention to the larger social structures
and power relationships in which its meaning is equally embedded. No
longer is the photograph of Alice an unmediated representation of black
femininity or even the black family; instead, through her interweaving
of photographs, captions, and audiotapes, [Weems] resists and subverts
these normative models and in so doing calls attention to the larger
gender, class, and racial structures as well as political ideologies that have
informed them.

Aerospace Folktales

In using her work and especially its incorporation of language to chal-
lenge and undermine the myths of the black family, Weems again seems

to align herself with the group of photographers, including her teacher Fred Lonidier, that Allan Sekula identifies in his seminal 1978 essay, "Dismantling Modernism, Reinventing Documentary (Notes on the Politics of Representation)" as having "reinvented" the documentary tradition.[16] Moreover, in turning to family as well as the tradition of storytelling as ways to disrupt these ideologies, Weems also suggests parallels with a work that Sekula produced in 1973 titled *Aerospace Folktales*, which he also discusses as part of this essay.[17]

In *Aerospace Folktales*, Sekula, like Weems, disrupts commonplace and often-internalized perceptions about the American family; but, whereas Weems uses the intersection of the history of migration with her black, working-class family to contest prevailing stereotypes of gender politics within the black family, Sekula turns toward the effects of unemployment on his own white, middle-class family as a way to challenge widespread assumptions about, among other things, middle-class affluence in Southern California. Like *Family Pictures and Stories*, *Aerospace Folktales* also consists of a tri-part structure of images, text, and audiotapes that are interwoven so as to uncover, as Sekula explains, "the structuring of the familial institution through ideology and socialization."[18] In the photographs, Sekula depicts a white family living in an apartment in Southern California. From the accompanying text and other materials—including a typed, one-page resume—viewers learn that the father is an engineer who worked until 1970 at Lockheed-California, Co. in Burbank, California. His current relationship to Lockheed, however, remains unclear. In one photograph, for instance, Sekula depicts the father and another elderly man standing alongside a station wagon that is parked in the empty lot of an industrial complex. While the text that immediately precedes the image clarifies that the empty parking lot is at Lockheed—"The engineer and his old friend stood in the empty Lockheed parking lot while I photographed them"—the father's relationship to the company is still ambiguous, since the text concludes, "Unable to fathom my motives, they were uneasy." It is only in deciphering the narratives, which are broadcast simultaneously and continuously from different corners of the room, that a larger framing context for the text and images begins to emerge. In each of these audiotape narratives, three voices speak—Sekula's mother and father as well as Sekula himself—and, though their format is vastly different—Sekula's mother, for instance, speaks largely anecdotally while his father's

discussion is much more analytic—viewers come to understand not only that the engineer in the photographs is Sekula's father but also that he is an unemployed aerospace engineer who worked at Lockheed until he was laid off two and a half years ago.

In exhibiting *Aerospace Folktales* in this manner, Sekula attempts to let the meaning of the work unfold obliquely rather than transparently. This strategy produces several results. First, it distances the work from the tradition of documentary photography and especially, as Sekula explains, its "belief in the efficacy of the single image."[19] Second, it also forces viewers, as Sekula further elucidates, "to link the sort of micro-sociological observations that are cast up for the camera or tape recorder—characteristic turns of phrase, small habitual gestures—to a broader context and pattern of meaning."[20] A case in point is the sequence of five photographs in which Sekula depicts his father painstakingly straightening the lamps in the bedroom. While this series of images may at first seem inconsequential, when viewed in terms of the overlapping narrative voices that speak in various ways about and around the effects that unemployment have had on Sekula's father and family members, another meaning begins to develop, however, indirectly. In the audiotaped conversations, for instance, one hears Sekula attempt to have a conversation with his father about his unemployment as well as its causes and effects. Yet, rather than speak personally much less intimately about this situation, he adopts a largely detached, analytic voice that lectures about pertinent economic and political issues. Consequently, the language that Sekula's father uses represents not just a coping strategy but more importantly it reveals, as Sekula elaborates in "Dismantling Modernism," "the effects of white-collar technical workers, on people who have internalized a view of themselves as 'professionals' and subsequently suffer the shock of being dumped into the reserve army of labor."[21] This same inability to deal with the effects of unemployment as a white-collar worker, who despite living in a working-class neighborhood envisions himself as upwardly mobile, is then played out in the sequence of photographs of Sekula's father compulsively rearranging the lamps. This is not an inconsequential act; rather, it signifies a "micro-sociological" gesture that provides a sense of usefulness and control in the wake of Sekula's father's own powerlessness to recognize the underlying ideologies that inform his ongoing beliefs in the material and economic frameworks that structure the world around him.

The engineer and his old friend stood in the empty Lockheed
parking lot while I photographed them.

Unable to fathom my motives, they were uneasy.

Allan Sekula, *Aerospace Folktales*, one of fifty-one images, 1973.
Courtesy of the Allan Sekula Studio.

Family Folktales

In using his own class and family background in *Aerospace Folktales* as a means to unmask these ideological beliefs, Sekula sets up an uneasy relationship between the political and the personal or, in his words, "between mock-sociological distance and familiarity."[22] Sekula turned to this seemingly private material for several reasons. First, it was a way for him to avoid the subject/object hierarchy implicit in most traditional documentary practices. By purposefully, as he explains, looking "straight across at the social circumstances of the author, in this case at the world of college-educated intellectual labor," Sekula sought to overcome the tendency of traditional documentary photography to "look downward" and thus "speak for" its less privileged subjects while at the same time maintaining the social legitimacy of his work within this tradition.[23] This did not mean, however, that in turning toward autobiography as the subject of his work, Sekula sought to give a voice to the specificity of his own experiences as a white, college-educated male. By calling his work a "veiled autobiography," in fact, Sekula explicitly denies such connections, since he refuses to allow his selfhood or even the psychic implications of his investigation from being the focus of his work. "I'm not trying to discover my self," explains Sekula in the work's voice-over narration, "I am not trying to present you with a record of my anguished investigations [sic] this material is interesting only insofar as it is *social* material."[24] In short, while the actuality of his family autobiography is essential to the documentary meaning of his work, he does not wish to fall into the subjectivism of a fine-art documentary practice in which, as Sekula avidly maintains, "a cult of authorship, an auteurism, takes hold of the image, separating it from the social conditions of its making and elevating it above the multitude of lowly and mundane uses to which photography is commonly put."[25] Yet, in making this statement about the effects of "auteurism" on documentary photography, Sekula necessarily positions subjectivity as belonging to the realm of the all-knowing author and not the processes of social relations so essential to a critical documentary practice. For an artist like Carrie Mae Weems, who understood the importance of speaking from both the position of author and subject, this repudiation of subjectivity was exceedingly problematic.

It is clear that Weems, influenced by the critique of documentary photography initiated by Sekula, wants to establish the "social material" of *Family Pictures and Stories* without falling prey to the assumed objectivity of this tradition and its supposed unmediated ability to produce social change. Yet, even though she uses her work as a form of social critique and more particularly as a way to challenge the narrow and judgmental ideological myths of the black family perpetuated in such sociological studies as the "Moynihan Report," she was equally invested in using the work to explore her selfhood and its relation to both her family and to the larger context of African American history in which it was intertwined.[26] For Weems, then, this "dig[ging] in her own backyard," as she has called it, fulfilled not just a personal or an autobiographical need but also a collective one. Weems elucidates: "The collective and I are both in there. You can't talk about something unless you've experienced it on some psychological or physical level. So that's where I come in, as a certain conduit for a kind of experience, because I'm a real working-class girl, a 'cotton-pickin, corn-pickin negro,' you know. I know what that experience is, it's not abstracted from some Marxian text."[27] At the same time, while Weems acknowledges her "insider" perspective, she does not assume that her relationship to this content is essential. In fact, throughout *Family Pictures and Stories*, she calls attention to the contingency not only between her self and her family but also between viewers and this subject matter. In her photograph *Welcome Home*, for instance, Weems depicts two women in the immediate foreground of the frame who walk arm in arm toward the camera. Taken from a relatively close distance, the women, beaming radiantly, seem ready to jump out of the frame and into the arms of Weems and by extension the viewer. Yet, as in her work *Alice*, the authority of this reading is complicated through her use of an accompanying text, which reads:

> I went back home this summer. Hadn't seen my folks for awhile, but I'd been thinking about them, felt a need to say something about them, about us, about me and to record something about our family, our history. I was scared. Of What? I don't know, but on my first night back, I was welcomed with so much love from Van and Vera, that I thought to myself, "Girl, this is your family. Go on and get down."

In appending this text to her image, Weems adds a layer of complexity to this seemingly transparent family snapshot since, in reading about the hesitation and even anxiety that she felt in relation to *her* family and to *her* history, viewers are encouraged to not only rethink assumptions about Weems's unmediated relationship to them but also about the intricacy of their own subject positions in relation to this content. As Weems explains, "A black family experiencing *Family Pictures and Stories* has a different thing to say to me than a white person experiencing the work. And certain black people find it really offensive, depending on where they are coming from."[28] For Weems, then, *Family Pictures and Stories* is as much about asserting *her* family and *her* history in the wake of the legacy of the debilitating representations of the "Moynihan Report" as it is about thinking about the complexity of what it means to occupy a subject position within and in terms of this story. As Weems explains, "I attempt to create in the work the simultaneous feeling of being *in it* and *of it*. I try to use the tension created between these different positions—I am both subject and object; performer and director."[29]

Carrie Mae Weems, *Welcome Home*, from *Family Pictures and Stories*, 1978–1984.
© Carrie Mae Weems. Courtesy of the artist and Jack Shainman Gallery, New York, NY.

Ironically, this understanding of the indeterminacy of subject positions is also one that Sekula recognizes in *Aerospace Folktales*. In fact, this contingency is another reason why he insists that his autobiography remain "veiled" and why he tries "to achieve a critical distance from a family context with which I was already intimate."[30] Sekula further clarifies, in part of the voice-over narration from *Aerospace Folktales*:

> I cannot provide you with *an* experience [sic] because you will relate to this differently depending on who you are [sic] if you are the president of Lockheed you will relate to this in a different manner from the manner of an engineer [sic] if you are an important professor you will relate to this in a different manner from the manner of a student [sic] if you are a pizza cook you will relate in a different manner from the manner of a sociologist [sic] if you are a man you will relate in a different manner from the manner of a woman and so on.

Here Sekula cogently addresses the limitations of his position as an all-knowing author; yet, in making this critique about the subjectivism of documentary photography, he fails to recognize that the question of who is speaking or who is providing an experience cannot be so easily dismissed, especially when that subject is one who has historically been denied the right to speak in the first place. As cultural critic Kobena Mercer points out in his influential 1991 essay "Skin Head Sex Thing," "The question of enunciation—who is speaking, who is spoken to, what codes do they share to communicate?—implies a whole range of important political issues about who is empowered and who is disempowered in the representation of difference."[31] In recognizing the importance of the critique of documentary photography to her own practice, Weems, then, joined a cohort of politically motivated artists who sought to use language as a way to subvert, circumvent, and dislodge the assumed transparency and implied hierarchy implicit to this practice. But what differentiates Weems from this group is her refusal to distance or even negate the equally imperative role that selfhood occupied in terms of this critique.

Notes

1. John Szarkowski, *New Documents* [unpublished wall label], 1966. Exhibition files, Museum of Modern Art, New York. The exhibition included the work of Diane Arbus,

Lee Friedlander, and Garry Winogrand. For a brief critical overview of this exhibition, see Steve Edwards, "Vernacular Modernism," in *Varieties of Modernism*, ed. Paul Wood (New Haven, CT: Yale University Press, 2004), 241–268.

2. There have been numerous accounts of the conceptual art movement. A particularly important one is Ann Goldstein and Anne Rorimer, eds., *Reconsidering the Object of Art: 1965–1975* (Cambridge, MA: MIT Press, 1995), which includes Jeff Wall's influential essay "'Marks of Indifference': Aspects of Photography In, Or As, Conceptual Art." For a general overview of the complex relationship of photography to the conceptual art movement, see Steve Edwards, "Photography Out of Conceptual Art," in *Themes in Contemporary Art*, ed. Gill Perry and Paul Wood (New Haven, CT: Yale University Press, 2004), 137–180.

3. Lois Tarlow, "Carrie Mae Weems," interview, *Art New England* 12 (August/September 1991): 11.

4. Andrea Kirsh, "Carrie Mae Weems: Issues in Black, White and Color," in *Carrie Mae Weems* (Washington, DC: The National Museum of Women in the Arts, 1993), 9.

5. Sekula also included Fred Lonidier's work in his essay "Dismantling Modernism, Reinventing Documentary (Notes on the Politics of Representation)," *The Massachusetts Review* 19, no. 4 (December 1978): 859–883.

6. Brian Wallis, "Questioning Documentary," *Aperture* 112 (Fall 1988): 60–71.

7. Weems continued to work on *Family Pictures and Stories* until 1984 when it was first exhibited as part of her MFA thesis for UCSD. See Carrie Mae Weems, *Family Pictures and Stories: A Photographic Installation*, artist's book (San Diego: Alternative Space Gallery, 1984).

8. Dawoud Bey, "Carrie Mae Weems," interview, *BOMB*, no. 108 (Summer 2009): 66.

9. The significance of these publications for Weems is addressed in Kirsh, "Carrie Mae Weems," 9–10. In addition, Weems speaks about the importance of the *Black Photographers Annual* in Bey, Weems interview, 63; Tarlow, Weems interview.

10. Bey, Weems interview, 63.

11. Carrie Mae Weems, "Personal Perspectives on the Evolution of American Black Photography," *Obscura* 2, no. 4 (1982): 8–17.

12. For a discussion of the circulation of these sorts of images in the 1960s and 1970s, including Bruce Davidson's *East 100th Street*, see Erina Duganne, *The Self in Black and White: Race and Subjectivity in Postwar American Photography* (Hanover, NH: Dartmouth College Press in association with University Press of New England, 2010).

13. See Daniel P. Moynihan, *The Negro Family: The Case for National Action* (Washington, DC: Office of Policy Planning and Research, United States Department of Labor, March 1965). For an excellent overview of the production and reception of the "Moynihan Report," see Lee Rainwater and William L. Yancey, eds., *The Moynihan Report and the Politics of Controversy* (Cambridge, MA: MIT Press, 1967).

14. See Michele Wallace, *The Black Macho and the Myth of the Superwoman* (New York: Dial Press, 1979).

15. Tarlow, Weems interview.

16. An earlier version of Sekula's "Dismantling Modernism, Reinventing Documentary," titled "Reinventing Documentary," was published in 1976 in an exhibition catalogue of Fred Lonidier's *The Health and Safety Game* and Philip A. Steinmetz's *Somebody's*

Making a Mistake at the Long Beach Museum of Art in Long Beach, California. It was subsequently expanded and published in its present form in 1978 in *The Massachusetts Review* (see note 5). It has also been republished in Allan Sekula, *Photography Against the Grain: Essays and Photo Works, 1973–1983* (Halifax: The Press of Nova Scotia College of Art and Design, 1984), 53–76; and in Allan Sekula, *Dismal Science: Photo Works, 1972–1996* (Normal, IL: University Galleries, 1999), 117–138.

17. *Aerospace Folktales* was first exhibited at the University of California at San Diego in 1973. In 1974, it was exhibited at the Brand Library Art Center in Glendale, California. That same year, the commentary and six photographs from *Aerospace Folktales* were published in *Journal* 3 (1974): 34–38.

18. Allan Sekula, "Conversation between Allan Sekula and Benjamin H. D. Buchloch," in Allan Sekula, *Allan Sekula: Performance under Working Conditions*, ed. Sabine Breitwiser (Wien: Generali Foundation, 2003), 25.

19. Sekula, "Dismantling Modernism, Reinventing Documentary," 251.

20. Sekula, "Conversation between Allan Sekula and Benjamin H. D. Buchloch," 25.

21. Sekula, "Dismantling Modernism, Reinventing Documentary," 251.

22. Allan Sekula, introduction to *Photography Against the Grain*, xi.

23. Debra Risberg, "Imaginary Economies: An Interview with Allan Sekula," in Sekula, *Dismal Science*, 244.

24. Risberg, "Imaginary Economies," 224. The transcript for the audiotapes is reproduced in Sekula, *Dismal Science*, 96–115; as well as in Sekula, *Allan Sekula*, 136–161.

25. Sekula, "Dismantling Modernism, Reinventing Documentary," 236–237.

26. In Tarlow, Weems interview, Weems asserts that *Family Pictures and Stories* grew out of her own "desire to understand my experience in relation to my family and my family's experience in relation to black families in this country."

27. Susan Canning, "Carrie Mae Weems," interview, in *Interventions and Provocations: Conversations on Art, Culture, and Resistance*, ed. Glenn Harper (Albany: State University of New York Press, 1998), 58.

28. Ibid., 60.

29. Bey, Weems interview, 66.

30. Sekula, "Conversation between Allan Sekula and Benjamin H. D. Buchloch," 38.

31. Kobena Mercer, "Skin Head Sex Thing: Racial Difference and Homoerotic Imaginary," in *How Do I Look? Queer Film and Video* (Seattle: Bay Press, 1991), 181.

From Here I Saw What Happened and I Cried: **Carrie Mae Weems's Challenge to the Harvard Archive**

Yxta Maya Murray

Who owns the violent past? In the early 1990s, New York artist Carrie Mae Weems traveled to Harvard University's Peabody Museum of Archaeology and Ethnology to see some mysterious photographs. Entering into the archives, she first signed a contract promising not to use any Peabody images without permission. She next found herself staring down at the daguerreotype of a miserable, dignified, and stripped-naked woman named "Delia" who had been enslaved by white masters in 1800s South Carolina. This picture of Delia, as well as images of fifteen other enslaved people, had been commissioned from photographer J. T. Zealy by Harvard ethnologist and Museum of Comparative Zoology founder Louis Agassiz in the nineteenth century.

As Weems already knew from previous study, Agassiz's suite of pictures had been undertaken to prove his very own "son of Ham" theory of "separate creation." A proponent of "polygenesis," Agassiz imagined god had cooked up the races from entirely separate species, endowing some with masterful gifts and others with more servile talents. Agassiz illustrated his thesis with the aid of Dr. Robert W. Gibbes, a paleontologist who enjoyed close friendships with South Carolina slaveowners. Together, they hired Zealy to document enslaved people handpicked by Gibbes.[1] One portion of the suite showed the subjects full length and nude, and the second portion focused on their heads and torsos. The images were not publicized during Agassiz's time. After Charles Darwin's *The Origin of Species* trounced Agassiz's fantasies in 1859, he stored the pictures away.[2] Years later, Agassiz or his son Alexander donated

them and a trove of natural wonders to the museum. The daguerreo-
types remained in an attic of the Peabody until cataloguers rediscovered
them in 1976.[3]

Weems realized that in Agassiz she had discovered the Ivy League
equivalent of Josef Mengele or Harry Laughlin. Though she had
signed Harvard's restrictive contract, she unilaterally photographed
the daguerreotypes and included these copies in her 1995–1996 series
From Here I Saw What Happened and I Cried. Weems here displayed the
image of Delia, as well as other subjects that Agassiz's labels identi-
fied as "Jack," "Renty," and "Drana." She enlarged the images, shaped
them in the portrait "tondo" circular shape, and tinted them red. She
emblazoned Drana's profile image with the white boldface words "You
Became a Scientific Profile," Jack's with "An Anthropological Debate,"
Renty's with "A Negroid Type," and Delia's with "& A Photographic
Subject."

Weems then combined this quartet with twenty-nine other appro-
priated pictures, such as the famous *carte de visite* of a man's scourged
back and a snapshot showing expatriate chanteuse Josephine Baker in
a pensive mood.[4] Bracketing the series are two identical blue-toned
images of a Nubian woman, who faces the series as a witness. In all, the
text that marks the individual cells reads:

> From Here I Saw What Happened/You Became a Scientific
> Profile/A Negroid Type/An Anthropological Debate/& A Pho-
> tographic Subject/You Became Mammie/Mama, Mother &
> Then, Yes, Confidant—Ha/Descending the Throne You Became
> Footsoldier & Cook/House/Yard/Field/Kitchen/You Became
> Tom John & Clemens' Jim/Drivers/Riders & Men Of Letters/
> You Became a Whisper A Symbol of a Mighty Voyage & By The
> Sweat Of Your Brow You Laboured For Self Family & Others/For
> Your Names You Took Hope & Humble/Black and Tanned Your
> Whipped Wind of Change Howled Low Blowing Itself—Ha—
> Smack Into the Middle of Ellington's Orchestra Billie Heard It Too
> & Cried Strange Fruit Tears/Born With a Veil You Became Root
> Worker Juju Mama Voodoo Queen Hoodoo Doctor/Some Said
> You Were The Spitting Image of Evil/You Became A Playmate
> To The Patriarch/And Their Daughter/You Became An Accom-
> plice/You Became The Joker's Joke &/Anything But What You

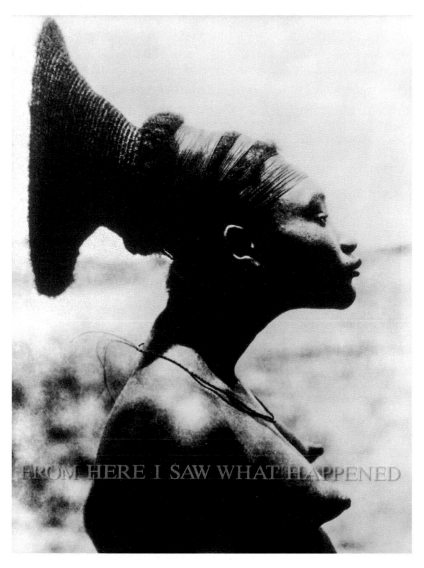

Carrie Mae Weems, *From Here I Saw What Happened . . .* , from the series *From Here I Saw What Happened and I Cried*, 1995–1996.
© Carrie Mae Weems. Courtesy of the artist and Jack Shainman Gallery, New York, NY.

Were Ha/Some Laughed Long & Hard & Loud/Others Said 'Only
Thing A Niggah Could Do Was Shine My Shoes'/You Became
Boots, Spades & Coons/Restless After The Longest Winter You
Marched & Marched & Marched/In Your Sing Song Prayer You
Asked Didn't My Lord Deliver Daniel?/And I Cried.

Perhaps predictably, Harvard threatened to sue Weems. Its admin-
istrators argued that it owned the copyright to the Agassiz daguerreo-
types and Weems had violated their contract. Weems later spoke about
the imbroglio as part of her contribution to the *Art in the Twenty-First
Century* program on compassion in 2009, confessing that she felt flab-
bergasted by Harvard's response: "I thought, Harvard's going to sue me
for using these images of Black people in their collection. The richest
university in the world." Weems spent considerable time "worrying
about it and thinking about it," and then issued a remarkable response.
"I think that I don't have really a legal case, but maybe I have a moral
case that [should] be . . . carr[ied] out in public," she told Harvard
University representatives. "I think that your suing me would be a
really good thing. You should. And we should have this conversation in
court." Weems won this fraught staring contest when Harvard eventu-
ally blinked. It now demanded payment whenever Weems reproduced
a cell, but then Harvard administrators also purchased her images for its
art museum. Weems called this result "confus[ing]."[5]

Harvard's oblique way of handling Weems seems half a concession,
and half noblesse oblige. It certainly doesn't answer the rights question
in copyright or contract law. Did Harvard actually own the copyrights
to a series of photographs made in 1850? And if it did, did the fair
use doctrine of the 1976 Copyright Act allow any leeway for Weems's
superior "moral case"? More fundamentally, did Harvard indeed own
the daguerreotypes, which would clinch their copyright and contract
claims? And if they did, should they own images of enslaved people that
Agassiz won through violent coercion? Or should we regard these relics
as cultural property belonging to African Americans, which should be
returned to the descendants of African-born enslaved people?

In this essay, I argue that images and objects that help us bear witness
to the United States' violent past deserve special treatment in copyright
and property law. I pay special attention to the relics of enslavement,
drawing inspiration from Weems's observant Nubian woman depicted

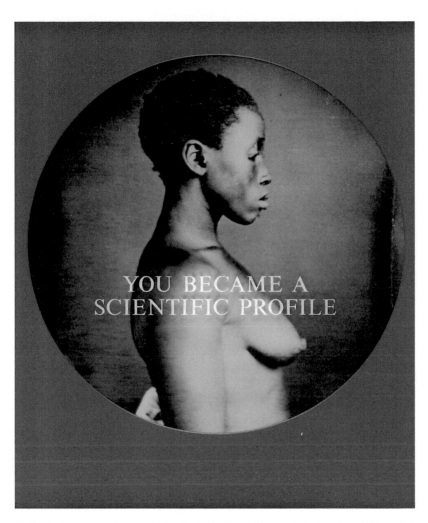

Carrie Mae Weems, *You Became A Scientific Profile, A Negroid Type, An Anthropological Debate, & A Photographic Subject*, from the series *From Here I Saw What Happened and I Cried*, 1995–1996. © Carrie Mae Weems. Courtesy of the artist and Jack Shainman Gallery, New York, NY.

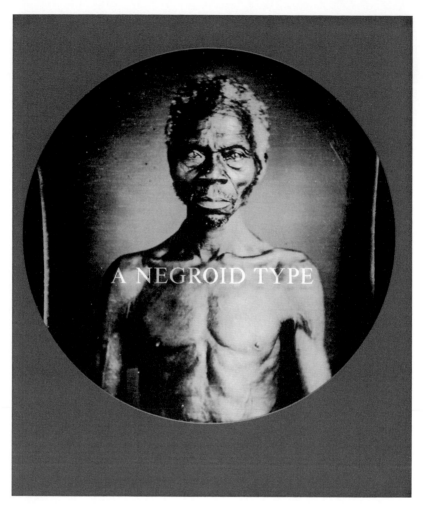

Carrie Mae Weems, *You Became A Scientific Profile, A Negroid Type, An Anthropological Debate, & A Photographic Subject*, from the series *From Here I Saw What Happened and I Cried*, 1995–1996. © Carrie Mae Weems. Courtesy of the artist and Jack Shainman Gallery, New York, NY.

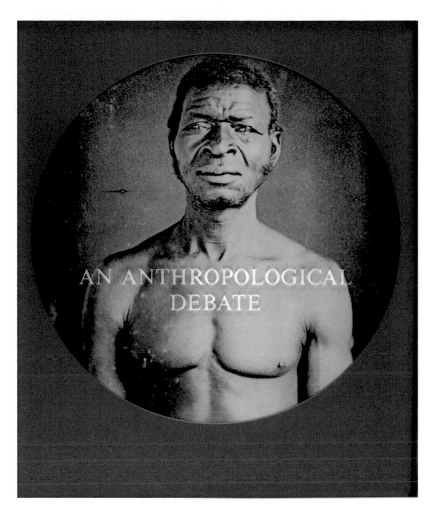

Carrie Mae Weems, *You Became A Scientific Profile, A Negroid Type, An Anthropological Debate, & A Photographic Subject*, from the series *From Here I Saw What Happened and I Cried*, 1995–1996. © Carrie Mae Weems. Courtesy of the artist and Jack Shainman Gallery, New York, NY.

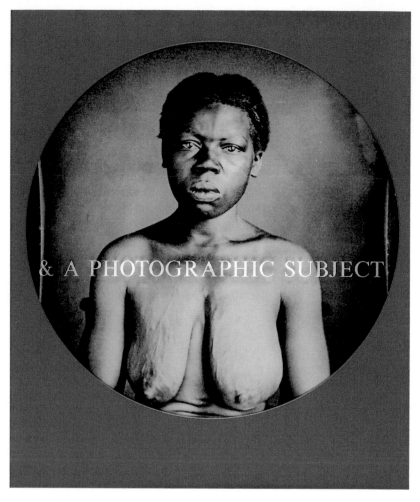

Carrie Mae Weems, *You Became A Scientific Profile, A Negroid Type, An Anthropological Debate, & A Photographic Subject*, from the series *From Here I Saw What Happened and I Cried*, 1995–1996. © Carrie Mae Weems. Courtesy of the artist and Jack Shainman Gallery, New York, NY.

in *From Here I Saw What Happened*. Her image prompts me to make the following case: Witnessing relics such as the Agassiz daguerreotypes give us rare opportunities to recall the history of slavery in the United States, and this exercise in memory can trigger peaceable transformations in our law and culture. In my continuing effort to energize a jurisprudence of nonviolence, I maintain that remembering atrocities like slavery is a necessary practice for evolving a more peaceable legal and social discourse.[6] This nonviolent objective will drive my analysis of Weems's art, as well as of the copyright law and property issues that punctuate the Weems case.

With respect to copyright law, I argue that the fair use doctrine should give broad permissions to artists who appropriate witnessing images and relics, particularly when such borrowings illuminate how the violent past informs contemporary political practices. The fair use doctrine pivots on whether an artist "transformed" a work that they appropriated. I show that artists who minimally alter relics of the violent past, but meaningfully showcase them, can transform our understanding of the works, as well as of our current society and laws. Specifically, I reveal how Weems's appropriation, when read in the context of her larger oeuvre, performs transformations in two related ways. First, Weems changes the daguerreotypes themselves through a kind of "observer effect," wherein her very act of witnessing the daguerreotypes transforms their meanings. Second, and relatedly, Weems's re-seeing of the daguerreotypes alters our comprehension of the modern world. It challenges our perceptions of social practices like de facto segregation and intelligence testing that now pass as legitimate, race-neutral, nonviolent, and legal conventions. Weems reveals that these customs trace back to past abuses that U.S. slaveholders once visited upon the bodies of African-born slaves. This brand of transformation—that is, the alteration of our comprehension of "race-neutral" conventions and legal practices—should qualify for fair use protection.

In the latter part of my essay I shift focus from copyright law to the underlying question of property ownership. Should Agassiz ever have been able to claim a right to these images? And, by extension, should Harvard? Agassiz pirated these images through capture and exploitation. But no legitimate law should recognize this violent taking of property rights. Allowing the Agassiz daguerreotypes to remain in Harvard's custody sustains a violent offense. As such, Harvard's ownership blinds

instead of bears witness to the violent past. In the interests of peace, the law should transfer the property to new hands: This would involve transforming the daguerreotypes' title from that of Harvard University to those who bear the closest lineal relationship to the subjects of the daguerreotypes, being Drana, Renty, Jack, and Delia. . . .

When it comes to the history of racial science, some of Weems's most adaptive sampling may be found in her watershed 1989–1990s series *Colored People*. This sequence consists of variously tinted portraits of African American boys, girls, men, and women. In its presentation of headshots of people of color, it riffs on photography innovators such as Francis Galton, the nineteenth-century eugenicist, Darwinist, fingerprint-science pioneer, founder of biometry (that is, the use of statistical techniques and body measurements to determine intelligence), and mug-shot inventor.[7] The connection between eugenics, photography, and Weems's tinted headshots may initially seem hazy, but at this stage Weems had begun working on appropriations and critiques of racist science that would find their apotheosis in *From Here I Saw What Happened and I Cried*.

Weems found much to comment on with photo-metrists like Galton. He had been elected to Britain's Royal Society of Geography in 1850 and soon thereafter explored South Africa.[8] Inspired by Georges Cuvier's 1815 dissection of Sarah Baartman, the original, doomed Hottentot Venus, Galton . . . encountered a second goddess on his journeys, and measured her every square inch with a sextant.[9] Back in Europe, Galton expanded on his practice of measuring people he believed resided on the lower reaches of the Great Chain of Being. . . . With the assistance of Paris's Surveyor-General of Prisons, he photographed convicts in close-up front view format, in the hopes of establishing certain physiognomic criminal traits, but in fact setting the precedent for booking photos now taken of arrestees.[10] . . . Galton and Agassiz both used types to gauge the moral and intellectual worth of white privileged people versus people of color and the white poor.

In *Colored People*, Weems borrows from Galton in her play with front and side profile close-up shots. The series consists of monochrome triptychs of repeated headshots of her subjects, some of which she titled *Burnt Orange Girl, Magenta Colored Girl, Blue Black Boy, Golden Yella Girl*, and *Violet Colored Girl*. The images are a beautifully tinted repurposing of Galton's grim forensic traditions. Their soft coloring and resolution

quotes daguerreotypes like Galton's, but rebut his brutal schemes by showing boys, girls, men and women in attitudes of contemplation, happiness, and melancholy. . . . Yet, as far as I can tell, Weems made her first direct appropriation of existing images when she encountered Agassiz's daguerreotypes.

The Getty Museum commissioned *From Here I Saw What Happened and I Cried* from Weems, asking her to react to the museum's 1995 show *Hidden Witness: African Americans in Early Photography*. *Hidden Witness* displayed images of African Americans from the 1840s through the 1860s owned by the Getty itself as well as a Detroit collector named Jackie Napoleon Wilson.[11] Weems assembled a presentation based on thirty images, which she tinted red (signifying the outrages evidenced by the appropriated, violent images) and blue (signaling the confessional thoughts of the bookending Nubian observer) and emblazoned with her texts. . . .

From Here I Saw What Happened and I Cried marks Weems's most direct confrontation with photography's history, particularly portraiture. A nineteenth-century subject either paid to sit for a portrait that would birth an admirable doppelganger—or would find herself trapped, snapped, and stuck like a specimen. "The real issue of photography of this period is that the sitter pays the photographer," Weems told a reporter at the time. "I began to imagine the people in a viable context, as real people living at a specific time whose lives had specific meaning."[12] Weems also invested the images with her longing, a state of mind that she has said drives her art.[13] As in her work with intimate portraiture and mug shot riffing, her act of sifting through history, emerging with a document, and putting her fingerprints on it achieves the twin goals of the artist: To make it new, and to promote feeling.

From Here I Saw What Happened and I Cried begins with the archival, rectangular image of the Nubian woman in profile. Tinted blue, she gazes on the lineage of thirty-one red-dyed pictures of African Americans from the 1850s through the 1950s or 60s. The series ends with a flipped image of the Nubian observer. As I've already stated, the Agassiz images inhabit the first four cells of the series, which hosts additional appropriated pictures that portray other enslaved people, as well as folks living under segregation.

The etched text that sprays across the images provides a volcanic accompaniment to this record of endurance and infamy. The series

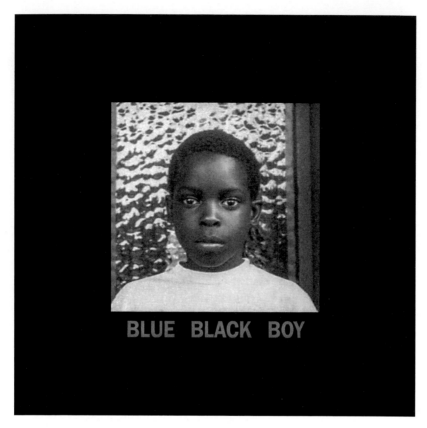

Carrie Mae Weems, *Blue Black Boy*, from the *Colored People* series, 1989–1990.
© Carrie Mae Weems. Courtesy of the artist and Jack Shainman Gallery, New York, NY.

From Here I Saw What Happened and I Cried brings the reader visions of an unmolested Black womanhood observing red-tinted crime. Men are forced to wear huge prosthetic lips. Men are whipped. Handsome women and men pose in their fine clothes while incriminations are slashed across their features. Here is proof that Josephine Baker wasn't always smiling. White people thought that it was funny to compare Black people to monkeys. People weathered life under segregation. In Weems's hands, these works bear witness to how these crimes actually happened. In so doing, they elicit an immense catharsis from the viewer. This emotional response encourages a view that the present moment remains haunted by those past crimes. It is a visual version

of William Faulkner's argument that "[t]he Past is never dead. It isn't even past."[14]

Along with *Colored People* and *From Here I Saw What Happened and I Cried*, Weems's 1997 *The Hottentot Venus* also figures in my analysis. This diptych shows black-framed images of the Parisian zoological garden where Cuvier displayed Sarah Baartman to inquisitive colleagues. The first cell shows a Victorian hothouse set amid leafy trees and manicured grasses. The second reveals a mansion with a pleasure garden ornamented by a beautifully oxidized bronze statue of a fawn. Beneath the images, elegant white script reads: "I passed Monsieur Cuvier; he fixed his gaze onto me; a sudden chill rose and the hairs on the nape of my neck stood on end, in defense, I touched myself, & fled."[15] Weems displays the existing site's evident civilization, and its elegant décor that harkens to "better times"; beneath it all, however, Baartman speaks to us, revealing the outrages committed there.

Though the diptych does not make use of borrowing like that found in *From Here I Saw What Happened and I Cried* or even the allusive *Colored People*, it does nod to heroizing nineteenth- and early twentieth-century landscape photography such as that of Eugène Atget and Édouard-Denis Baldus, who so romanticized Paris. Further, it demonstrates Weems's awareness of the interwoven history of racist science that she exposes in those series. Read in combination with *Colored People* and *The Hottentot Venus*, *From Here I Saw What Happened and I Cried* reveals how Agassiz encouraged a belief in a "scale of races"[16] that sought to "shape people according" to white supremacy's "wishes."[17] This *idée fixe* bled into culture, world politics, and law. It also inspired outrages by Galton, and led to atrocities such as that suffered by Drana, Renty, Delia, Jack, and Baartman.

Moreover, the works expand our consciousness beyond even these connections. Weems's art encourages a deep study of this history of violence, which teaches us that Agassiz had a vast, amazingly interlinked life story whose influence veers far beyond an isolated incident with Drana, Renty, Delia, and Jack. Agassiz was a Zelig of his day, and not only because of his dread-inspiring friendships with Ralph Waldo Emerson and Oliver Wendell Holmes. Cuvier—Sarah Baartman's dissectionist and Galton's role model[18]—was Agassiz's first professor of zoology and motivated his work on fish.[19] Morton, the head-hunter who taught Agassiz polygenesis, learned the theory from observations

made by Cuvier after his dismemberment of Baartman.[20] Agassiz further infiltrated European intellectual history through his relationship with Arnold Guyot. The Princeton geographer would leverage Agassiz's concepts of divine design, separate origins, and a horror of racial mixing into a theory of geography that influenced colonialism[21] and also segregation.[22]

Thus, Weems's appropriation of the Agassiz daguerreotypes is a hallmark of the liberatory, anti-racist, anti-sexist, and peaceable art and activism for which she is known. Her unilateral taking of the daguerreotypes, moreover, adds to the works' meaning. Her "theft" takes back what Agassiz, Morton, Cuvier, Guyot, Galton, and their ilk stole from African-born people and their descendants in the United States. Weems acknowledged as much when, responding to an interviewer's question about her use of the Agassiz images, she said:

> I wanted to uplift them out of their original context and make them into something more than they have been. To give them a different kind of status first and foremost, and to heighten their beauty and their pain and sadness, too, from the ordeal of being photographed.[23]

However, Weems's artistic integrity and provocative consciousness raising do not necessarily resolve the question of whether her taking proved legal. In the following analysis, I attend to the question of whether Harvard had good cause to threaten her, or whether Weems should have a fair use defense for this appropriation. I argue that her appropriation may find protection under cases that came after she made the series and faced down Harvard. Additionally, I contend that to the extent there remains an ambiguity, her witnessing of the violent past should be understood as transforming the daguerreotypes through the "observer effect." I also elaborate upon Weems's role in changing our understandings of modern customs, such as the segregation and intelligence testing that she reveals are rooted in racist science and Agassiz's brand of hysteria. This latter mode of transformation should further qualify her for protection under the fair use doctrine.

After that analysis, I turn to the underlying question of whether Harvard indeed owned the daguerreotypes such that it could lay claim to copyright and contract privileges. . . . Does Harvard own

the copyright to the Agassiz daguerreotypes? If it does, does Weems enjoy fair use defense of her appropriation? In the summer of 2012, I interviewed Dr. Pamela Gerardi, director of External Relations for the Peabody. I asked her for Harvard's version of the Weems story, and she quickly answered, with great forthrightness, that Harvard tried to block Weems's appropriation because the University "doe[sn't] want to be associated with exploitation . . . we would prefer not to be . . . I mean, would you?" As to the question of whether Harvard was in the right to so threaten Weems, Gerardi acknowledged that Harvard's copyright claim was "murky," as indeed it appears to be.[24]

Harvard's enjoyment of the copyright in the daguerreotypes encounters several obstacles, the first being whether Agassiz—and thus Harvard—ever owned the copyright in the first place. Recall that Agassiz commissioned the images in 1850, and that Dr. Robert Gibbes arranged a selection of enslaved people for Agassiz to examine; that Agassiz picked Drana, Delia, Renty, and Jack among others for the images, and then returned to Harvard; and that Gibbes hired J. T. Zealy to take the pictures.[25] Did Agassiz own the copyright to the images? Certainly, he did if the images were a "work for hire." . . . But I've encountered no hard evidence that Agassiz "hired" Gibbes. I have discovered no record of payment, though Gibbes did write Morton in 1850 that he had "just finished the daguerreotypes for Agassiz of native Africans of various tribes."[26] Still, the work for hire doctrine was not recognized until 1903, and only codified in the Copyright Act of 1909. Moreover, Congress did not extend copyright protection to photographs until 1865.[27]

Assuming that the copyright did belong to Agassiz, and that Agassiz or his heir transferred it to Harvard when his collection of "accumulated specimens" was purchased for Harvard University around 1858, or when Alexander Agassiz gave his father's property to the university in 1935, the question next becomes whether the duration of the right extended until the 1990s.[28] One problem is the lack of publication history, which I cannot find anywhere. Moreover, Harvard counsel refuses to enlighten me about this history.[29] If the images were published around 1850, the copyright would certainly have run out by the 1990s.[30] However, if the daguerreotypes malingered in the obscurity of the Peabody's attic until their discovery in 1976, then Harvard could have claimed sole copyright in the images until well into the 2000s.[31]

Even if we assume that the university owned the copyright, the baffling doctrine of fair use unsettles the question of its dominion over the Agassiz images. Harvard's claim here would have been that Weems violated its right to make derivative works. Weems would defend that her appropriation in *From Here I Saw What Happened and I Cried* constituted fair use. The fair use doctrine permits appropriation of the copyrighted work "for purposes such as criticism and comment," and courts determining whether the use is fair will consider "factors [that] shall include":

1) The purpose and character of the use, including whether the use is commercial or nonprofit and educational;

2) The nature of the copyrighted work;

3) The amount and substantiality of the portion used in relation to the work as a whole;

4) The effect of the use on the potential market of the copyrighted work.[32]

In the years directly preceding Weems' creation of *From Here I Saw What Happened and I Cried*, fair use's allowances looked miserly from the artist's perspective. . . . There is an urgent need for courts to set forth clear, liberal standards for appropriations, particularly as Weems forms part of a sisterhood of artists who study racism, sexism, and violence through takings that bear witness to a history of U.S. violence.

Current legal copyright scholarship that focuses on race, sexuality, poverty, and gender supports an argument that Weems fairly used the Agassiz daguerreotypes. Rebecca Tushnet, Laura A. Foster, Jennifer Rothman, Peter Yu, and Madhavi Sunder are just some of the theorists whose work combines intellectual property theory with politically progressive critiques.[33] . . . Together these theorists invest the fair use doctrine with progressive possibilities, which could help the case that Weems's taking fulfills a liberatory objective, and also recognizes inequalities. It is true that Tushnet's analysis of the fair use cases cautions that Weems's study of violence in *From Here I Saw What Happened and I Cried* may not qualify it as a worthwhile taking in the copyright

jurisprudence.[34] I advocate that to the anti-subordination, anti-racist, anti-homophobic, anti-poverty, and pro-feminist values advanced by copyright scholars, one other ethic should specifically be promoted: That of nonviolence. Artists who appropriate existing works in order to witness and showcase the violent past should be recognized by law as levying constructive social critiques that come within the fair use ambit.

We should boost our understandings of "transformation" in fair use beyond physical interventions in images or objects: Where an existing work is minimally altered, the "transformation" analysis should be recognized as encompassing transformations of social understandings, not just images or objects. And courts engaging with this enlarged conception of transformation should take care to give leeway to artists like Weems, whose transformations of our conceptions of race, history, law, and justice fulfill socially beneficial, peaceable objectives. . . .

The [preceding] analysis of *From Here I Saw What Happened and I Cried*, which is read in light of *Colored People*, *The Hottentot Venus*, and their revealed histories, shows that artists transform witnessing relics such as Agassiz's daguerreotypes by their simple act of re-looking at them. Where an artist—perhaps, particularly an artist of color—takes charge of unaltered documents that witness raced violence, she transfigures the document via a right-brained version of physicist Werner Heisenberg's "observer effect."[35] That is, she alters our understandings of the daguerreotypes by investing them with her point of view. Having seen them through her eyes, we cannot regard them the same way ever again. We discern them now as evidence of the violent past, as well as of forgotten cataclysms wrought by racist science and beliefs in Black "separateness" that we would like to believe have faded with time—but alas, as these works suggest (and as most of us already know), have not entirely.

As such, Weems's re-seeing of the Agassiz daguerreotypes transforms not only the images, but possibly even the violent, racist, and amnesiac contemporary world in which they exist.[36] . . . This brings me to my second argument, which concerns the conclusion I just made: Throughout this essay I have announced that Weems did, in fact, "take" and "appropriate" the daguerreotypes from Harvard, and that this taking should be legal.

But did they belong to Harvard? The assessment that Weems snatched the images from the school's grasp assumes that the daguerreotypes

indeed do qualify as university property. However, while engaging in my lengthy and bookish fair use analysis, I have been continually dogged by the sensation that this control should not be right. I am beset by the conviction that the copyright issue amounts to a red herring, and that Agassiz should never have owned these works. The question of ownership, of course, underlies the issues of not only copyright claims. It also supports the contract breach that Weems hazarded when she spirited away the daguerreotypes and copied them.

Harvard objected because she took their property without permission. But I think that there's an argument that Weems should have more right to the daguerreotypes than even this old, storied, and esteemed university that sheltered Agassiz so many years ago. . . . In other hands, the daguerreotypes would take on other meanings and readings. Weems's illegal transport of them foregrounds the agony, distrust, betrayal, and crime that birthed them. By making such huge copies, she also gives us an excellent opportunity to see them. But in Harvard's expensive halls, sighed over by connoisseurs, they become precious, peeped-at rarities instead of badges of murder, sexual assault, and shame. . . .

By owning these daguerreotypes, Harvard is changing them, as any owner changes any object. Their meaning grows obscured by inaccessibility and the fact that they remain owned by an institution that gave aid and comfort to the villain who commissioned them.

But does Harvard own them?

The contract that Carrie Mae Weems and I signed presumes that Harvard owns the daguerreotypes. And, certainly, if Harvard does own good title to the images, if not the copyright, then they could still contract with Weems for access to the pictures on their terms.[37] However, did Agassiz or his son pass on good title to Harvard such that it could threaten Weems in the early 1990s? If he did not, then the contract could be illusory.[38]

In an 1859 issue of the *Harvard Register*, one Julius H. Ward writes in homage to Agassiz, and describes the scientist as effectively thrusting a mountain of specimens and oddments at the university.[39] Were the daguerreotypes included in this hoard? It's possible that Agassiz just forgot the photos in one of Harvard's attics. If Agassiz wanted to keep his naked photos for himself, to gloat over in the shadowy nooks and crannies of the university, then that would not suffice for an *inter*

vivos or *gift mortis causa* (a gift that takes effect after death).[40] So, there's a possibility here that the daguerreotypes actually belong to Agassiz's heirs.[41] Indeed, Pat Kervick explained that she believed that Agassiz's son, Alexander, transferred the documents to Harvard in 1935.[42]

However, could Louis pass on title to Alexander? Depending on whether Agassiz paid Dr. Robert Gibbes for producing the daguerreotypes, maybe they belonged to him. And, also, since "work for hire" was not recognized until 1909, long after Agassiz died, then it's possible that the images belonged to the photographer, J. T. Zealy.

Still, let's assume Agassiz owned them under working legal principles, and that either independently, or via his son, he gave them to Harvard, which also enjoys dominion over them. If so, then, as noted above, Weems probably breached the contract. . . . Yet once we begin to question the chain of title of relics made as a result of the violent oppression of enslaved people, of course, we can begin to reconsider the entire nature of property ownership in this country.

Returning to the Agassiz daguerreotypes for the moment, we know from recorded history as well as Delia, Jack, Renty, and Drana's facial expressions that they "sat" for their portraits under a persistent threat of violence. If the subjects of the photographs did not consent to their portraits being taken, and race supremacists injured them and profited from the resulting images, then there is a problem with Agassiz's, and thus, Harvard's claim over them. Dr. Gerardi is correct: They are the fruits of slavery, battery, duress, and exploitation. How should we analyze this issue? Today, photographs taken of unwilling subjects may be barred from use in advertising or trade under a right of privacy[43] or a right of publicity.[44] North Carolina does not provide for rights of publicity, never mind post-mortem ones, though it does have a right of privacy that prohibits exploitation of people's photographs.[45] Agassiz and Harvard's use and occasional display of these research images conceivably would violate post-mortem tort rights of privacy . . . since the daguerreotypes were made without informed consent.[46]

But more is at stake here than an invasion of privacy. People committed serious crimes in the course of taking these photographs. Perhaps the better framing of the problem occurs as follows: If Agassiz and his cohorts wrested enslaved people's property from them through violence or the threat of violence, then the daguerreotypes are the proceeds of robbery.[47] We now regard the protection of one's image as an

outgrowth of property rights, and so this construction appears apt.[48] And, if the images cannot be separated from the pictures, as indeed they can't, then the daguerreotypes themselves are the fruits of taking through fear of force.[49]

Consequently, a commitment to nonviolence—or even common sense—militates that Harvard should not now own these objects. Further, once we start down this road, as I have shown, we may start to question and challenge the nature of all sorts of property claims, from those of museums' holdings of pretty quilts to the foundations of mighty Wall Street.

But under what legal doctrine could we transform legal title in properties made by enslaved people, driven by the concern that these properties are the fruits of illegal force? . . . A body of law now exists that creates certain rights to reclaim cultural artifacts taken via violent theft. Categorizing the Agassiz daguerreotypes and other slave-made artifacts as forms of protected cultural property could pave a path for redistributing assets torn from enslaved ancestors through violence. That is, rebranding artifacts like the Agassiz daguerreotypes as forms of cultural patrimony could reconfigure who owns the violent past. . . .

Carrie Mae Weems is to Harvard University as Darwin was to Agassiz. She is a force of radical transformation. Her challenge to the Harvard archive changed not only the Agassiz daguerreotypes that it protected, but in her broadcast of those images she also shifted our modern fathoming of race, intelligence, living arrangements, and property rights.

Her varieties of transformation—via the observer effect and this mutation of our modern comprehension of the world in which we live—should be recognized as activating a fair use defense in copyright law.

Perhaps more importantly, her acts of civil disobedience should spur us onto a reorganization of property rights. There is no good reason why Agassiz should ever have been able to claim these daguerreotypes. And so there remains no good reason for Harvard's ownership of these images of Jack, Delia, Drana, and Renty. The violent past should be recognized in modern property law, at the very least providing that relics made and left by enslaved people should be returned to their descendants. The national conversation that would ensue from this redistribution would, I hope, elicit peaceable if discomfiting witnessing

and conversation that could further transform our alienated, unequal nation.

Notes

1. See Brian Wallis, "Black Bodies, White Science: Louis Agassiz's Slave Daguerreotypes," *American Art* 9, no. 2 (Summer 1995): 42–45.

2. M. Susan Barger and William Blaine White, *The Daguerreotype: Nineteenth-Century Technology and Modern Science* (Washington, DC: Smithsonian Institution Press, 1991), 80–81.

3. Elinor Reichlin, "Faces of Slavery," *American Heritage Magazine* 28, no. 4 (June 1977), http://www.americanheritage.com/content/faces-slavery; also see Molly Rogers, *Delia's Tears: Race, Science, and Photography in Nineteenth-Century America* (New Haven, CT: Yale University Press, 2010), 5–7.

4. This image is of a man named Gordon, whose scars were documented by photographers William D. MacPherson and Mr. Oliver in 1863. Gordon's photograph was widely reproduced in the United States, serving both prurient and abolitionist interests. See Martin A. Berger, *Seeing Through Race: A Reinterpretation of Civil Rights Photography* (Berkeley, CA: University of California Press, 2011), 43.

5. Interview with Dr. Pamela Gerardi, director of External Relations for the Peabody, June 26, 2012. See also Weems's interview in the 2009 PBS documentary *Art in the Twenty-First Century*, season 5, http://www.art21.org/videos/segment-carrie-mae-weems-in-compassion, beginning at 2:10–14.

6. See, e.g., "A Jurisprudence of Nonviolence," *Connecticut Public Interest Law Journal* 9 (2009): 65–160; "The Pedagogy of Violence," *Southern California Interdisciplinary Law Journal* 20 (2011): 537–584.

7. James Franklin Crow, *Perspectives on Genetics: Anecdotal, Historical, and Critical Commentaries* (Madison: University of Wisconsin, 2000), 359.

8. Karl Pearson, ed., *The Life, Letters, and Labours of Francis Galton* (Cambridge: Cambridge University Press, 1914), 215.

9. Francis Galton, *The Narrative of an Explorer in Tropical South Africa* (London: John Murray, 1857), 87–88.

10. M. G. Bulmer, *Francis Galton: Pioneer of Heredity and Biometry* (Baltimore, MD: Johns Hopkins University, 2003), 34.

11. Suzanne Muchnic, "Going for a Gut Reaction: Outspoken African American Artist Carrie Mae Weems Could Be Expected to Provide a Hot Response to Historical Images of Blacks," *Los Angeles Times*, February 26, 1995.

12. Ibid.

13. Dawoud Bey, "Carrie Mae Weems," *BOMB*, no. 108 (Summer 2009): 63.

14. William Faulkner, *Requiem for a Nun* (New York: Vintage International, 2012), 73.

15. Debra S. Singer, "Reclaiming Venus: The Presence of Sarah Baartman in Contemporary Art," in *Black Venus 2010: They Called Her "Hottentot,"* edited by Deborah Willis (Philadelphia: Temple University, 2010), 92.

16. See James H. Read, "The Limits of Self-Reliance: Emerson, Slavery and Aboli-
tion" (paper presented at the annual meeting of the American Political Science Asso-
ciation, September 3–6, 2009), 4.

17. Oliver Wendell Holmes, *Mechanism in Thought and Morals: An Address with Notes and
Afterthoughts* (London: Sampson Low, 1871), 103.

18. See Pearson, *The Life, Letters, and Labours of Francis Galton*, 215.

19. Wallis, "Black Bodies, White Science," 41.

20. See Samuel George Morton, *Crania Americana: Or a Comparative View of the Skulls
of Various Aboriginal Nations* (Philadelphia: J. Dobson, 1839), 31.

21. See Arnold Guyot, *The Earth and Man: Lectures on Comparative Physical Geography
and Its Relation to the History of Mankind* (New York: Charles Scribner's Sons, 1906),
248.

22. On Agassiz's horror of racial mixing and Guyot's belief in pure noble races, see
Charles Frederick Holder, *Louis Agassiz: His Life and Work* (New York: G. P. Putnam's
Sons, 1893), xxi–xxii. On Guyot's influence on anti-miscegenationist thought, see
Donald William Weinig, *The Shaping of America: A Geographical Perspective on 500 Years
of History*, vol. 2 (New Haven, CT: Yale University Press, 1993), 191. On segregation
and its relationship to fears about racial romance and mixed-race children, see Renee
Christine Romano, *Race Mixing: Black-White Marriage in Postwar America* (Cambridge,
MA: Harvard University Press, 2003), 14.

23. Lisa Gail Collins, "Confronting Visual Evidence and the Imaging of Truth," in
Willis, *Black Venus 2010*, 81.

24. Interview with Dr. Pamela Gerardi, June 26, 2012.

25. Wallis, "Black Bodies, White Science," 42–45.

26. Ibid., 45.

27. For information about work for hire doctrine, see *Bleinstein v. Donaldson Lithograph-
ing Co.*, 188 U.S. 239 (1903); Copyright Act of 1909, ch. 320, 62, 35 Stat. 1075 (1909).
See also Jennifer Sutherland Lubinski, "The Work for Hire Doctrine under Com-
munity for Creative Non-Violence v. Reid: An Artist's Fair Weather Friend," *Catholic
University Law Review* 46, no. 6 (1996): 119 (citing *Bleinstein* and the Copyright Act).
For information on the Copyright Act of 1909, see Gregory Kent Laughlin, "Who
Owns the Copyright to Faculty-Created Web Sites?: The Work-for-Hire Doctrine's
Applicability to Internet Resources Created for Distance Learning and Traditional
Classroom Courses," *Boston College Law Review* 41 (2000): 549–565. For information
on copyright protection for photographs, see Christine Haight Farley, "The Lingering
Effects of Copyright's Response to the Invention of Photography," *University of Pitts-
burgh Law Review* 65, no. 3 (2004): 385 and 404 (citing the Copyright Act of 1865, ch.
126, 13 Stat. 540). Even so, Rebecca Tushnet questions whether there should be ample
copyright protection of photographs in "See Worth a Thousand Words: The Images of
Copyright Law," *Harvard Law Review* 125, no. 3 (2012): 45.

28. Julius H. Ward, "Louis Agassiz and His Friends," *The Harvard Register* 3, no. 13
(1881): 13.

29. Email from Diane Lopez, Harvard University general counsel, to Yxta Murray,
July 3, 2012, on file with author.

30. If the rights were obtained under the Copyright Act of 1790, then copyright protection for a publication from 1850 would have run out by 1878. See J. A. Lorengo, "What's Good for the Goose Is Good for the Gander: An Argument for the Consistent Interpretation of the Patent and Copyright Clause," *Journal of the Patent & Trademark Office Society* 85 (2003): 51, 53. If publication or registration occurred in or after 1909, then copyright could have expired as early as 1965; see David Nimmer, *Copyright: Sacred Text, Technology, and the DMCA* (The Hague; New York: Kluwer Law International, 2003), 62.

31. Elizabeth Townsend Gard, "January 1, 2003: The Birth of the Unpublished Public Domain and Its International Implications," *Cardozo Arts & Entertainment Law Journal* 24, no. 687 (2006): 689 (citing 17 U.S.C. 302 and 303(a) (2006)).

32. 17 U.S.C. § 106 (2006). Section 17 U.S.C. 101 defines derivative works as "a work based upon one or more preexisting works, such as a translation, musical arrangement, dramatization, fictionalization, motion picture version, sound recording, art reproduction, abridgment, condensation, or any other form in which a work may be recast, transformed, or adapted. A work consisting of editorial revisions, annotations, elaborations, or other modifications which, as a whole, represent an original work of authorship, is a 'derivative work.'" See also *Harper & Row, Publishers. v. Nation Enters.*, 471 U.S. 538, 547 (1985) (*Harper & Row II*).

33. See Rebecca Tushnet, "My Fair Ladies: Sex, Gender, and Fair Use in Copyright," *American University Journal of Gender, Social Policy & the Law* 15, no. 2 (2007): 287–290; Laura A. Foster, "Situating Feminism, Patent Law, and the Public Domain," *Columbia Journal of Gender and Law* 20, no. 262 (2011): 297; Jennifer E. Rothman, "Liberating Copyright: Thinking Beyond Free Speech," *Cornell Law Review* 95, no. 463 (2010): 513, 522; see Peter K. Yu, "Ten Common Questions about Intellectual Property and Human Rights," *Georgia State University Law Review* 23, no. 709 (2007): 719, and Peter K. Yu, "Reconceptualizing Intellectual Property Interests in a Human Rights Framework," *University of California-Davis Law Review* 40 (2007), 1039; Madhavi Sunder, "IP3," *Stanford Law Review* 59, no. 257 (2006): 333.

34. See Tushnet, "My Fair Ladies," 287–290. However, since the Agassiz daguerreotypes reveal men and women in the nude, perhaps this would cohere with the poisonous fair use doctrine documented by Tushnet. In my own correspondence with Professor Tushnet, she cautioned that a skeptical scholarly assessment of Weems's transformation of the Agassiz daguerreotypes under current doctrine could only exacerbate the problem of the fair use doctrine's opacity. She referred me to Patricia Aufderheide and Peter Jaszi's book *Reclaiming Fair Use: How to Put Balance Back in Copyright* (Chicago: University of Chicago, 2011), which issues a call for the development of expansive best practices that will allow people to "reclaim the constitutional and human rights they have as creators under copyright . . . and change both practice and policy." I acknowledge that a firm assertion that Weems's work did transform the Agassiz daguerreotypes would help nudge copyright law toward greater openness, but in the interest of seeing the pitfalls of the fair use doctrine and urging a new take on transformation, I here examine the possible legal claims of unfair use under current case law.

35. See Werner Heisenberg, *The Physical Principles of the Quantum Theory* (New York: Dover Publications, 1949), 3.

36. Legal scholars have often noted a historicism characteristic of both judicial and legislative endeavors. See, e.g., Tanya Washington, "Loving Grutter: Recognizing Race

in TransRacial Adoptions," *George Mason University Civil Rights Law Journal* 16, no. 1 (2005): 55n207. For additional citations on legal amnesia, see original publication.

37. See Robin J. Allan, "After Bridgeman: Copyright, Museums, and Public Domain Works of Art," *University of Pennsylvania Law Review* 155 (2007): 961, 980.

38. See *Black's Law Dictionary*, 9th ed., ed. Bryan A. Garner (St. Paul, MN: West Group, 2009), 370.

39. Julius H. Ward, "Louis Agassiz and His Friends," *The Harvard Register* 3 (1881): 14.

40. For one, it's possible that he did not "deliver" the daguerreotypes to the museum, a requirement for both types of gifts. See "Duryea v. Harvey," *Mass.* 183 (1903): 429, 433. See also "Fuss v. Fuss," *Mass.* 373 (1977): 445, 450.

41. See Marilyn Bailey Ogilvie, "Agassiz, Elizabeth Cary (1922–1907)," in *The Biographical Dictionary of Women in Science: Pioneering Lives from Ancient Times to the Mid-20th Century*, vol. 1, ed. Marilyn Bailey Ogilvie and Joy Dorothy Harvey (New York: Routledge, 2000), 12.

42. Conversation with Pat Kervick, October 12, 2012. See also email from Pat Kervick to Yxta Murray, October 19, 2012, on file with author; Rogers, *Delia's Tears*, 332n39 ("The daguerreotypes were transferred in 1935.")

43. The right of privacy was first recognized in *Pavesich v. New England Life*, 122 Ga. 190, 50 S.E. 68 (1905), a case that condemned the use of a photograph of the plaintiff in connection with a life insurance advertisement. See Edward J. Damich, "The Right of Personality: A Common-Law Basis for the Protection of the Moral Rights of Authors," *Georgia Law Review* 23 (1988): 79. See also *Molony v. Boy Comics Publishers,* 277 A.D. 166, 169 (1950) (Sections 50 and 51 of the New York Civil Rights law deemed to forbid the use of the name, portrait or picture of a living person, without his consent for advertising purposes, or for the purposes of trade); *Gill v. Curtis Publishing Co.,* 38 Cal. 2d 273, 277 (1952).

44. The right of publicity was first recognized in *Haelan Laboratories, Inc., v. Topps Chewing Gum, Inc.*, 202 F.2d 866 (2d Cir.), *cert. denied,* 346 U.S. 816 (1953). See Brandon Johansson, "Pause the Game: Are Video Game Producers Punting Away the Publicity Rights of Retired Athletes?," *Nevada Law Journal* 10 (2010), 784–786. The elements of a right of publicity claim are that there is an appropriation by the defendant that derives from the use of the plaintiff's name or likeness, that the appropriation must be for the defendant's use and benefit, and that there must be an appropriation of the plaintiff's name or likeness, though in California the appropriation is of the plaintiff's "identity." See William A. Drennan, "Wills, Trusts, Schaudenfreude, and the Wild, Wacky Right of Publicity: Exploring the Enforceability of Dead-Hand Restrictions," *Arkansas Law Review* 58 (2005): 43–70.

45. Rights of privacy cases in connection with uses of photographs are few and far between in North Carolina. It is worth noting that they have applied to the living. See *Flake v. Greensboro News*, 212 N.C. 780 (1938) (photograph published without consent in advertising a violation of right of privacy); *Barr v. Southern Bell Teephone and Telegraph Co..*, 13 N.C. App. 38 (1972).

46. See Jordan Paradise and Lori Andrews, "Tales from the Crypt: Scientific, Ethical, and Legal Considerations for Biohistorical Analysis of Deceased Historical Figures," *Temple Journal of Science, Technology & Environmental Law* 26 (2007): 233–283.

47. See Model Penal Code Section 222.1, defining "robbery" as a theft that includes the infliction of serious bodily injury on the victim, or where the defendant threatens the victim with such harm. Theft requires the taking of property. See MPC 223.2.

48. See, e.g., Paula B. Mayes, "Protection of a Persona, Image, and Likeness: The Emergence of the Right of Publicity," *Journal of the Patent & Trademark Office Society* 89 (2007): 819.

49. Ibid.

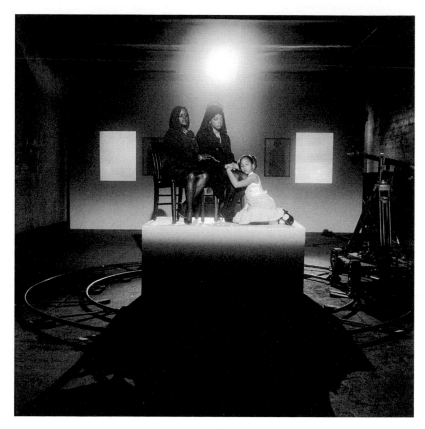

Carrie Mae Weems, *Mourning*, from the *Constructing History* series, 2008.
© Carrie Mae Weems. Courtesy of the artist and Jack Shainman Gallery, New York, NY.

Carrie Mae Weems

Dawoud Bey

In 1976 I had been making photographs for a couple of years. I had certainly been looking at a lot more photographs than I had actually made. From looking at photographs in books and magazines and going to exhibitions of pictures by Mike Disfarmer at MoMA, Richard Avedon at Marlborough, and haunting whatever other places there were to see photographs in New York in the early 1970s, I had begun to educate myself, with the intent of adding something to the conversation through my own pictures.

The artist Janet Henry, who was from the same Jamaica, Queens neighborhood that I lived in, had gotten a job in the Education Department at the Studio Museum in Harlem then located above a Kentucky Fried Chicken on 125th Street and Fifth Avenue in a large second-floor loft space. When Frank Stewart, the museum's staff photographer and photo teacher, left to do a commissioned project in Cuba, Janet called me and asked if I would take over the class. On the first day of class a few students straggled in. One of them, a seemingly shy woman with big expressive eyes, introduced herself. "Hi, my name is Carrie. Do you think I could be a photographer?" she asked, holding her Leica camera in her hand. That began what has now been thirty-three years of friendship and camaraderie with one of the most brilliant people I know.

From the very beginning, Carrie Mae Weems has had a sharp intelligence that was looking for a way into the world. From her early documentary photographs to the more expansive and materially varied recent works, she has consistently set out to visually define the world on

her own terms and to redefine for all of us the nature of the world we are in. After all these years I still anticipate her work with a fresh sense of wonderment, knowing that her restless search for the deeper meaning of things will yield a continuing rich trove of objects and images. On a Sunday morning in May I called from my home in Chicago to reconnect with my dear friend while she was traveling in Seville, Spain.

DAWOUD BEY: We're doing this interview while you're in Europe, and of course I'm wondering what you're working on there; I know you were in Rome previously, and now you're in Seville. What's going on over there?

CARRIE MAE WEEMS: When I first decided to return to Rome, I wanted to relax a little but because I was working very hard and I knew that I needed a mental *break* before I had a mental breakdown. I decided to leave the country and come to a place that I knew and felt comfortable in. I also wanted to finish some aspects of the work that I began in Rome in 2006. So I've been standing in front of all these monuments and palazzos, thinking about questions of power. I've stayed because I'm working on an exhibition here that opens in October, and wanted to see the space and start preparing the work for the exhibition and the catalog.

DB: Your work has had a very grand sweep since we first met in 1976. I would say you began in a kind of documentary mode, turning your camera on aspects of your surrounding world that allowed you to visually talk about the things that you were seeing and the things that had value or meaning for you. Your *Family Pictures and Stories* brought those observations closer to home in an autobiographical way and also began to shift through the introduction of a textual voice in your work. Since that work you have deployed a range of strategies in realizing your ideas. I'm wondering if you could go back for a minute and just talk briefly about where you were in 1976 when you had decided that the camera was going to be your voice. What influenced you and who were your models at that point?

CMW: We were young. *(Laughter.)* It's wonderful to have the benefit of hindsight. I think often about planning retrospectives—I've got one coming up this fall in Seville at the Contemporary and one at the Frist Center for Contemporary Art in Nashville in 2011. They give me the chance to look back over the work, over my history. The thing that surprises me most about the early work is that it's not particularly

Dawoud Bey, *Carrie Mae Weems*, 1976.
Courtesy of the artist and Stephen Daiter Gallery, Chicago.

Carrie Mae Weems, *Matera—Ancient Rome,* from the *Roaming* series, 2006.
© Carrie Mae Weems. Courtesy of the artist and Jack Shainman Gallery, New York, NY.

different from the work I'm making now. Of course I was trying to find a unique voice, but beyond that, from the very beginning, I've been interested in the idea of power and the consequences of power; relationships are made and articulated through power. Another thing that's interesting about the early work is that even though I've been engaged in the idea of autobiography, other ideas have been more important: the role of narrative, the social levels of humor, the deconstruction of documentary, the construction of history, the use of text, storytelling, performance, and the role of memory have all been more central to my thinking than autobiography. It's assumed that autobiography is key, because I so often use myself, my own experience—limited as it is at times—as the starting point. But I use myself simply as a vehicle for approaching the question of power, and following where it leads me to and through. It's never about me; it's always about something larger.

In *Family Pictures and Stories*, I was thinking not only of my family, but was trying to explore the movement of black families out of the South and into the North. My family becomes the representation vehicle that allows me to enter the larger discussion of race, class, and historical migration. So, the *Family* series operates in this way, as does the *Kitchen Table Series*. I use my own constructed image as a vehicle for questioning ideas about the role of tradition, the nature of family, monogamy, polygamy, relationships between men and women, between women and their children, and between women and other women—underscoring the critical problems and the possible resolves. In one way or another, my work endlessly explodes the limits of tradition. I'm determined to find new models to live by. Aren't you?

DB: Can you talk about some of the earlier relationships that shaped you? I know how important those early relationships were to my formation, and I think yours, too—to realize that there were indeed black people who were out there making this work. There had been black artists making work for a very long time, but of course they were largely invisible—we didn't know but maybe one or two. So to discover a whole community of them to whom we had access was just amazing. It was like, we're not invisible, there are others like us. We were in fact part of a long and rich tradition, and it's not merely located in the past.

CMW: It's fair to say that black folks operate under a cloud of invisibility— this too is part of the work, is indeed central to the work. The stuff

that I'm doing right now has so much to do with this notion of invisibility. Even in the midst of the great social changes we've experienced just in the last year with the election of Barack Obama, for the most part African Americans and our lives remain invisible. Black people are to be turned away from, not turned toward—we bear the mark of Cain. It's an aesthetic thing; blackness is an affront to the persistence of whiteness. It's the reason that so little has been done to stop genocide in Africa.

This invisibility—this erasure out of the complex history of our life and time—is the greatest source of my longing. As you know, I'm a woman who yearns, who longs for. This is the key to me and to the work, and something [that] is rarely discussed in reviews or essays, which I also find remarkably disappointing. That there are so few images of African American women circulating in popular culture or in fine art is disturbing; the pathology behind it is dangerous. I mean, we got a sistah in the White House, and yet mediated culture excludes us, denies us, erases us. But in the face of refusal, I insist on making work that includes us as part of the greater whole. Black experience is not really the main point; rather, complex, dimensional, human experience and social inclusion—even in the shit, muck, and mire—is the real point. This is evident in video works like *In Love and in Trouble*, *Make Someone Happy*, *Mayflowers*, and *Constructing History*. But again, these ideas are rarely discussed. Blackness seems to obliterate sound judgment, reason.

DB: There was a wonderful article in the *New York Times* two or three weeks ago about Mickalene Thomas and her work.

CMW: Right, I haven't read it but I keep hearing about it.

DB: There's a wonderful point where she talks about your work, and it being absolutely formative to her own sense that she could *do this*, that she could talk about what she wanted to through her work. Even though it's a second-hand kind of relationship, which is very different from the community in New York that we came out of, surrounded by people like Frank Stewart, Adger Cowans, Lorna Simpson, Shawn Walker, Beuford Smith, Tony Barboza. . . . I honestly don't know what I would have ended up doing in the absence of that community of support.

Carrie Mae Weems, *The Capture of Angela*, from the *Constructing History* series, 2008.
© Carrie Mae Weems. Courtesy of the artist and Jack Shainman Gallery, New York, NY.

CMW: It's been critical to have some of these artists as mentors and fellow travelers. My first encounter with black photographers was as an eighteen-year-old, when I saw the *Black Photographers Annual*. I remember standing in the middle of the floor flipping the pages, seeing images that just blew me away, like a bolt of lightning. I truly saw the possibility for myself—as both subject and artist. I knew that I would emulate what they had begun. Shawn Walker, Beuford Smith, Anthony Barboza, Ming Smith, Adger Cowans, and, certainly, the phenomenal Roy DeCarava. Of course, this comes back to you; because you were one of my first teachers. You too showed me the possibilities, showed me a path—I love you for it. But I also learned to *create* a path; finding

my own nuanced voice on that road toward self-definition, as well as defining/describing a people and our historical moment. Sometime in the early 1980s, traditional documentary was called into question, it was no longer the form; for my photographs to be credible, I needed to make a direct intervention, extend the form by playing with it, manipulating it, creating representations that appeared to be documents but were in fact staged. In the same breath I began incorporating text, using multiples images, dipytchs and triptychs, and constructing narratives.

DB: I'm also thinking about the Studio Museum in Harlem and the way in which that institution looms very large in this conversation. It's been there since 1976, and as I think about the artists who continue to come out of that institution, I can't imagine where else those artists would have emerged from in its absence. That was obviously the rationale for its existence; there was no other place that could have provided that extraordinary level of support.

CMW: The Studio Museum was *home* for us. Many of my most important relationships were formed there. Of course, meeting you was of singular importance in my life; meeting Ed Sherman, incredible. We're still in touch to this day. It was a place that offered opportunity, a place for engaged social dialogue, not just about photography, but around the arts in general. When I lived in San Francisco before moving permanently to New York, I would fly to events at the Studio Museum. I remember Michelle Wallace's talk on her book *Black Macho and the Myth of the Superwoman*: there must have been 500 people there, folks standing in the rafters. Debates went on for weeks after. It was a place not only for artists but for the black intelligentsia in the city. Now, Thelma Golden is there re-energizing the place. Listen, the Studio Museum is my home away from home. It's where I go to find out what's going on in African American—and *African*—culture and art. As much as we attempt to work in a number of other kinds of institutions, it's still the Studio Museum that first and foremost recognizes our contributions.

DB: I don't know if I've ever asked you this, but given that in 1976 you came to New York by way of California, what originally brought you to the Studio Museum community?

CMW: Even as a girl of fourteen, I knew I was going to live in New York. I'm from Portland, Oregon, which was a very small town not

long ago. It's changed tremendously in the last fifteen years. *I knew* that I was going to be an artist; what kind of artist, I didn't know, but I knew that my comfort would be found in the world of art. I came to New York when I was seventeen and turned eighteen with a big, fine gay boy who took me to see James Brown. But I was young and ill-formed for the city; I went back to San Francisco. My boyfriend gave me my first camera for my twenty-first birthday and it changed everything.

In the mid-1970s I started thinking about returning to New York, but I loved San Francisco, so I lived bi-coastally for a long time. I came to New York to figure out how to study and be connected to the art of photography. I had nobody to introduce me. It's possible that Jules Allen, who was also living in San Francisco, told me about the Studio Museum. I don't know how else I would have found out about it. As soon as I came back to New York in my early twenties, I went there to take classes.

DB: There are some things that I want to ask you that are more specific to your work. Things I haven't actually asked you but have thought about for some time. One has to do with an aspect of your work in which you are, conceptually, both in front of and behind the camera. You're the subject and you're the photographer. Certainly the earlier *Kitchen Table Series* introduced that idea quite forcefully. More recently there's a recurring figure that has been appearing in your work; what I would call a silent witness to history. This woman, although we can't always see her face, seems to be a kind of omnipotent presence, signaling perhaps that what she bears witness to is more highly charged than what we might think. She seems like a witness who, through *witnessing*, almost carries the weight of each place. This woman—this avatar—who is she? What's her function in relation to places and the narratives you're constructing?

CMW: I call her my muse—but it's safe to say that she's more than one thing. She's an alter-ego. *My* alter-ego, yes. But she has a very real function in my work life. I was in the Folklore program at UC Berkeley for three years, working with Alan Dundes on the strategy of participant/observer. I attempt to create in the work the simultaneous feeling of being *in it* and *of it*. I try to use the tension created between these different positions—I am both subject and object; performer and director.

I only recently realized that I've been acting/performing/observing in this way for years—the work told me.

The muse made her first appearance in *Kitchen Table*; this woman can stand in for me and for you; she can stand in for the audience, she leads you into history. She's a witness and a guide. She changes slightly, depending on location. For instance, she operates differently in Cuba and Louisiana than in Rome. She's shown me a great deal about the world and about myself, and I'm grateful to her. Carrying a tremendous burden, she is a black woman leading me through the trauma of history. I think it's very important that as a black woman she's engaged with the world around her; she's engaged with history, she's engaged with looking, with *being*. She's a guide into circumstances seldom seen.

Much of my current work centers on power and architecture. For instance, I find myself traveling to Seville, Rome, and Berlin. It's been implied that I have no place in Europe. I find the idea that I'm "out of place" shocking. There's a dynamic relationship between these places: the power of the state, the emotional manipulation of citizens through architectural means, the trauma of the war, genocide, the erasure of Jews, the slave coast, and the slave cabins. Here I can see an Egyptian obelisk in every major square, one riding on the back of Bernini's sculpture. The world met on the Mediterranean, not on the Mississippi—these things are linked in my mind. From here, Africa is just one giant step away. Spain is closer than Savannah, Rome closer than Rhode Island. Mark Antony lost his power languishing in the arms of Cleopatra; Mussolini established Italian colonies in Egypt; the Moors and Africans controlled the waters of Spain, leaving their mark in the Alhambra. Money was minted here, not in Maine. See what I mean? I'm not here to eat the pasta. I'm trying in my humble way to connect the dots, to confront history. Democracy and colonial expansion are rooted here. So I refuse the imposed limits. My girl, my muse, dares to show up as a guide, an engaged persona pointing toward the history of power. She's the unintended consequence of the Western imagination. It's essential that I do this work and it's essential that I do it with *my* body.

DB: How do you think about what the next piece of this conversation is as you construct this narrative?

CMW: I'm a woman who's engaged with the world. I feel as at home in Seville as in Spanish Harlem. *(Laughter.)* So I have these curious

interests. I'm walking down curious paths trying to connect the dots. For instance, in Seville I wanted to see some flamenco dancing. I jumped into a cab and the first music I heard was Cuban music. I've been thinking about flamenco for years because I have loved the form. In Spain, the gypsies are the greatest dancers of flamenco. It's more related to African dance and blues than the Spanish Cha-cha-cha. If I want to know something about the African influence on dance, then I need to know Mississippi and go to Cuba, Brazil, and Spain, because that's how you connect the dots. I can't connect them in my living room. So when I'm thinking about a project, I'm thinking about the dots; the way in which something starts small and radiates out to points of contact. If I can see things and understand them with my mind and body, I might be able to use them. It keeps me out in the world, even when I would prefer to be home, in bed and near my husband.

DB: What about form? There's the *how*, but there's also the *what*.

CMW: I think the *how* is the most difficult and rewarding. Sometimes my work needs to be photographic, sometimes it needs words, sometimes it needs to have a relationship to music, sometimes it needs to have all three and become a video projection. I feel more comfortable now without my muse. I've figured out a way of making pictures that suggests that something is being witnessed. The most recent work, *Constructing History*, does this.

DB: Over the years you've been particularly adept at not only merging ideas with an engaging material form, but [also] creating evolving material forms in the sense of process.

CMW: The work tells you what from it needs to take. What's important is knowing when to put your ego aside so you can see what the work wants to be. Being sensitive to the world around you and paying attention to your aesthetic tools. . . . Once you know that you can make it, you get out of the way. There's also economy of means. I'm not interested in stomping around the world with thirteen cameras, ten lenses, umbrellas and stands, and all that bullshit. I move around with an old beat-up camera, a fucked-up tripod, and as much film as I can carry. Then I just trust that I know what I'm doing with this little black box and that it's going to be okay. I *hate* the idea of spending $100,000 on a

bullshit photo shoot. It's so stupid. I believe in using economy—but not when buying shoes. *(Laughter.)*

DB: What have you seen in Seville that's made you smile recently?

CMW: This morning I was at Feria, a traditional fair that happens every year in Seville, and there were two little girls whose mother was pushing them in a stroller. They had on *crazy-ass* flamenco dresses. They were like three years old, wearing these *amazing* dresses—flowers and ribbons in their hair. Seville is a place where ideas about clothes, dress, presentation, sexuality, engagement, and tradition are so rooted. It was thrilling and lovely to see. I've been out and about, and, of course, keeping my ears open for music.

DB: Talking with you over the years, I've been acutely aware of a particular cultural wellspring of references that runs through your work and indeed through you, informing both the production of your work and the way you choose to be in the world. One of those strong references is music. A while back I was listening to the poet Quincy Troupe read his work and just as clear as day I was hearing John Coltrane, who Quincy later confirmed as a strong influence. I often hear music when I look at some of your work, too, and even when I hear you speak. So I'm wondering what role music plays in your personal life, your creative and intellectual life; how you have drawn from it?

CMW: Music has saved my life, more than once. Abbey Lincoln is my favorite, I listen to her music often. She sets the tone—she's a woman of yearning and of longing. Miles's forlorn trumpet sets the pace and Jason Moran carries the melodic line. Link Monk, I'm spinning, but hum along.

Photographic Incantations of the Visual

Kimberly Juanita Brown

The Body and the Ruin

Carrie Mae Weems's body represents a conflation of temporality and space, the afterimage of slavery, and the elongation of the residue of empire. History is carved into the flesh of rock and concrete, forming a cast out of which the figure emerges repeatedly. Yet, as she duplicates a singular corporeal form, she becomes multiple subjectivities, and her body is the only tether to an aesthetic and political framework doubling as a racial disavowal and a racial reiteration. She provides for the viewer an *archive of time* that at once prefigures future slaughter and conquest, and survives it. In this way her engagement with the body is a structural mandate, what Eduardo Cadava calls "the dialectical transfer between the Then and the Now," and the viewer receives the offering as a figurative temporal artifact, boldly straddling past and present, ethereal and material.[1]

Weems's series *Roaming* (2006) situates the photographer at the center of architectural structures that have drastically impacted the history of Western civilization. Her body, placed in the center of a series of buildings meant to connote the hyperpresence of constructed power, provides the linchpin that disturbs the existing narrative. In her haunting of the city of Rome and its outer areas, her complication of ritual and form into geometric patterns constructed out of concrete and stone, the artist reorganizes the visual imperative of race and body, preferring, it appears, a photographic ceasefire. With Weems's back turned

Carrie Mae Weems, *The Edge of Time—Ancient Rome*, from the *Roaming* series, 2006.
© Carrie Mae Weems. Courtesy of the artist and Jack Shainman Gallery, New York, NY.

Carrie Mae Weems, *In De Sica's Light*, from the *Roaming* series, 2006.
© Carrie Mae Weems. Courtesy of the artist and Jack Shainman Gallery, New York, NY.

away from the viewer as she faces disparate structures around the Italian capital, the viewer must enter the frame through her, or at least with her permission.

As this permission is granted, it becomes the task of the viewer to manage visual comportment, to complement the sovereignty of the eye with a concomitant negotiation, one that has at its center the machinations of sight (ocularity) and site (location). And so it is here that the artist interrogates the rigidity of the racialized body by continually repealing her corporeal frame in front of the viewer's resistant indexical understanding. This is an understanding that takes race and conquest as two interlocking modes of understanding form and extending the discourse of the corporeal. But in this body there is a muted dichotomy of volition, and a softened conflict of race and place. The structural sites are one of several ways to understand hegemony, to see it overwhelm a body and envelop that body in its undertow. "Spatial strengths and the spatial imaginary in black narratives and theory," according to Katherine McKittrick, "return the reader to important questions about the production of space."[2] In the production of space (or the artistic production over space) that Weems enacts, a different measure of mystery is invoked. And it is here, "in this place" (to quote Baby Suggs in Toni Morrison's *Beloved*), that the flesh of the landscape can be seen to contain the divergent inheritances of the past.

Ingrid Pollard, in her series *Pastoral Interlude* (1987–1988), engages explicitly with the divergent inheritance of empire, race, and conquest. She does so by subjecting her body to the iterations of the "this has been" that Roland Barthes reminds us exists in each photographic display. The "this" Pollard highlights forces the eye to contend with the uncomfortable nature of the photographer's self-stance in the face of the British Empire. She does not enact a refusal as the mechanism of her engagement. She stands against a constructed stone wall alone on the edge of an English countryside. Her body becomes the boundary marker she reinforces in the photograph, upright, rigid, and awkwardly integrated. The place she cannot go is into the countryside. Her unbelonging is marked and mediated, measured and delineated. A legacy of slavery has brought her to this present space, so that her body can signal an internal conflict. And so, as another of these images illustrates, she seems to have abandoned her quest altogether. Her form measures starkly against the foliage of the underbrush beneath her feet, and her

expression might be described as caught somewhere between introspective contemplation and a mournful fixation.[3]

The written narrative that accompanies both images is intended to further discomfort, to provide the lush landscape with violent intent.[4] What Ulrich Baer regards, in the context of Holocaust memory, landscape, and photography, as the "uncoupling of seeing and knowing" gestures toward the "deep doubts about the possibility and limitations of mastering past events by integrating them into an account of an individual's or a collective's path toward their present position."[5] Doubt renders Pollard's scene a racial extension of the interplay between an invisible imperial power and its colonized afterimage. What is left of the foliaged fecundity, clusters of leaves and grass, trees and branches, is the body of the other—frozen and still.[6] Even the remnants of a stone wall merge seamlessly with the plant life it borders, so much so that Pollard seems a conspicuous vertical line forming out of the wooden poles that frame her seated body. Head turned to her right and manually winding the film back into its canister with her back to a barbed-wired blockage, Pollard exacts a handheld reversal of the scene she has just offered the viewer. And landscape as ruin is enacted through this postcolonial body.

Within self-portraiture photography, the task of convincing a collective constituency of the subject's right to render the vicissitudes of her history a thing that is *seen* and therefore *known* falls to the image-maker herself, and the body she carries with her through the world. While I do not want to read self-portraiture photography as the ultimate solution to the problem of racial legibility and slavery's lingering effects, I would argue nonetheless that the pattern of enforced recognition (both subject and object) allows for a greater measure of visual mobility. That photographic self-portraits also offer an explicit engagement with the medium's historically negotiated framing, documentary, and stereotyping capacities begs the question inferred by the famous Rita Dove poem about Billie Holiday. To turn her statement into that question, then, *if you can't be free, can you still be a mystery?*[7] Black female photographic practices in a postmodern paradigm attest to the poem's conundrum in an inverted affirmative: Freedom is mystery. Mystery is freedom.

Mystery is what curtails black Atlantic subjectivity as it wrestles with the enormous burden of slavery. When the figure later known as Beloved makes her way to 124 Bluestone Road in Morrison's novel, she

is a vision of mystery. "Nobody saw her emerge or came accidentally by," we are told.[8] And when she is finally discovered by the residents of 124 Bluestone, "the rays of the sun struck her full in the face, so that when Sethe, Denver, and Paul D rounded the curve in the road all they saw was a black dress, two unlaced shoes below it," and the dog "Here Boy nowhere in sight."[9] From where this lovely stranger has emerged and why, no one knows. Paul D is curious but cautious. "He was about to ask her who her people were but thought better of it. A young colored woman drifting was drifting from ruin," and ruin is a state of being best traversed carefully.[10]

Claiming the expansiveness of the ruin as part and parcel of a mobile exterior life, Weems prefers the strictures of the built environment over landscape, and a bodily stance that arrives, enters, and highlights the constraints of race and gender over space. As Anne Cheng writes, "What it means to occupy space thus comes very close to what it means to be occupied. We are in fact confronting an implicit critique of modern architecture as monumentality and its implied project of self-mastery."[11] Using a reversed temporal order, Weems utilizes premodern structures to mark her body in the space of an intimate, even if that intimacy is, as Christina Sharpe might argue, "monstrous."[12] To suture the empire to the visibility that attends its formation, the subject containing the viewer's entrance into the framework of the corporeal produces the centralizing feature of this gesture photographically.

And yet when Weems uses her body to enter the Jewish ghetto on the outskirts of the "eternal city," she moves the viewer through the history of delineated force while restraining the double entendre of land and body she contains. The space is contending with itself, and she is engaging that battle. Her long black gown strongly resembles the liturgical cassock worn by Catholic priests.[13] Along with the repetition of her body within the historical location, her dress gestures toward an engendered gender transference that marks her body as a text unread and unfixed. If masculinity is defined as movement, and whiteness is rendered as entitlement, the figure transmits both that aura and that cadence. She moves through these spaces—indeed, she *roams*—and her purposelessness as well as her certainty set her apart. Although the diminutive size of the figure within the space calls the structures around her into astounding question, she is a figuration of unknown origin, and therefore not marked racially by the boundaries of this particularized

Carrie Mae Weems, *Jewish Ghetto—Ancient Rome,* from the *Roaming* series, 2006.
© Carrie Mae Weems. Courtesy of the artist and Jack Shainman Gallery, New York, NY.

hegemonic order.[14] "The photograph" Amelia Jones writes, "is a death-dealing apparatus in its capacity to fetishize and congeal time."[15] In her collapsing of temporal order, Weems appears as a death-dealer, as well as the specter encroaching on history's fissures and fixations. I do not mean here to argue that race can be postarticulated out of existence, that its ever-present force can become a negation of social and political order, but I believe Weems presents us with an opportunity, one

that envisions repetition as release. "Fine art photographers constructed ways to explore self-portraiture," Deborah Willis contends, "and ideas of beauty both in front of and behind the camera."[16] Of nineteenth-century white, middle-class respectability, Shawn Michelle Smith writes, "Photographs and especially photographic portraits function as particularly problematic objects . . . collapsing the already tenuous oppositional distance between subject and object, identity and commodity, owner and owned."[17] Weems probes the deep layering of this negotiation by utilizing the self-portrait that is also a self-commodity, and an engagement that is also disengagement.

The figure repeats this singular form in order to defamiliarize the racial dimension of imperialism from the body she uses to enact the space. This is a repetition that has served Weems well over the years as she has maneuvered between an overwhelming rigidity of black female representation and her artistic desire to be, particularly in her later works, both subject and object. Mining the deep field of counterinterpretation, her performance of both public and private spaces, of the interiority of a collective lived experience and its habitual iteration, secures for Weems the recognition of racial mimetic coding while parsing out its impossibility. "It's been implied that I have no place in Europe," Weems has said. "I find the idea that I'm 'out of place' shocking. There's a dynamic relationship between these places: the power of the state, the emotional manipulation of citizens through architectural means, the trauma of the war, genocide, the erasure of Jews, the slave coast, and the slave cabins."[18] Layering impact after impact of movement, decimation, subjection, and migration out of a hegemonic reordering, Weems reinforces this reordering through corporeal repetition and structural recognition.

Temporal *Roaming*

Weems has consistently tussled with slavery's corporeal embankment, its syncretized vision of the body's commodification, its balance of duality and division. Initially beginning her photographic process as a documentarian, Weems soon finds that the "evidentiary" offers her no true evidence, and the viewer's ability to fill the eye with culturally rehearsed semiotics of race and gender does nothing to release the body from the violence of the gaze. She then shifts her focus to narratives

of visual performance, attempting, it appears, a structure of corporeal refusal that also reclaims the body by chaining it to the architectural space. She has done this before.

The mysterious figure with her back against the viewer's entrance into the frame is, according to the photographer, her muse. For the viewer she is an escort and a guide, a silent witness and a body, unfixed and figured in the center of the frame, lending to the ambiguity the photograph depends upon. Architectural structures figure prominently in Weems's series *The Louisiana Project* (2003), commissioned by Tulane University's Newcomb Art Gallery to commemorate the bicentennial of the Louisiana Purchase. With this series, Weems uses the opportunity to haunt the present with the past and place her accidental and incidental body within the layered context of New Orleans slave history.

Highlighting literal construction alongside corporeal destabilization, the cover image envisions slavery's memory as a series of entrance points marked by known and unknowable possibilities. Though the ghostly/guiderly figure appears to pause before entering one such possibility, another lies beyond the door, a straight pathway to another spatial configuration. She enters alone, but her solitary stance at the center of the frame locks the viewer out of the experience, but within its witnessing. Amelia Jones writes, "Through the pose, then, and this is where the productive tension of self-portrait photography resides, the embodied subject is exposed as being a mask or screen, a site of projection and identification."[19] These performances engage in repetitions that are architectural and atmospheric, corporeal, gendered, and tethered to the landscape. They allude to collective traumas that are generational, diasporic, temporal, and unyielding. I want to end . . . by examining the possibilities embedded in the sight of a black woman moving across photographic time, through and beyond the demarcations of transatlantic slavery.

The Reversal of Space

Weems sits in full view of the former Chalmette Plantation, where the Battle of New Orleans was fought and Andrew Jackson's victory over the British solidified the Louisiana Purchase. Now known as the Malus-Beauregard House, this structure was built in 1833 on the ruins of the former plantation. Weems situates her body in a state of quiet

Carrie Mae Weems, *Approaching Time*, from *The Louisiana Project*, 2003.
© Carrie Mae Weems. Courtesy of the artist and Jack Shainman Gallery, New York, NY.

contemplation. The viewer is not meant to swiftly glide through the scene but to pause here and take in the enormity of all that passed before the landscape was reshaped. It is her body that privileges the past in a particular way, its impact on the spatial configuration she presents to the viewer. Removed from the contemporary scene, her body cannot haunt the space the way that her performative persona can. Subjecting the photograph to its divided lateral components, the image casts Weems as the shadow against which a national narrative is framed, the ghost in the machine of American memory, and the recalcitrant "body in the archive," to use Allan Sekula's terminology, that remains even after layers of reconfiguration flood the landscape.

There is something of the spirit photography of the nineteenth century at play here as well, the intersection of representation and creation fused into the compartments of collective pain. When Morrison spoke of writing her novel *Beloved* as a monument to slavery—where anyone could go to contemplate its enormous national weight—she literally created a ghost in the figure of the character Beloved, a woman of immense mystery who stands in for all those lost and without names. As Weems duplicates her body against slavery's most visible and enduring remains, the plantation loses something of its own mystery, tethered as it is to the perpetual unfreedom of others.

The racial containment of plantation sites, with their eerie proximity to the specificity of corporeal trauma and racial debasement, gives Weems a visual working definition of the index in its most strident form. The body she presents to the viewer is there to both witness and instruct, leading the eye into the framework of history's impact against specific people, and specific structures against individual histories. This explicit purposefulness enacts upon the space a near-totalizing harbinger of later haunting, allowing the architecture of that containment to centralize the thematic evocation of the scene as the scene of a crime.

If *The Louisiana Project* is meant to encapsulate the viewer through a series of reinforced passageways, tunnels through which race narrows the parameters of belonging, then the *Roaming* series is an overwrought treatise on power's expansive hold. Using the body's miniaturized form against massive structures connotes an understanding of domination that does not have to necessitate a racialized gaze. Standing at Western civilization's precipice, the figure maps the Western imperatives of conquest and imperialism with one word: more. Weems's video interview,

Carrie Mae Weems, *A Distant View (Malus-Beauregard House)*, from *The Louisiana Project*, 2003.
© Carrie Mae Weems. Courtesy of the artist and Jack Shainman Gallery, New York, NY.

aired on the PBS show *Art in the Twenty-First Century* (created by Art21) on October 7, 2009, situates the impetus of the photographer as global, mindful of the particularities of visual indentations, and attuned to the historical pertinence of the photographic eye. Featuring the established photographer's newest imagistic endeavors, this interview was part of *Art in the Twenty-First Century*'s themed episode "Compassion," in which Weems asserts, "I think that architecture . . . in its essence, much of the fabric of it, is very much about power. . . . You are always aware that you are a sort of, you know, minion in relationship to this . . . enormous edifice, the edifice of power."[20]

The "edifice of power," as the framing mechanism of Weems's photographic intent, is a way both to highlight a built totality of constructed infringement and to negotiate its dominance. Every edifice is permeable, with a way in and a way out. And the figure in the center of the frame is performing her body's release through the buildings that envelop her body, the texture of that enjambment. "What one is made to feel," Weems asserts, "is the power of the state in relationship to the lower subject." This "lower subject," while likely racialized in very particular ways, nonetheless inherits this position from below, from the underbelly of subjectivity, and it is incumbent upon the subject to negotiate the sight (site) and the measure of its temporal order.

Weems is most consistent when she invokes the subterfuge of mystery, when she enacts upon the viewer a puzzle that he or she must monitor and negotiate. "It is essential that I do this work," she has stated, "and it is essential that I do this work with my body."[21] Using her body as a way to open up a dialogue on the architectural modality that the power of the state implies, she makes the connection between race and power part and parcel of the unfortunate imperatives of the victors over the vanquished. "The visual culture surrounding the racialized female body," writes Anne Cheng, "understood to be one of the most pernicious examples of masculinist colonial imagination, also tells alternate stories about the intersection of power, shame, and exhibition."[22] This "telling" is the place to "locate these alternate stories by attending to the utterances left on the surfaces of black bodies and white buildings."[23] The echoes of a racialized haunting permeate every stone and concrete structure in every major city in Europe and throughout the Americas. What happens when photography and literature probe these interstices and tether the corporeal to the demarcations of the ocular

Carrie Mae Weems, *Untitled (Path to the Manor)*, from *The Louisiana Project*, 2003.
© Carrie Mae Weems. Courtesy of the artist and Jack Shainman Gallery, New York, NY.

that others have neglected? And what happens when all of it is slavery's afterlife?

With *Roaming,* Carrie Mae Weems has positioned her body with an eye toward the bifocality of sight and site. We see the structures the figure presents to us. We see them through her and with her body's permission. With the viewership tethered to the architectural space, we need her body to move us beyond the mandates of race and onto the expansive manipulations of structural power. This is the body offered and the gaze refused, facing a series of Italian structures in order to demarcate the elongation of empire over space, of bodies over time. She is the survival of conquest, prefiguring that survival. Repetitive, singular, and possessed of a purposeful saunter, it is the mystery of that sauntering that is meant to engage the eye and to extend the concept of temporality within and beyond death, ruin, haunting, slavery, gender, empire, and form.

Photographic Incantations of the Ocular

"The postmodern body," Linda Nochlin asserts, "is conceived of uniquely as the 'body-in-pieces': the very notion of a unified, unambiguously gendered subject is rendered suspect" by the artists attempting to bring postmodernity into focus.[24] Black women enter the frame photographically—as a collective body *always already* in pieces; their inability to unify a collective discourse only lengthens the measure of their malleability. "The past cannot be recovered," Saidiya Hartman writes, "yet the history of the captive emerges precisely at this site of loss and rupture."[25] Contained within the register of imagistic layering, the figure is allowed to retain a measure of that loss and rupture while performing a kind of covert exposure.

Photography affords a black female body a wealth of possibility mired in both the mystery and the subterfuge of slavery's resonance in the contemporary. It is "the lie that tells the truth," the secret of the frame, the marked terrain of the past, and the suspenseful dispensation of the future.[26] Because the frame has the ability to "remember everything" and preserve nothing, it disallows the viewer's inclination toward the "aversion of the eye," as Fred Moten articulates it through the photograph of Emmett Till. Fixed or malleable, black women's photographic bodies are the symbol within the referent, proof that what

Susan Sontag calls "the arbitrariness of photographic evidence" extends beyond the mechanisms of the eye.[27] That so many black Atlantic photographic processes of gender and race refuse full entrance into the frame, that they often deny the viewer the ocular possession they desire by inscribing the private space of a singular body with the public duplication of a layered contingency, is both curious and compelling. Maybe photography is an answer to a four-hundred-year conundrum: Can one envision the totality of slavery's traumatic legacy without leaving the collective body in pieces? How can one be seen without violence? Turn one's back? Refuse and include?

And what is a black woman's back in the context of slavery's resonance? In Lorna Simpson's hands, it reveals what the prostrated silence of John Edgar Wideman's black woman cannot. In *Corridor (phone)*, by centralizing the figure of focus and intention, Simpson tautly contains the enormous weight of history against the flesh, forcing the viewer to take in information he or she might ordinarily self-regulate, and making the subject the master of her own subjectivity.[28] This works especially well for Simpson, whose photographs routinely take away the viewer's expected enjoyment while leaving all pertinent information in place. The present and the past merge here, often with all of the varied nuances of time and delineation. "Unlike any other image," John Berger writes, "a photograph is not a rendering, an imitation or an interpretation of its subject, but actually a trace of it."[29] What can we trace here that does not avail itself to previous genres of embodiment? What is particular about black women's contemporary photographic insistences?

What, for instance, is in the sway of the subject's dress in Carrie Mae Weems's image? What is the fragment of the door in the frame that both faces the portrait in front of itself and also obscures it? Everything about the self-portrait is an embodiment of corporeal conflation—the layering of intimate and contingent relationships. The subject's body holds a secret, and yet in the spinning flow of the arms there is also a ballerina's singular controlled release—subverting everything we think we see. Sharp architectural lines divide the space but are also marked by the circular intentions of the room. You are being brought from one side of history clear through to the other. And she is refusing the gaze as well, purely on her own terms, but also keeping the viewer at a distance that comforts the subject, privileges the interiority of the *waltz*, and swaddles the frame.

Carrie Mae Weems, *A Single Waltz in Time*, from *The Louisiana Project*, 2003.
© Carrie Mae Weems. Courtesy of the artist and Jack Shainman Gallery, New York, NY.

Robyn Wiegman assures us that "while the visible must be understood as giving way to the authority of the invisible recesses of the body, to organs and functions, the full force of this production was nonetheless contingent on the status of an observer, whose relationship to the object under investigation was mediated and deepened by newly developed technologies for rendering the invisible visible."[30]

The quest for a centrality of visibility, a centrality of subjectivity repetitively embedded, places the photograph in direct linkage with a literary impetus framed in highly visual and often largely photographic terms. *Therein lies the difficulty in attempting to wrest black women from the trace of the corporeal. Where might they go without bringing the past along with them? Where might we let them go without our perception of their bodies' utility in an ocular world?* Much like the cadent repetition embedded in black Atlantic musical improvisation, cultural productions of the visual seek to reorient external expectations. Photography affords the body a wealth of possibility. With it memory—fragmented, fluid and malleable, rigid and still—situates the black female body as one photograph in a continually duplicating frame constantly looking back on itself. And within that space is the possibility of freedom.

Notes

1. Eduardo Cadava reinvigorates the discourse of Walter Benjamin's oeuvre within the context of ruination and melancholia. Eduardo Cadava, "Lapsis-Imaginis: The Image in Ruins," *October* 96 (2001): 38.

2. Katherine McKittrick, *Demonic Grounds: Black Women and the Cartographies of Struggle* (Minneapolis: University of Minnesota Press, 2006), 21.

3. *Pastoral Interlude* consists of five hand-tinted silver prints.

4. The text on the photograph reads: "It's as if the Black experience is only lived within an urban environment. I thought I liked the Lake District where I wandered lonely as a black face in a sea of white. A visit to the countryside is always accompanied by a feeling of unease, dread . . ."

5. Ulrich Baer, *Spectral Evidence: The Photography of Trauma* (Cambridge, MA: MIT Press, 2005), 88.

6. The body of the other is here displayed as distanced and displaced, isolated but strangely open to the uncomfortable invasion of the gaze.

7. Rita Dove's book of poetry *Grace Notes* (New York: Norton, 1989) contains the poem "Canary," which is dedicated to the poet Michael S. Harper. Farah Jasmine Griffin adapts this question as the title for her metabiography of Billie Holiday (*If You Can't Be Free, Be a Mystery: In Search of Billie Holiday* [New York: One World/Ballantine Books, 2003]). I think that for both Griffin and Dove, the cultural enigma that was

Billie Holiday is body, soul, voice, volition, drive, guts, and foul-mouthed determinism. In Dove's and Griffin's capable hands, she also was a woman who defied definition and was the epitome of mystery.

8. Toni Morrison, *Beloved* (New York: Penguin, 1987), 50.

9. Ibid., 51.

10. Ibid., 52.

11. In *Second Skin*, Anne Cheng uses Josephine Baker as symbol, referent, and icon in order to present a discourse of public and private spheres, bodies, and racialized dimensions of cities in the modernist aesthetic. Anne Anlin Cheng, *Second Skin: Josephine Baker and the Modern Surface* (New York: Oxford University Press, 2011), 57.

12. In Sharpe's articulation, it is precisely the interplay of proximity and flesh that often attends the denial of racial violence, offering up "everyday brutalities . . . made visible or masked." She aims, like Saidiya Hartman, to engage a discourse through visuality and therefore attendant to the temporal acceptance of our contemporary engagement with the past. Christina Sharpe, *Monstrous Intimacies: Making Post-Slavery Subjects* (Durham, NC: Duke University Press, 2010), 72.

13. I want to thank Paige McGinley for pointing out the significance of Weems as a solitary figure against a Roman landscape so often populated with priests-in-training traveling together.

14. For both Baudelaire and Benjamin, the *flâneur* participates in a subject position of experiential observation, able to embody a space by moving through it with little discernible purpose. I am purposely avoiding the term here, since I feel there is in the photographic endeavors of Black women artists a visual conflation juxtaposed in order to reproduce power on a massive scale. For an extensive reading of Baudelaire's and Benjamin's considerations of the sauntering figure in verse and image, see Beryl Schlossman, "The Night of the Poet: Baudelaire, Benjamin, and the Woman in the Street," *Modern Language Notes* 119, no. 5 (2004): 1013–1032.

15. Jones's landmark essay positions the structure of self-portraiture as one imbued with inalienable powers. Amelia Jones, "The Eternal Return: Self-Portraiture Photography as a Technology of Embodiment," *Signs: Journal of Women in Culture and Society* 27, no. 4 (Summer 2002): 949.

16. Deborah Willis, *Posing Beauty: African American Images from the 1890s to the Present* (New York: Norton, 2009), xxiii.

17. Writing about the convergence of race, gender, and class in nineteenth-century literary and visual narratives, Smith notes "the relationship between photography and women, and between the camera and women, was sexualized in the earliest popular discourses of photography." With Weems's refusal to be read in a highly sexualized way, her engagement requests an alternative relationship with the viewer while also highlighting Black women's always already sexualized relationship to photographic practices. Shawn Michelle Smith, *American Archives: Gender, Race, and Class in Visual Culture* (Princeton, NJ: Princeton University Press, 1999), 94–95.

18. Weems says in part, "I'm trying in my humble way to connect the dots, to confront history. Democracy and colonial expansion are rooted here. So I refuse the imposed limits. My girl, my muse, dares to show up as a guide, an engaged persona pointing toward the history of power. She's the unintended consequence of the Western imagination." See Dawoud Bey, "Carrie Mae Weems," *BOMB*, no. 108 (Summer 2009): 67.

19. Jones, "Eternal Return," 959.

20. *Art in the Twenty-First Century*, PBS, http://video.pbs.org/video/1281748949/, accessed July 4, 2010.

21. Bey, "Carrie Mae Weems."

22. Cheng, *Second Skin*, 166.

23. Ibid.

24. Linda Nochlin, *The Body in Pieces: The Fragment as a Metaphor of Modernity* (London: Thames and Hudson, 1994), 55.

25. Saidiya V. Hartman, *Scenes of Subjection: Terror, Slavery and Self-Making in Nineteenth-Century America* (New York: Oxford University Press, 1997), 74.

26. "Art is the lie that makes us realize truth" is a quote attributed to Pablo Picasso.

27. Susan Sontag, *On Photography* (New York: Delta, 1973), 80.

28. Lorna Simpson's *Corridor (phone)* was published in the original version of this chapter.

29. John Berger, *About Looking* (New York: Pantheon, 1980), 50.

30. Robyn Wiegman, *American Anatomies: Theorizing Race and Gender* (Durham, NC: Duke University Press, 1995), 31.

The Wandering Gaze of Carrie Mae Weems's *The Louisiana Project*

Gwendolyn DuBois Shaw

In 2003, the Newcomb Art Gallery at Tulane University commissioned Carrie Mae Weems (b. 1953) to create a work in response to the impending bicentennial of the Louisiana Purchase.[1] Consisting of more than seventy separate photographs and screen prints, a video, and a live performance by the artist at its debut, *The Louisiana Project* examines both the distant past of slaveholding, antebellum Louisiana, and the state's recent present, characterized by economic crisis and racial segregation. *The Louisiana Project* takes as its starting point the ubiquitous New Orleans festival Mardi Gras and the parades and balls associated with the all-white Krewes of Comus, Momus, and Rex—the oldest of the thirty-odd groups who parade through the streets during the annual celebration of Carnival that precedes the Lenten season. *The Louisiana Project* juxtaposes the secrecy that surrounds the Rex Ball, an exclusive event attended by members of New Orleans's white upper class, and the not-so-secret sexual liaisons had by the male scions of these elite families with African American women from the adjacent community of the *gens du coleur* throughout the nineteenth and twentieth centuries.

In *The Louisiana Project*, Weems continues an artistic practice of reinterpreting the facts of history by placing her own body within its extant detritus. In many of the photographs that comprise the project, the artist stands with her back to the camera in front of an architectural edifice, amid a rural landscape, or within a domestic interior. She wears period clothing: a plain, long-sleeved dress that falls to the floor, evoking the daily wear of working-class women in the nineteenth century.

In other photographs, in which her body faces the camera, she wears masks and men's tuxedos. Susan Cahan observes in the catalogue for the project that "Weems's focus on masking and facades underscores the notion that social hierarchies result from a differential in relations of power, not birthright."[2] The masks, costumes, and choice to turn away from the camera prompt a reconsideration of the physical presence of history. This essay will argue that by turning her back to the viewer, Weems also engages a long history of visual obfuscation associated with the sublime, a history that may be most powerfully seen in the Caspar David Friedrich (1774–1840) painting *Wanderer above the Sea of Fog* (c. 1817).

Wanderer above the Sea of Fog pictures the figure of a romantic wanderer at the top of a craggy peak somewhere in Saxony or Bohemia, looking out over a landscape that is shrouded in mist. With his back turned to the viewer, not only is his identity concealed, but his expression is as well. Is he delighted with the vista or horrified and aghast? His confident pose, with his left foot planted firmly on the penultimate step of the peak and his right side braced with a walking stick, makes him appear unaffected by the strong wind that briskly blows his blond hair to one side. There is little indication of a vertiginous instability, only a sense of mastery despite the seeming insignificance of the lone walker himself.

Like Friedrich's wanderer, we do not have to *see* through Weems to know what she is seeing. Instead we can see *through* Weems. Weems prompts us to reconsider our understanding of domestic spaces and architecture as we gaze upon a photograph of her sitting on the grass before a Greek Revival–style plantation home. "Who lived here?" "Who looked out of these windows?" "Who walked these halls?" "Who died here?" "Whom did they love?" "What fate befell them?" This process of what I term a "re-membering" of history through Weems's body and gaze indicts the landscape and the buildings that populate as key players in multiple histories.[3] By seeing *through* Weems as she moves through space, time, and place, we are privy to visions both real and ethereal. And in these pictures, we see a place that is on the edge of expiration and yet struggles valiantly to hold its own decay at bay.

In his 2004 book *The Landscape of History: How Historians Map the Past*, John Gaddis ruminates on Friedrich's *Wanderer above the Sea of Fog*, using the painting and its sole figure as a metaphor for the way

Carrie Mae Weems, *Missing Link (Happiness)*, from *The Louisiana Project*, 2003.
© Carrie Mae Weems. Courtesy of the artist and Jack Shainman Gallery, New York, NY.

Caspar David Friedrich, *Wanderer above the Sea of Fog*, c. 1817. Oil on canvas, 94.8 × 74.8 cm. Hamburger Kunsthalle, on permanent loan from the Foundation for the Promotion of the Hamburg Art Collections, Hamburg. Photo: Elke Walford, courtesy of Art Resource, NY.

that we as historians can only represent the past by portraying it as a near or distant landscape. "We can perceive shapes through the fog and mist, we can speculate as to their significance, and sometimes we can even agree amongst ourselves as to what these are," argues Gaddis. "We pride ourselves on not trying to predict the future, as our colleagues in economics, sociology, and political science attempt to do. We resist letting contemporary concerns influence us—the term 'presentism,' among historians, is no compliment. We advance bravely into the future with our eyes fixed firmly on the past: the image we present to the world is, to put it bluntly, that of a rear end."[4] In *The Louisiana Project*, Weems shows us her backside in order to emphasize her own privilege as the primary holder of vision.

Here, Weems is the revenant among the exteriors and interiors of Greek Revival plantation homes; the disremembered specter standing on a stretch of deserted railroad or traversing above-ground tombs; standing still akin to the figure in the Friedrich painting *Wanderer above the Sea of Fog*, she is always poised on the brink, having come to a sublime vista just a bit too late to find it at its peak. She makes us a witness to the landscape around her. Here, Louisiana has become the object of her gaze; a gaze that reads different visions than those seen by others, apocryphal visions. Through her wandering gaze we encounter a landscape that is oddly predictive, one that in its mix of pasts juxtaposes the slowly evanescing Greek Revival architecture of the 1840s with the decrepit expanse of a mid-twentieth-century public housing project (a sort of postbellum slave quarters). In its poignant repetition of condition, the landscape of *The Louisiana Project* is profoundly prescient in nature.

A key component of the installation is a video that intercuts television footage from 2003 of Rex, the King of Mardi Gras, dancing with his queen at the Rex Ball, with a shadow drama of characters dressed in eighteenth-century clothes engaging each other in a silhouetted tableau of domesticity, masquerade, and sexual domination. Mardi Gras marks the annual outing of rituals that are both creative and destructive, defining and mystifying, a world in which things are turned on their head on purpose; a world in which transgression is constantly rewarded so long as it follows tradition. By providing the viewer with an "other" way to see Mardi Gras, and the parades of Rex, Endymion, Orpheus, Zulu, and Bacchus, Weems remembers a new Carnival through the

age-old tradition of topsy-turvy. Mikhail Bahktin describes this tradition as practiced in pre-Enlightenment Europe as a social institution through which the "temporary suspension of all hierarchic distinctions and barriers among men . . . and of the prohibitions of usual life" was the rule.[5] For Bakhtin, "carnivalesque," the term used to describe the kind of behavior displayed during these periods, is both the description of a historical phenomenon, the activities that took place during the great medieval carnivals of Europe, and the designation for specific literary tendencies, as well as a relation to our understanding of the physically grotesque. Bakhtin viewed such raucous festivities as regulated moments in time when the social authority of the secular and religious authorities was suspended at least momentarily for the ascendance of licensed transgression. Such communally sanctioned, and essentially participatory, festivals of the grotesque and fantastic allow participants to move beyond a regular membership within a crowd to become part of a whole. In this way, to participate in Carnival, and in the case of New Orleans to attend the parades of Mardi Gras, is to become a part of a collective; a collective in transgression. Within Carnival, asserts Bakhtin, "[A]ll were considered equal. . . . Here, in the town square, a special form of free and familiar contact reigned among people who were usually divided by the barriers of caste, property, profession, and age."[6] Carnival, and its progeny, the Mardi Gras of New Orleans, both construct and deconstruct the social rules that govern transgression and trauma.

The visual drama of Weems's video is accompanied by an audio track of the artist's voice slowly reciting a detailed poem of remembrance. The combination of audio and video work to conjure up a world of faded majesty remembered beneath a veneer of deceit that evokes Louisiana's complicated and uneasy mythic legacy of race and gender. Weems has inserted herself as a real and figurative witness to the romantic tales that we tell ourselves about slavery and interracial sexuality in the Creole South: tales about the voodoo priestess Marie Laveau and Labelle's "Creole Lady Marmalade," tales that veil the legacy of enslavement and the conflicting truths about interracial sexual liaisons in the eighteenth and nineteenth centuries.[7]

Of all the myriad elements of *The Louisiana Project*, it is Weems's solitary Friedrichian wanderer and the physical constancy of the landscape in which she moves—a landscape that is as much a constructed

character as the ones that Weems creates and embodies—that hold the pain of the past and the possibility of a future. I argue strongly for the project's prescience, for its ability to help us envision the future through visions of the past, and for its oracular gift to see the reflexive nature of the present in relation to history. *The Louisiana Project* transforms Weems's body into a vehicle through which we are made to *see*, and at other times a body that we are made to see *through*. This task of specular transcendence is accomplished through images that posit the artist's physical presence in the picture plane as a momentary and yet ever-present imprint upon time and space, so that representations of many pasts and recent futures can be seen from multiple perspectives. In this way, her body and the landscape in which she moves are made to hold the past and the pain of our individual and collective trauma of enslavement, as well as the historical blindness that has affected our understanding of the past, present, and possible futures of Louisiana, and especially New Orleans, just two years later, following the traumatic experience of Hurricane Katrina.

To experience *The Louisiana Project*, in which Weems constantly positions herself as a witness to both past and future histories, is to be confronted by one's own position as a viewer and to acknowledge the ever-present power of the gaze and the perpetual struggle by women artists, in their work and in their persons, to control it. Much of Weems's work during the past three decades has been about controlling the gaze, from the *Kitchen Table Series* of 1990—in which we are asked to virtually join the artist and her models at one end of a table as silent witnesses to dramatic domestic events that unfold over a series of photographs—to the *Jefferson Suite* from 2001, where our spectatorial presence is elided and rechanneled as we consider the ramifications of genetic research in relation to race, ethics, and morality as well as the American judicial system.

In order to control both the narrative and the gaze, Weems enters her own work through a process of self-objectification. In the *Jefferson Suite*, we see the artist in several guises, but most strikingly in the role of Sally Hemings, the enslaved consort of our third president, Thomas Jefferson. In the *Jefferson Suite*, Weems served as her own model, a role that she has frequently inhabited in her work. Alternately dressed as Hemings and also undressed as an example of a genetic topos, Weems functions as focalizer for a visual tale of sexual attraction, political

intrigue, and social deception that leads the viewer from the eighteenth century through to the 1998 revelation of the Jefferson DNA study that scientifically demonstrated the connections between the black Hemings and the white Jefferson families. Weems collapses time and space in the *Jefferson Suite* and rechannels the authority of voice into the body of one whose enslavement had imposed a loud silence in history. By juxtaposing this staged photograph with a more natural one of our forty-second president, William Jefferson Clinton, and his much younger mistress, White House intern Monica Lewinsky, Weems encourages our gaze to wander across a historical legacy of unequal power relations and sexual attraction that span more than two hundred years of American history. In *The Louisiana Project*, Weems continues the practice of inserting herself into a truly apocryphal version of history. In this way, Weems mobilizes what I call a "wandering gaze."

As an art-historical theory of spectatorship, the gaze has its origins in film theory and the work of Laura Mulvey. Mulvey's 1975 essay "Visual Pleasure and the Narrative Cinema" introduced the gaze as a theory of gendered, spectatorial differences in popular twentieth-century film that help to explain the ways that men and women view the world and each other on screen.[8] Mulvey asks that we imagine a darkened movie theater in which every member of the audience has their eyes locked on the screen. All vision follows the cone of light that travels from one side of the theater to the other, from the projection booth to the screen. In this scenario, Mulvey places an active male viewer seated in the theater and a female image on the screen. It is a kind of perennial geometry through which male vision consumes the female image. In the past thirty-plus years, much has been written to dispute Mulvey's argument that cinematic vision is posited as male and heterosexual. Feminist film scholars including B. Ruby Rich, Teresa de Lauretis, and Linda Williams have since argued that the relationship of female viewers to the screen image is less patriarchal and more dialectical.[9] They argue that the female viewer retains more agency through a selective filtering process. Williams encourages a questioning of "the orthodoxies of a classical spectatorship without abandoning the fundamental [importance of] the spectators who gaze at [film], glance at it, or avert their eyes from it."[10] Rich pushes back a bit more firmly against the dominance of gaze-based Lacanian psychoanalytic feminist film criticism, charging it with an unblinking ahistoricity that fails

to account for "the key determinants of context, audience, or even aesthetic fashion."[11] Similarly, de Lauretis argues the importance of "engaging all of the codes of cinema . . . to articulate the conditions and forms of vision for another social subject" as a way to broaden the possibilities for the "production and counterproduction of social vision."[12] The idea that the only person who could be interpolated into the subject of the gaze, the primary person who could be called forth to be the "gazer," if you will, would be a man whose sexualized vision would contain the female object on the screen in an unequal power relation, is simply not tenable when you begin to think about the multiplicity of points of vision that are possible in a contemporary, expanded viewing environment. Simply put, there are multiple points of view. Weems's wandering gaze allows multiple individuals to occupy the position of power as the holder of the gaze, regardless of gender identity, sexual orientation, or race.

With the wandering gaze, we can allow ourselves the freedom to move into an expanded field of vision. If we begin to conceive of visual art as unbound narrative, we can read images as connecting not only to a past, but also a present, and a future as well. In this way, we begin to see how a multifold increase in the diversity of vision would inform the interpretation of the moment of viewing in more complicated ways than those provided for by the simple assumption of a uniform, heterogeneous, white world; a world in which the ability of class, ethnicity, and education to separate whites from one another is ignored and sublimated beneath a brittle veneer of pink-skinned sameness.

The wandering gaze allows us to step inside the skin of Friedrich's omniscient white viewer, who, above the mists, commands the landscape below him. We are aware of our own significance, standing astride the peaks of history, and our utter insignificance as one of many who has risen to consciousness only to fall. We not only dominate our field of vision, but we also falter in its sublimity, which proves to diminish our standing. What is offered by an expansion into the wandering gaze is an ever-more inclusive theory of vision in which myriad spectators, regardless of race, gender identity, or sexual orientation, can be the empowered agents of their own pleasure and (I would argue) their own pain, experiencing vision as an ever-widening field of subjective choice and experience. In this way, multiple identifications are possible.

Increasingly, we are better able to grasp the association of power with various raced and gendered positions in society and see how a multifold increase in the diversity of vision would inform the interpretation of the moment of viewing in more complicated ways and allow for multiple identifications.

And it is this type of viewing, that of gazing back at the past from the perspective of the present, that *The Louisiana Project* opens for its audience. Weems's photographs push us to recognize that you can see *through* me and you can see through *me*, regardless of my original position or yours. After all, all forms of knowledge are channeled through our experience as individuals within specific cultural moments; as the artist allows his or her work to move out into the world, it is constantly (re)interpreted through each individual act of viewing.

The photographs of *The Louisiana Project*, rather than being the result of a single visualization, present multiple visualities. In this expanded visual and temporal field we begin to see that in *The Louisiana Project*, vision is embodied in the wandering gaze as an intervention into the meta-narrative, creating a number of differing histories beyond the present and into the past and into the ever-present, yet ever-changing, landscape. However, such an approach requires that the viewer not be lured into the notion that Weems the narrator is the same person as Weems the model, for these images and those she has created previously in the *Kitchen Table Series* or the *Jefferson Suite* are not unbidden snapshots or autobiographical records, but instead are staged images in which the artist has assumed a role that is of her own conception and creation. It is not Carrie Mae Weems the narrator who stands in the doorway of a Greek Revival plantation house with her back to the camera. *That* Weems stands outside the photograph, in the role of what Mieke Bal would call the visual focalizer, initiating and directing vision into the distance.[13] We are view-pointed *by* her, *to* her, and *through* her, and we see the land beyond the building. She is the intercessor through whom we come to know the landscape of the past in a new and different way.

Through the wandering gaze of *The Louisiana Project*, we are able to see the relation of trauma to the visualization of memory, and the act of forgetting or refusing to see in relation to our irrevocable separation from the Lacanian notion of the real.[14] To view *The Louisiana Project* is to see the (un)dead New Orleans of the past, a world that is no more

and yet resists erasure through the reassurance of ritual. *The Louisiana Project* creates a space for the dramatization of individual and collective memory, a space in which personal and communal trauma is shared. Through these multiple points of focalization that Weems's wandering gaze marshals, viewers become open to the multiple narratives that are possible within the spaces of her address. Domestic architecture is no longer home so much as it is place, a place in which reanimated bodies move though a landscape and architecture that is eternal and ever changing, enacting relationships that are predicated on social structures at once remote and yet wholly familiar. It is the scene of the crime, and Weems's presence in it is as much accusation as it is reflection. As our wandering gaze is focalized through that of Weems, we see New Orleans as a matrix of communities afloat in the wake of an antebellum history of enslavement, a postbellum product of segregation, and, in the contemporary moment, a city still marked by post-Katrina displacement, creative resurrection, and creeping gentrification. To view and re-view *The Louisiana Project* is to see the future through visions of the past, and through this oracular gift, to see the ever-reflexive nature of the present in relation to the past.

The act of prescient reconstruction and stitching back together of the past, affected by Weems's wandering gaze, brings into focus terrestrial revenants to cloud our vision like the mists before Friedrich's wanderer. In the absences, in the vacated landscapes that endure both before and beyond, we may reflect on the roles we ourselves have played in the past, in the present, and in the future.

Notes

1. Carrie M. Weems, Susan Cahan, and Pamela R. Metzger, *The Louisiana Project* (New Orleans: Newcomb Art Gallery, Tulane University, 2004).

2. Susan Cahan, "Carrie Mae Weems Reflecting Louisiana," in Weems, Cahan, and Metzger, *The Louisiana Project*, 7–16.

3. I have argued elsewhere, most extensively in *Seeing the Unspeakable: The Art of Kara Walker* (Durham, NC: Duke University Press, 2004), for a type of transgressive, creative artistic practice that repositions and "remembers" the authoritative voice of history. In this way, artists such as Walker and Weems remove the dominant narrative from its position of mastery by "remembering" it via a privileging of alternative facts and experiences taken from a subaltern position and location. In this practice of reinterpretation, memories are formed and reformed, revealing purposefully or actively "disremembered" histories. My use of the terms "remember" and "disremember" are

taken from Toni Morrison's novel *Beloved* (New York: Alfred A. Knopf, 1987), in which the protagonist uses them to describe strategies for psychological survival following the traumas of enslavement.

4. John Lewis Gaddis, *The Landscape of History: How Historians Map the Past* (Oxford: Oxford University Press, 2002), 2–3.

5. Mikhail Bakhtin, *Rabelais and His World*, trans. Hélène Iswolsky (Bloomington: University of Indiana Press, 1984), 15.

6. Bakhtin, *Rabelais and His World*, 10.

7. For more on the woman known as Marie Laveau, see Martha Ward, *Voodoo Queen: The Spirited Lives of Marie Laveau* (Jackson: University Press of Mississippi, 2004). The song "Lady Marmalade," about a Creole prostitute, was written by Bob Crewe and Kenny Nolan in 1974 for the group Eleventh Hour. It was later popularized by the group Labelle, featuring Patti Labelle.

8. Laura Mulvey, "Visual Pleasure and Narrative Cinema," *Screen* 16, no. 3 (Autumn 1975): 6–18.

9. See B. Ruby Rich, *Chick Flicks: Theories and Memories of the Feminist Film Movement* (Durham, NC: Duke University Press, 1998); Teresa de Lauretis, *Figures of Resistance: Essays in Feminist Theory*, ed. Patricia White (Urbana, IL: University of Illinois Press, 2007); and Linda Williams, *Viewing Positions: Ways of Seeing Film* (New Brunswick, NJ: Rutgers University Press, 1995).

10. Williams, *Viewing Positions*, 4.

11. Rich, *Chick Flicks*, 292.

12. De Lauretis, *Figures of Resistance*, 34.

13. W. Bronzwaer, "Mieke Bal's Concept of Focalization: A Critical Note," *Poetics Today* 2, no. 2 (1981): 193–201, http://www.jstor.org/stable/1772197, accessed March 16, 2018.

14. For Jacques Lacan, our relationship to a natural state, a state of the real, is lost once we enter into the practice of language. For more, see Tom Eyers, *Lacan and the Concept of the Real* (Houndmills, Basingstoke, Hampshire, UK: Palgrave MacMillan, 2012).

Public Forum: "Pictures and Progress"

Carrie Mae Weems, Sarah Elizabeth Lewis, José Rivera,
and Jeremy McCarter

As part of the Public Forum series at the Public Theater in New York City, this April 7, 2014, panel discussion begins with a reading by Sarah Elizabeth Lewis of a chapter on Frederick Douglass from her book *The Rise: Creativity, the Gift of Failure, and the Search for Mastery* (2014). This is an excerpt from an edited version of that reading and of the conversation between Lewis, Carrie Mae Weems, and José Rivera, moderated by Jeremy McCarter, which followed.

CARRIE MAE WEEMS: I think what artists do and what people who care about things do is to stretch towards the truth, and the truth is a complex thing with many shades and contours, and that's the thing that we find powerful and engaging and moving. Something that gets us closer to what we understand in the deepest parts of our self to be true about what we see in the world, in relationship to ourselves. And I think that's also the deciding factor in a way—that none of this is universal. It's all very, very specific, which is the reason that you can experience something very, very differently than I do, depending on your background, your understanding, who you are, what memories you have. All of those things are really playing into what we come to understand to be beautiful, what we understand to be true, what we understand to be powerful, what we understand to be transformative.

And I want to say one other thing about this. Yesterday I spent a lot of time reading lots of things. I was looking at something about art

and money, because I'm always interested in art and money. I was just at a conference at Yale about economics and the arts, about the nature of investing. It was very interesting. So I'm reading lots of different things, and I stumble on a website that is looking at how the collections at the Detroit Museum of Art are being currently assessed for their value, because art might finally have to save the city. This is really fascinating. Art might have to save the city. About a year ago, the Charles Wright Museum of African American History was built, designed by the same person who designed the Holocaust Museum in Washington, DC. So I'm reading along, and the title of the blog was *Things That Black People Don't Like*, and I thought "Oh, this is interesting, let me read this." So I start reading this text and it was a group of people writing about the benefit of finally getting rid of the Detroit Museum of Art because who needed those Matisses, and who needed Rembrandt, and who needed Degas? It was also this racist spin on the Charles Wright Museum as one of the writers ended with: "We'll get rid of Magritte, we'll get rid of Rembrandt, and then we can go to the Charles Wright Museum where nothing has been produced of value and we can look at photographs of poor black people." Here is that idea of who is looking. We come to Degas, we come to Rembrandt, we come to these notions of what is powerful, what is beautiful, what is true, what is transformative, and there's a whole group of people on the other side of that thinking that art actually has no value. They are further away from themselves than anyone can imagine, at least I can imagine. But there is a huge force in the world that operates in that way, and so what we're up against as artists, as seekers of dynamic truths, we're up against incredible forces, an incredible tide. Our dear brother Frederick Douglass recognized that we would be up against a huge tide of opposition, even as you attempt to speak truth and beauty to power.

SARAH ELIZABETH LEWIS: I've said so much already about Douglass, but what I would add, what I don't think we remember or focus on enough, and Carrie's alluding to this point, is the context in which Douglass was speaking at the time. The Democratic Party, when it wasn't the Democratic Party that we know now, was trying to make an argument that African Americans didn't deserve universal suffrage because they/ we didn't have an appreciation for pictures, for art. He was trying to undercut that argument by talking about the amount of images that

"disfigure" our dwellings, he said. So no matter how much we say we need our Degases, we need our Matisses, there's still this undercurrent tied up with the argument about who is human and how human you can be if you don't appreciate art. I wonder if Douglass was partially overstating the case to drive that point home.

I want to go back to this idea about beauty. The reason I use the term "aesthetic force" is to emphasize how the arts impact our hearts and minds and maybe even souls, we hope. This dynamic doesn't have to do with this kind of Kantian view about beauty. It's not so much about a normative sense of what is beautiful. I think the reason why I'm in the field that I'm in, the reason I wake up every day, is because I want to be able to give a platform for and give honor to those who are changing the world, not necessarily by beautiful means, but by means that impact us. It is not just in the Civil War; it is a nineteenth-century idea, but we are living it out through the Arab Spring, through revolutions. In some ways beauty becomes sidelined in this discussion, and we end up instead with "impact."

CMW: I think that's what beauty is actually—profound impact. It's not just a vague notion, but it's really what love is. It's this moment of illumination, a moment of clarity when something allows you to see yourself far more deeply than you would in any other way or through any other means. When I say that I love you, I'm actually thanking you for the grace, I'm thanking you for the illumination, I'm thanking you for the experience of being able to see me differently than I had ever seen myself before. I think that's a really wonderful idea. I think beauty "functions," if we can use that term, in very much the same way.

These ideas about how we as artists use this idea, going back to Sarah's book (*The Rise: Creativity, the Gift of Failure, and the Search for Mastery*, 2014) and beyond Douglass, I think that there's something really powerful about it. I'm very interested in this idea of the rise and the near win and was wondering for instance for you, José, as a writer who deals with this subject area, what are your near misses? What are your near wins? What are your failures and how do you get up and over them?

JOSÉ RIVERA: They often all feel like failures. They are never quite the ideal image that you started out with as you created and you wrote. I love what you said earlier about the connection between art and love.

Sometimes you think, coming from a Catholic religious family, that God created the earth and heaven in seven days, but he left a lot out. He left out poetry, he left out the symphony, he left out the novel, he left out Frederick Douglass. Our jobs are in a way to finish creation, to finish the things that were begun and the seeds that were planted. I once wrote a children's play. God had created the world, and he created rabbits, and the rabbits are looking at a sunset and they're asking "where's my carrot, where's my food?" And God realized there was no one there to appreciate the sunset, so he created an artist, and the artist said about the sunset, "wow that's beautiful." And I think that's what we do. We go around and we say "wow that's beautiful." In relationship to what love is, we say "wow, I am worthy of love. Wow, I understand what love is because your poem helped me frame it." Or "the notes on your clarinet made me feel how I feel when I am in love." I do think that the aesthetic force you talk about is in a way the force of finishing creation, or at least evolving creation to the next level, because when I see a beautiful work of art, when I see a beautiful film for instance, or play, I am so grateful to be part of the species that made that.

CMW: But there are these moments, when you are working, when I'm working, and I know when it has all come together. Whether it's a sentence, or a photograph, you've been working all day and you know when you've just hit it. You talk about aesthetic force—you know when it's right and all you can do is get up and walk around the room.

JR: And then you say, "that will never happen again."

CMW: And you start to use other artists, other sounds, other entities to get you there. When I'm about to seriously work on something I go to Toni Morrison first, or I go to Louis Armstrong, "Stardust Memories," and I listen to that all day long, or Abbey Lincoln, the same song all day long. Do you know what I mean? There are these sounds that begin to create spaces of habitation for you to live in, and I think that is the way in which we are really moved by and embrace other artists, other writers, other thinkers around us. We are not floating out here as individuals on our own, we are in context. I think that it's really important to think about the way in which we are in context with one another, how we aid one another, how we shore up one another. And that's what I think really powerful art is. It really lives way, way, way beyond the

artists that create it, which is why it's usually much deeper than we are, more important than we are.

JEREMY MCCARTER: I want to leave a few minutes at the end for questions, but something I read in the paper this morning, you might have read it too, it got me thinking. There's a new and controversial figure in the art world. George W. Bush is devoting hours a day, every day, to painting. People are not quite sure if we should take this seriously or not, or what to make of the fact that this man is now attempting to do the things that we've been talking about. He's trying to find some kind of beauty, he's trying to capture the world as he sees it, he's trying to share something of his soul. What do you make of this?

CMW: Well, it's his near miss. No, no, just joking. I think in some form or fashion, we are all just trying to deal with being human and to understand what that is. So I don't have to agree with him politically in order to understand that he has a right to make and to be. I don't have to like it. I don't like a lot of things, but that's ok. He has a right. I think it's absolutely important to have a sense that we all have the right to express the complexity of ourselves, that we are all just trying, really at the end of the day, to be human.

JR: Yeah, what can I say. I maybe would feel better if he was painting a bombed-out building in Iraq, or if he were painting an orphan child who was made destitute by the war. I would love if he were actually examining the consequences of his decisions and his actions through art. I think that would be kind of powerful and beautiful. If he's going to make glorified, idealized images of himself, that's where I would have a problem. I agree with what you just said, let the man be human and see what he does. I'd rather have him paint than drop bombs.

SEL: The one thing I would add, the bravery, actually. How many of you would show me your paintings? There's a bravery involved that makes me feel badly when we mock it, to be frank. I think there's a courageousness involved in showing what he must know are maybe deliberate amateur works, and I actually feel a bit that it's a shame for making fun of that. Because regardless of what I think of him politically, I believe in some ways that it's fitting to end a discussion about Douglass with Bush, because here Douglass was also taking photographs, and there's a book coming out from Norton about what he did

photographically. I wouldn't want to judge the work that he was doing, but honor the impulse. That's what's interesting to me, that there's an irrepressible impulse to show what Bush thought Putin looked like, regardless of how many images we see of Putin, that his view of the world is something that he wants to explore, and show as complex, shifting and changing. That to me is a human impulse that I think we're celebrating.

JM: Well said. So we have a few minutes left to take some questions from the audience. . . .

AUDIENCE: In response to the last comment, I do feel that art matters. Art matters in what's beautiful, it matters in terms of what we have to say, but it's not all neutral. In fact, right now we're dominated by a revolting culture, just an absolutely revolting and disgusting culture. And there are bright spots in it, and they're on the stage. I just saw the exhibit at the Guggenheim of Carrie Mae Weems's work. It's beautiful, but it's on display with futurism, much of which, whatever you may think about it aesthetically, was a misogynist, anti-women, and eventually fascist form of art that created a great deal of harm and legitimated a great deal of harm. The question here is something I want Carrie to go a little further on. She was talking about how the meaning of art, the content of art, is, to put it this way, historically conditioned. I'd like you talk a little bit about it because I think it's really important for us to understand that it's not just timeless, it actually has meaning, and it's a question of who it's for and what it serves.

CMW: In a way, I think you've answered your own question. I'm showing in a museum. I'm not showing in a gallery, I'm not showing in a narrow space. I'm showing in a space that has to consider any number of artistic outputs over the course of time, that's what they do. I think it's sort of wonderful to have the work pitted against that, to have the work situated within that, between Christopher Wool's work and a futurist show, two little rooms. It's really wonderful to be positioned, and that's one of the things that I was talking about earlier, about seeing oneself in context, that we're not out here floating by ourselves. You're absolutely right. None of this is really neutral, it can go in any direction depending on one's political position, persuasion, background, and so forth. To that extent, I think we all have to think about how images are

constructed, and how they're used and who they are for. This question comes up again and again and again, this idea about audience. On the one hand, you have very specific audiences in mind, but when you place something on the table and you say, "I am looking at the notion of shift, I am looking at the notion of shift and disruption," I automatically assume that I am not unusual in that position and that there are any number of people who are interested in shifting as well. How they shift we don't know, but I make the assumption that I'm a part of something that's larger than myself and that I'm therefore going to have a kind of dialogue with interested bodies, not disinterested bodies, with interested bodies.

Page numbers followed by *f* refer to figures.

MacArthur Foundation, 73
Make Someone Happy (Weems), 146
Malcolm X, 78–79
Malus-Beauregard House, 161–163, 164f
Manet, Édouard, 58, 64, 66
Mardi Gras, 173, 177–178
Marlborough, 141
Marx, Karl, 109
Matera—Ancient Rome (Weems), 144f
Matisse, Henri, 186–187
Mattress Factory, 8
Mayflowers (Weems), 146
McCarter, Jeremy, 185–191
McKittrick, Katherine, 156
McInnes, Mary Drach, 4n2
Medal of the Arts, 73
Meg and Coco (Weems), 60f
Mehretu, Julie, 88
Mengele, Josef, 116
Mercer, Kobena, 3, 5n5, 111
Metropolitan Museum, 46
Middle Passage, 19, 21
Mirror, Mirror (Weems), 66–67, 68f
Mirzoeff, Nicholas, 3, 6n6
Missing Link (Happiness) (Weems), 175f
Mitchell, W. J. T., 3, 6n6
Modernism, 3–4, 25, 28, 105–106, 171n11
Mondrian, 25
Monet, Aja, 51
Monk, Thelonious, 76, 152
Moor, Ayanah, 8
Moran, Alicia Hall, 51
Moran, Jason, 152
Morrison, Toni, 3, 6n6, 156–158, 163, 183n3, 188
Morton, Samuel George, 127–129
Moten, Fred, 167
Mourning (Weems), 140f
Moynihan Report, 102–103, 109–110
Mullin, Amy, 4n2
Mulvey, Laura, 95, 180
Murray, Yxta Maya, 1, 115–139
Museum of Comparative Zoology, 115
Museum of Fine Arts (Boston), 46
Museum of Modern Art (MoMA), 7, 25–29, 40, 43, 75, 87, 91n4, 99, 141
Museum of the Confederacy. *See* American Civil War Museum

Museum Series (Weems), 4, 5f, 7, 42, 44, 45f, 87
Myrie, Eliza, 88
Myths, 20, 27–28, 58, 102–104, 109, 148, 178

National Museum of Rome, 42
Negro Family, The: A Case Study for National Action (Moynihan report), 102–103, 109–110
Negro Family in the United States, The (Frazier), 102
Nelson, Steven, 5n4
Neonationalism, 20
Newcomb Art Gallery, 67, 161, 173
New Documents (Szarkowski), 99
New Orleans, 58, 67, 161, 173, 177–179, 182–183
Newton, James, 51
New York Times, 7, 146
Nochlin, Linda, 167
Northampton, 39, 94
Not Manet's Type (Weems), 58, 64, 66

Obama, Barack, 35, 146
OCTOBER, 1
October Files (series), 3
O'Grady, Lorraine, 97
O'Jays, 28
Okediji, Moyosore B., 6n5
Origin of Species, The (Darwin), 115
Orpheus, 177
Ose, Elvira Dyangani, 71
Outterbridge, John, 90

Park Avenue Armory, 40, 54–55, 88
Parsons, Marion Brown, 90
Pastoral Interlude (Pollard), 156
Past Tense/Future Perfect (Weems), 7, 88–89
Patterson, Vivian, 4–5n2
PBS, 165
Peabody Museum of Archaeology and Ethnology, 115–116, 129
Peaches, Liz, Tanikka, and Elaine (Weems), 60, 61f, 62
Pepper, John Henry, 13
"Pepper's ghost" illusion, 13
Pergamon, 87